THE ART OF THE NATIONAL PARKS

BY *Fifty-Nine Parks*

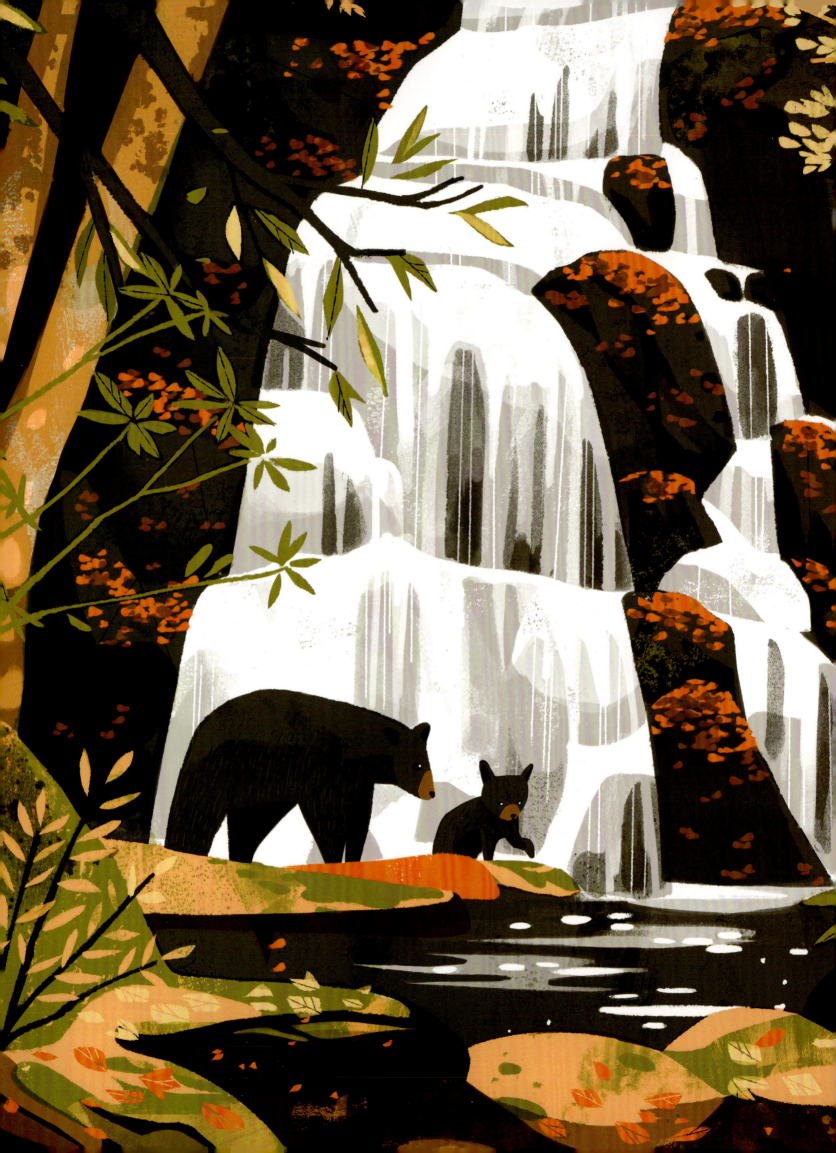

THE ART OF THE NATIONAL PARKS

BY *Fifty-Nine Parks*

EARTH AWARE

SAN RAFAEL • LOS ANGELES • LONDON

CONTENTS

7
Foreword

9
Introduction

17
THE NORTHEAST

18
Acadia National Park

21
THE SOUTHEAST

22
Mammoth Cave National Park

25
Shenandoah National Park

27
New River Gorge National Park

28
Great Smoky Mountains
National Park

31
Congaree National Park

33
Biscayne National Park

34
Dry Tortugas National Park

37
Everglades National Park

38
Virgin Islands National Park

41
THE MIDWEST

43
Cuyahoga Valley National Park

44
Isle Royale National Park

47
Indiana Dunes National Park

48
Gateway Arch National Park

51
Hot Springs National Park

52
Voyageurs National Park

55
Theodore Roosevelt
National Park

56
Badlands National Park

58
Wind Cave National Park

61
THE SOUTHWEST

63
Guadalupe Mountains
National Park

64
Big Bend National Park

69
Grand Canyon National Park

70
Petrified Forest
National Park

73
Saguaro National Park

74
Carlsbad Caverns
National Park

77
White Sands National Park

79
THE WEST

80
Black Canyon of the Gunnison
National Park

83
Bryce Canyon National Park

85
Great Sand Dunes National Park

87
Mesa Verde National Park

88
Rocky Mountain National Park

90
Grand Teton National Park

93
Yellowstone National Park

94
Glacier National Park

96
Death Valley National Park

99
Joshua Tree National Park

101
Kings Canyon National Park

103
Lassen Volcanic National Park

104
Pinnacles National Park

107
Redwood National and State Parks

110
Yosemite National Park

112
Sequoia National Park

114
Arches National Park

119
Capitol Reef National Park

121
Zion National Park

124
Canyonlands National Park

127
Great Basin National Park

131
THE NORTHWEST

132
Mount Rainier National Park

134
North Cascades National Park

137
Olympic National Park

138
Crater Lake National Park

141
Denali National Park

143
Gates of the Arctic
National Park

144
Glacier Bay National Park

147
Katmai National Park

148
Kenai FjordsNational Park

150
Kobuk Valley National Park

153
Lake Clark National Park

155
Wrangell—St. Elias
National Park

157
THE PACIFIC

159
Channel Islands National Park

160
Haleakalā National Park

163
Hawai'i Volcanoes
National Park

164
National Park of
American Samoa

167
BEHIND THE SERIES

172
Index

175
With Gratitude

FOREWORD

Art is a powerful form of storytelling, moving people when words fail us. Art can evoke emotions and drive action. And when it came to the designation of America's first national park, it did both.

The first Americans to explore the West were awestruck by its beauty. The stories they told of the grandeur—the jagged peaks of the Teton mountains, the giant sequoias of California, and the prismatic waters of the hot springs in Wyoming—were almost unbelievable to people back east.

In 1871, geologist Ferdinand Hayden had the foresight to bring two artists on his expedition to conduct a survey in northwestern Wyoming, in his quest to protect this land from the development moving farther west. Photographer William Henry Jackson and painter Thomas Moran captured bubbling mud pots, spewing geysers, and rock that was the most beautiful golden hue.

The photos and paintings carried the real-life beauty of Wyoming two thousand miles back to Washington, DC, where Hayden could not only tell, but now show, elected officials and decision makers just how special the area was. Members of Congress were so inspired they moved to establish a park at the site. Moran and Jackson's works paved the way for the creation of the world's first national park—Yellowstone—in 1872. Their art made once-distant landscapes real to people with the power to protect them, even though they had never set foot in Wyoming and probably never would.

Since then, many more artists have used their craft to inspire outdoor conservation. In the 1930s, Franklin Delano Roosevelt's Works Project Administration hired artists across the country to create the now-iconic See America posters for the National Park Service to educate and inspire the American public about the incredible places in their own backyard.

Photographer Ansel Adams captivated a generation of explorers and conservationists with his black-and-white photos of Yosemite National Park. QT Luong, the first known person to have photographed every national park, uses his images to inspire exploration of the places he loves. Ian Shive uses his photography and experiences in national parks to talk about the importance of their protection and preservation. *Fifty-Nine Parks* continues in this long-established tradition of supporting national parks, rendering their magnificent landscapes into beautiful, screen-printed posters.

Many people have never had the privilege of experiencing the majestic face of Denali or the turquoise waters and colorful reefs of the Dry Tortugas. But through the power of art, whether a painting from a national park's artist-in-residence or a photograph shared by a friend on social media, we become inspired to speak up to protect them. The National Parks Conservation Association helps people around the country use their voices to defend the more than four hundred national park sites found in every US state and territory.

Since their inception, art has inspired Americans' love of national parks. And for more than a century, NPCA has harnessed that passion and inspired people to protect and preserve them, so their beauty, their history, and their stories can be protected and preserved for generations to come.

We invite you to join us in this important mission by visiting npca.org/join. Together, we can carry on this legacy left to all of us. Like Jackson and Moran on that expedition to Wyoming, we all have the power to speak up for our favorite national parks and tell their stories. Through art and through our collective voice, we can protect the places we love.

Theresa Pierno

President & CEO, National Parks Conservation Association

INTRODUCTION

What you hold represents six years of actual blood, sweat, and tears. Bringing this series to life has been a challenge but incredibly rewarding. We're forever grateful to do work that is fulfilling on both a personal and professional level. A big reason for that sense of fulfillment comes from the company we keep. It's a genuine honor to collaborate with so many inspiring people. The old adage rings true: If you want to go fast, go alone. If you want to go far, go together.

Our love of posters and national parks goes back to 1999. Friends and I grew up in sleepy Palmer, Massachusetts. In high school we began setting up all-ages DIY music and art events. We hosted hundreds of shows in eclectic spaces like church basements, VFW halls, and spooky campgrounds. Thirty-nine of these shows took place in an empty storefront. Another 101 shows were held in my mom's backyard shed. We hosted bands and artists from all around the world. Sometimes we'd see twenty-five people come out—sometimes a few hundred. A lot depended on the venue and the inventive mix of bands we'd curate. This work was important to us because it was our way of doing something positive in our community.

We discovered screen printing through the necessity to promote these shows. Our love of the medium was immediate. There's something so beautiful about the way the ink stacks up one layer at a time. Or the quiet intention involved with dialing in registration for a print. Screen printing has its limitations—especially when printing on your bedroom floor. But those limitations made us more creative. We worked hard on these shows. That's why we felt it was so important to design—and print—a compelling poster.

Our adventures weren't just limited to Palmer. We spent years touring the United States with friends and our bands. Being young—and broke—meant we couldn't afford much on the road. We often visited parks, monuments, and museums because they were within our means. It was so humbling to visit the Grand Canyon on an early tour out west. The memory of my first hike through Glacier National Park is just as vivid. These parks made our curiosity for the natural world grow deeper. They reinforced the notion that these places—and their inhabitants—must be treated with reverence. These experiences also provided some much needed perspective during our youth. It turns out each of us is not the center of the universe. In many ways we are stewards of the land. Thanks for the insight, nature!

It was around this time that we discovered the posters of the WPA (Works Progress Administration). The simple charm of those prints is captivating. They're bold and modest all at once. The work from this era is inspiring from a design perspective—

1998
Began playing in bands and going to shows

1999
Began hosting all-ages DIY art and music events

1999
Began designing posters for our bands and our DIY shows

2000
Formative trip to DC monuments and museums

2000
Discovered the inspiring art of the WPA

2001
Picked up a squeegee—began screen printing posters

2002
First trip to the Grand Canyon—mind blowing!

but also from a social standpoint. The spirit of the WPA is all about what we can do together during times of real adversity. It's about celebrating where we are and working together toward a larger goal. Amazing.

The next evolution of our DIY shows came by way of the National Poster Retrospecticus. The NPR covers gallery walls from floor to ceiling with hand-printed posters. The first show took place in 2006 and was revisited again in 2012—this time as a touring show. The collection now features over 600 posters made by more than 200 amazing artists! We've hosted more than 150 of these shows in the last decade. Many of which took place in musty basements and makeshift galleries. We've also shown in places like the Rock and Roll Hall of Fame, Marvel Studios, and the Library of Congress. We love the spirit of these events because they bring together a diverse and creative crowd. The vibe at these shows is one of genuine warmth and enthusiasm. We live for this stuff!

So where does Fifty-Nine Parks fit in all this? Well, after a few years of touring with the NPR, we had an idea: What if we brought something else we love into the mix? Something like—the national parks! The idea was to work with artists from around the world to celebrate these natural wonders. We set out to highlight the beauty of each park and the unique voice of every artist. The result is an eclectic—but cohesive—series that pays respect to the past while still feeling new.

The leap of faith to turn our passion project into full-time work came in 2015. We spent the last decade working nights and weekends on posters and shows. We never made any money on some 200 events—this was always a labor of love. That usually made for a seventy-hour workweek. There was also a good seven-year stretch without a single vacation. We knew that the only way Fifty-Nine Parks could meet its full potential was to give it 100 percent of our bandwidth. We'd also need to make this a self-sustaining effort. For years we relied on the paycheck from our day jobs to fund our passion projects. It was a terrifying leap but we went all in—determined to bring this series to fruition.

We struggled a lot in those first two years. We encountered random setbacks and made our share of mistakes. We did our best to learn something new every day and use each hiccup as an opportunity for growth. Touring with the series definitely contributed to some of those challenges. On average we spent nearly half of the year on the road doing shows and half back home in Austin, Texas. It wasn't uncommon for us to drive ten to fourteen hours between shows. We'd hang one hundred posters, host a few hundred guests, and take it down in the same day. Then we'd hit the road and repeat for weeks. It was intense but it was also an adventure!

2005
Hosted our 150th show

2006
Life changing trip to Glacier National Park

2006
First Western Massachusetts Flyer Retrospecticus show

2007–2010
Visiting more parks, producing shows, and making posters

2011
Hosted our 200th show

2012
The National Poster Retrospecticus revisited

2013
The first NPR Tour

2015
Fifty-Nine Parks is born

2016
First park posters released

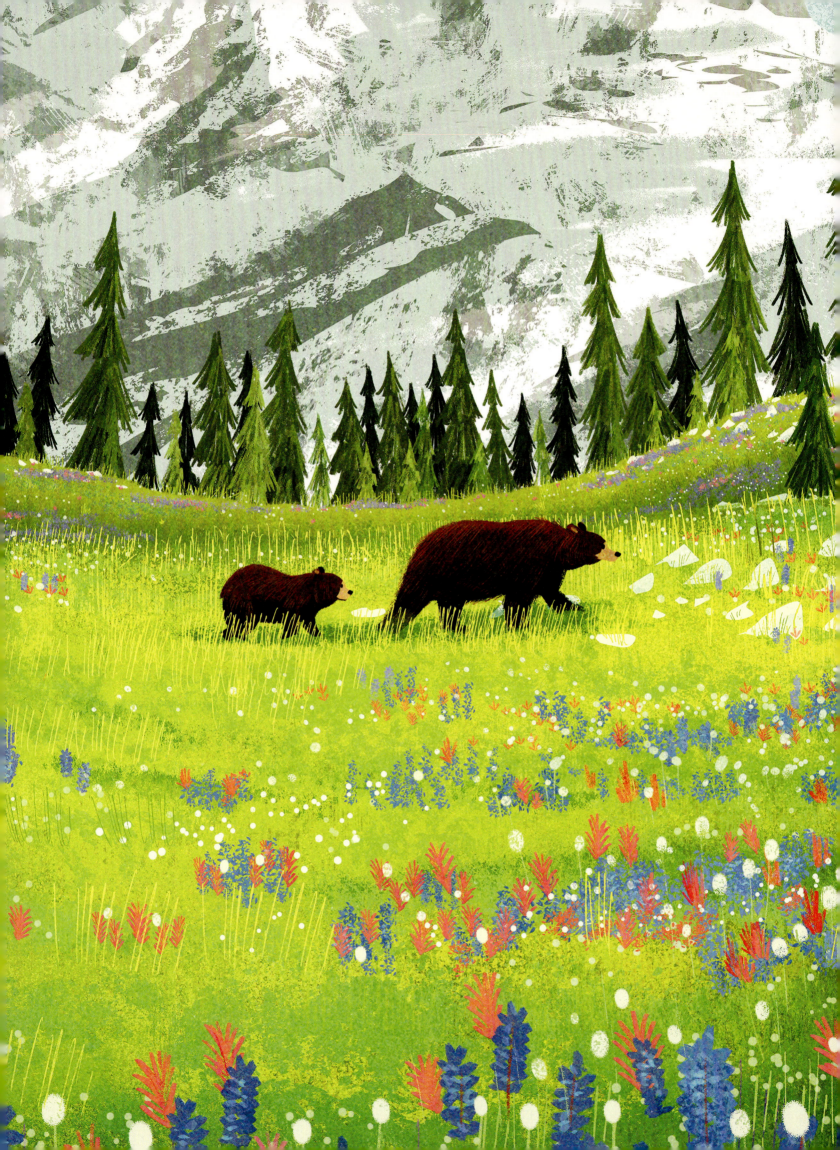

It was during this era that we learned how far a jar of peanut butter could go. We practically lived off the stuff. Struggling to make ends meet can be weirdly life-affirming though. Your clothes may be falling apart—and you're living month-to-month, but it's totally worth it. The work feels rewarding because you've invested so much of yourselves—and had so much at stake. We're fortunate to have a wealth of past experiences to draw upon. Our early days of setting up events helped foster the work ethic—and values—that still guide us today. That era taught us so much about creative problem-solving and resiliency. We also learned how to do a lot with very little. This made all the difference during the initial five-year journey with Fifty-Nine Parks.

When I think about the series, I'm filled with so much joy and gratitude. It's through this work that we've been able to spend more time visiting parks and digging deeper into their history. To date we are fortunate enough to have visited two-thirds of the parks! We're also fortunate to team up with some of the hardest working artists and printers in the world! Everything contained in this book is the result of a team effort. From the art, printing, branding, typography, and the creation of this book. We're also fortunate to work with brilliant partners outside of the poster world. Work on board games, notebooks, and hiking gear help the series take on life in new ways. True to our ethos in the early days of DIY shows—we still want to do something positive with our efforts. It's through the series that we have collectively raised over $100,000 for the preservation of public lands. We intend to expand upon this work for years to come!

Our goal has always been simple: get park nerds into posters and poster nerds into the parks. We love the heart warming stories that speak to that aspiration. Like the son who went to his first park with his mom—the park goer—and she got into posters with her son—the poster enthusiast—because of the series. If there's one thing we hope to reinforce, it's that art—and the parks—are for everyone. Just like our shows have always been. One of our greatest joys in this work is filling countless event spaces with people from all walks of life. It's in the spirit of treating our differences—and commonalities—with a sense of reverence. We can't think of a better way to celebrate this thing called life than to share it with one another. We're so grateful that the series can be a conduit for doing just that!

Thank you so much for your support and enthusiasm! All our best from Austin!

JP Boneyard
Creative Director; Fifty-Nine Parks
January 2021

2016
Series archived by the
Library of Congress

2017
Visited forty national parks

2018
Hosted our 300th show

2019
Completed all national parks
in the series

2020
One hundred thousand dollars
donated to date for orgs that
preserve public lands

2021
Our dream comes true and this
book is made!

THE NAT
OF THE UNIT

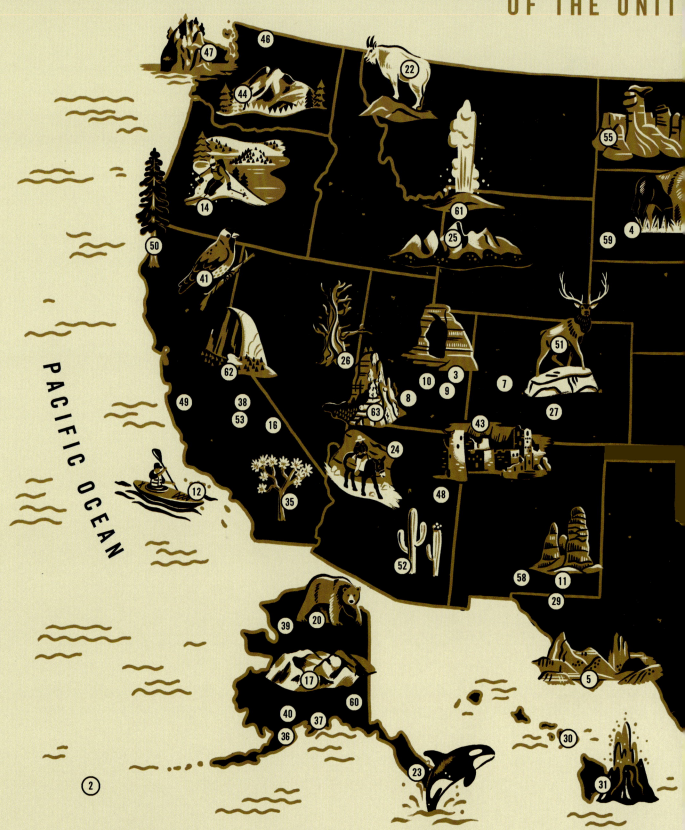

PACIFIC OCEAN

01. ACADIA (ME)	09. CANYONLANDS (UT)	17. DENALI (AK)	25. GRAND TETON (WY)
02. AMERICAN SAMOA	10. CAPITOL REEF (UT)	18. DRY TORTUGAS (FL)	26. GREAT BASIN (NV)
03. ARCHES (UT)	11. CARLSBAD CAVERNS (NM)	19. EVERGLADES (FL)	27. GREAT SAND DUNES (CO)
04. BADLANDS (SD)	12. CHANNEL ISLANDS (CA)	20. GATES OF THE ARCTIC (AK)	28. GREAT SMOKY MTNS. (TN)
05. BIG BEND (TX)	13. CONGAREE (SC)	21. GATEWAY ARCH (MO)	29. GUADALUPE MTNS. (TX)
06. BISCAYNE (FL)	14. CRATER LAKE (OR)	22. GLACIER (MT)	30. HALEAKALA (HI)
07. BLACK CANYON (CO)	15. CUYAHOGA VALLEY (OH)	23. GLACIER BAY (AK)	31. HAWAII VOLCANOES (HI)
08. BRYCE CANYON (UT)	16. DEATH VALLEY (CA/NV)	24. GRAND CANYON (AZ)	32. HOT SPRINGS (AR)

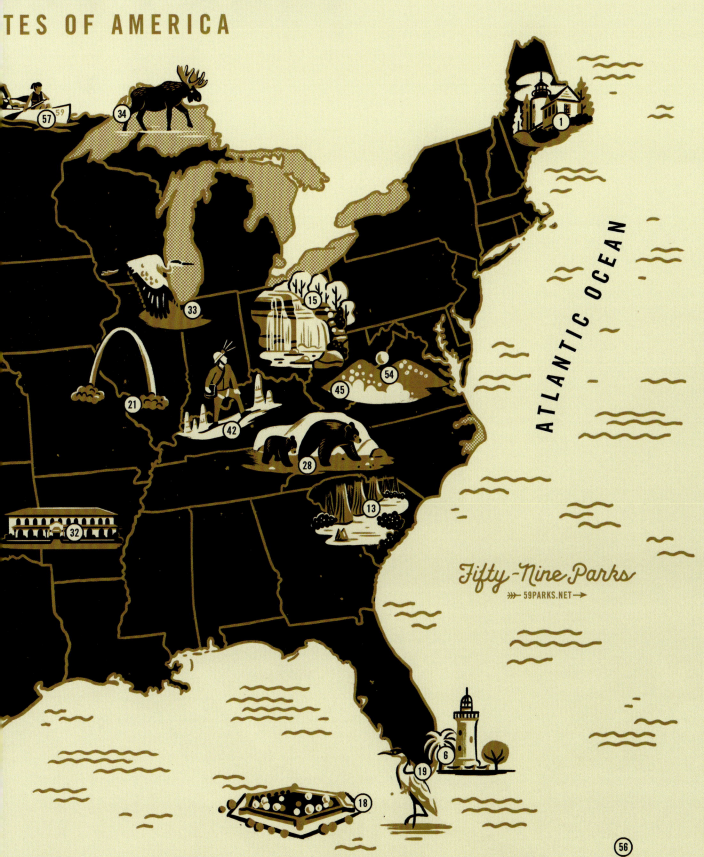

NAL PARKS
TES OF AMERICA

ATLANTIC OCEAN

Fifty-Nine Parks
59PARKS.NET

33. INDIANA DUNES (IN)	41. LASSEN VOLCANIC (CA)	49. PINNACLES (CA)	57. VOYAGEURS (MN)
34. ISLE ROYALE (MI)	42. MAMMOTH CAVE (KY)	50. REDWOOD (CA)	58. WHITE SANDS (NM)
35. JOSHUA TREE (CA)	43. MESA VERDE (CO)	51. ROCKY MOUNTAIN (CO)	59. WIND CAVE (SD)
36. KATMAI (AK)	44. MOUNT RAINIER (WA)	52. SAGUARO (AZ)	60. WRANGELL-ST. ELIAS (AK)
37. KENAI FJORDS (AK)	45. NEW RIVER GORGE (WV)	53. SEQUOIA (CA)	61. YELLOWSTONE (WY/MT/ID)
38. KINGS CANYON (CA)	46. NORTH CASCADES (WA)	54. SHENANDOAH (VA)	62. YOSEMITE (CA)
39. KOBUK VALLEY (AK)	47. OLYMPIC (WA)	55. THEODORE ROOSEVELT (ND)	63. ZION (UT)
40. LAKE CLARK (AK)	48. PETRIFIED FOREST (AZ)	56. VIRGIN ISLANDS	

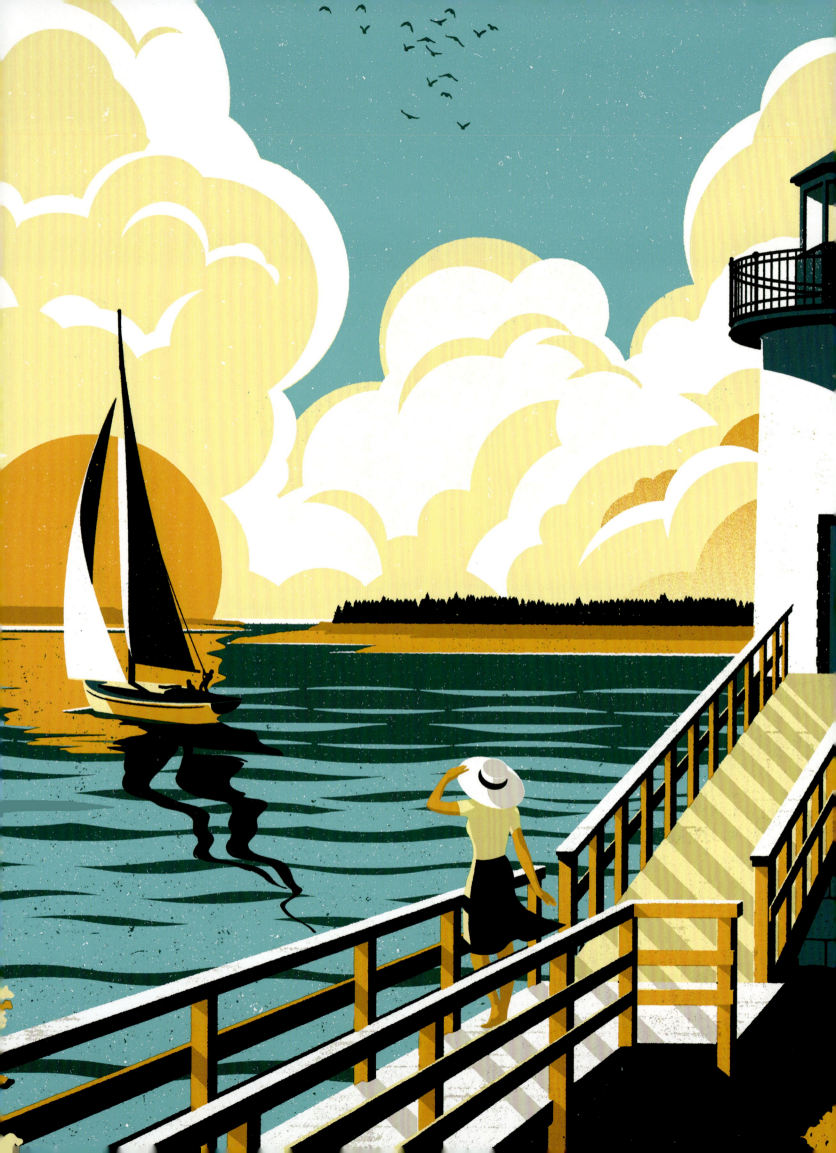

THE
NORTHEAST

ACADIA NATIONAL PARK

As the waves rise and fall in broken rhythms on the shore, as the tide flows and ebbs across the littoral belt, so the seas of former times have risen and fallen in uneven measure on the uneasy land; the rocks have grown and wasted; the ice of the North has crept down and melted away—all shifting back and forth in their cycles of change.

—William Morris Davis

To stand on the rocky mountains of eastern Maine and look out at the Atlantic at sunrise is to witness the dawn of a new day for the entire nation. This jewel at the easternmost point of the continental United States has long welcomed and also inspired weary travelers. Acadia consists of half of the island known as Mount Desert, several smaller islands, and the Schoodic Peninsula. It's the easternmost national park in the United States, providing stunning views of the Atlantic's waves crashing against the highest rocky headlands on the coastline. The definitive lighthouses and fishing boats of the region adorn the breathtaking shoreline.

New York's wealthiest once flocked to this area religiously, deeming it the perfect escape from the city's heat. John D. Rockefeller Jr. designed the 158 miles of hiking trails and 27 miles of scenic road with the goal of perfectly sampling the sprawling woodlands, lakes, and ponds.

Coniferous trees like hemlock, red pine, and red spruce—as well as deciduous trees like white ash, trembling aspen, and American beech—are abundant in the woodlands, while common junipers and pitch pines thrive along the winding mountains. The radiant oranges and reds of Acadia's autumn leaves are so brilliant that they've beguiled generations of artists who return year after year to capture their beauty. Whether kayaking alongside Cadillac Mountain, riding in a horse-drawn carriage through the woodlands, or ice fishing in Acadia's winter-frozen lakes, this park distills the idiosyncratic essence of New England into each breath of sea-flavored air.

- The Bass Harbor Head Lighthouse marks the entrance to Bass Harbor Village on the southwestern side of Mount Desert Island. It was built in 1858 and stands fifty-eight feet above mean water levels.

- The island upon which most of the park is located—Mount Desert—was given its name by French explorer Samuel de Champlain. He sailed there in 1604, and the name refers to how "deserted" it appeared to be.

- Artists and journalists in the early 1800s helped popularize the area. Finding great inspiration in the natural beauty of the landscape, many artists stayed in the homes of local farmers and fishermen. These quartered tourists became so common, they were dubbed "rusticators."

- Two of the painters who helped popularize the area were Thomas Cole and Frederic Church, both of whom are considered part of the Hudson River School of artists. They were known for painting natural landscapes and foliage, which is why they were so enamored with Acadia.

- Cadillac Mountain, the park's highest point, stretches 1,530 feet, making it the highest mountain on the East Coast of the United States.

STATE: MAINE
ARTIST: TELEGRAMME PAPER CO.

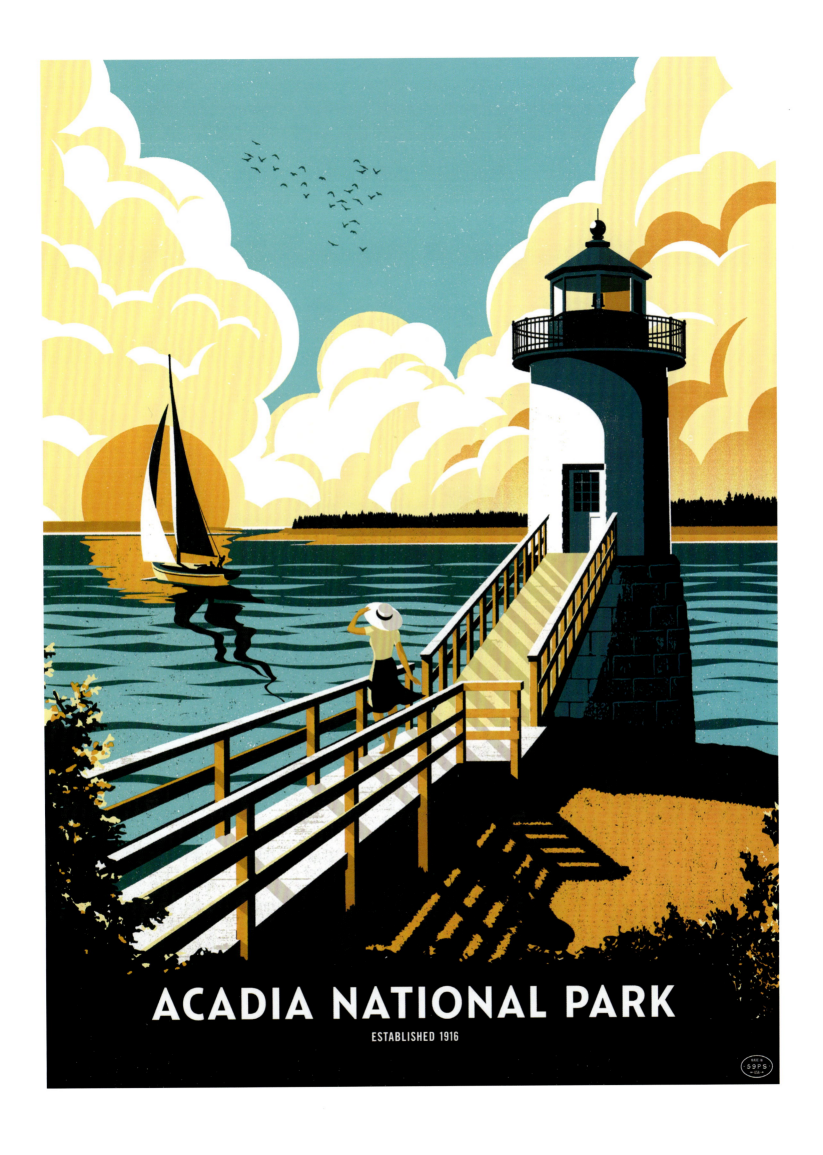

THE
SOUTHEAST

MAMMOTH CAVE NATIONAL PARK

I saw or seemed to see the night heaven thick with stars glimmering more or less brightly over our heads, and even what seemed a comet flaming among them.

—*Ralph Waldo Emerson*

Much of Mammoth Cave National Park looks like what you might expect to find in central Kentucky. There are waves of rolling green hills. There are bushels of leaves from deciduous forests as far as the eye can see. There are only a few rivers and streams here. The lion's share of the water in the area is absorbed into the soil, which is predominantly made of decomposed limestone. The result of the millions of years of dripping water is an underground pantheon.

Mammoth Cave is vast, expansive, and dead quiet. The nearly 400 miles of rooms and passageways make it the longest known cave system in the world. Stalagmites and stalactites jut from the shifting ceilings and floors. The steady drip of condensation is often the only sound breaking the intense silence.

At night, the area known as the Star Chamber creates the illusion of a night sky complete with stars and a comet. This occurs when visitors' lanterns reflect from chips in the gypsum ceiling of the cave. Passageways are marked by quaint wooden signs. One especially narrow passageway is dubbed FAT MAN'S MISERY, while another passageway with a low ceiling is called TALL MAN'S MISERY. Aboveground, the Green River runs throughout the park, rounding grassy bends and lurching down steep inclines. The dark and mysterious innards of Kentucky will ignite your wonder like a torch in a deep, dark cave.

- Mammoth Cave is by far the longest cave system in the world. At 400 miles long, it's nearly double the length of Mexico's Sac Actun.

- Semisubterranean waterways exist throughout the cave and can be toured by boat. One of the most notable is called River Styx.

- Natives are believed to have made use of the cave as far back as 4,000 years ago.

- The tallest part of the cave, Mammoth Dome, is 192 feet high.

- The lowest part of the cave—the so-called Bottomless Pit—is 105 feet deep.

STATE: KENTUCKY
ARTIST: NICOLAS DELORT

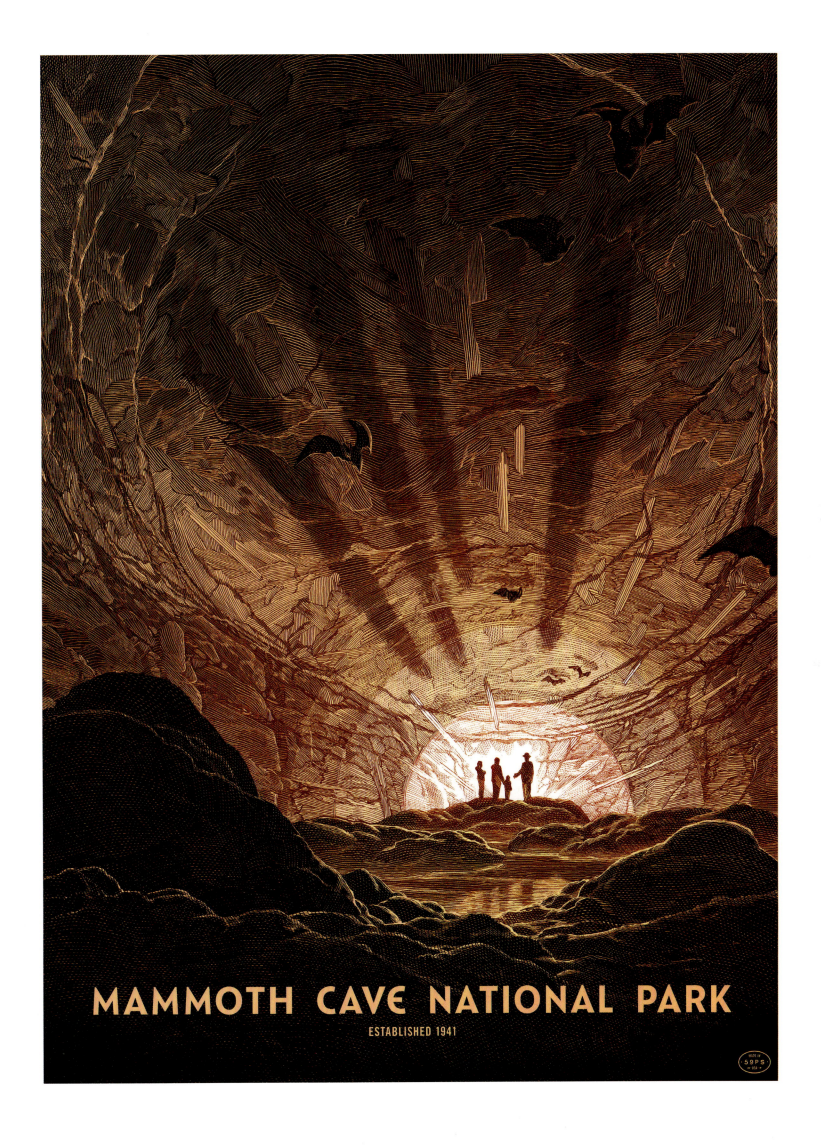

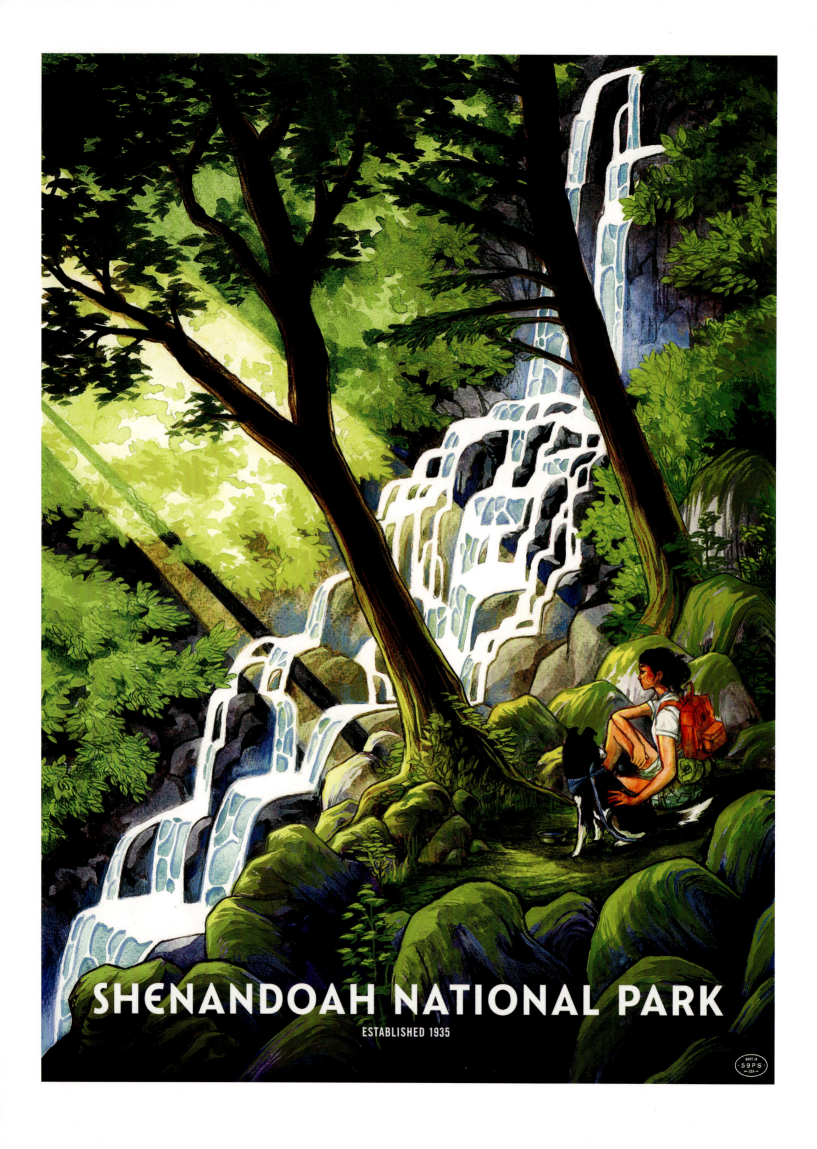

SHENANDOAH NATIONAL PARK

Oh Shenandoah, I long to see you. Away, you rolling river. Oh Shenandoah, I long to see you. Away, I'm bound, away.

—Anonymous

In northern Virginia, only seventy-five miles from our nation's capital, is a mysterious and stunning wilderness called the Shenandoah Valley. Sprawling and diverse forests thrive here, providing a protected home for myriad species of trees. The Blue Ridge Mountains loom in the distance. Water trickles down through brooks and streams, then tumbles down waterfalls en route to the Atlantic Ocean. Two such waterfalls include the ninety-foot behemoth Overall Run and the serene, multilevel Dark Hollow Falls.

Skyline Drive stretches along the entirety of the park, offering scenic views of the Blue Ridge Mountains and the rolling hills of Virginia. The western side of the park is home to the Shenandoah River, a tranquil fifty-six-mile tributary that runs in the shadow of the Appalachian Mountains.

Despite its beauty, the land has a bloody history. First the native peoples were displaced, and then the farmers who later settled in their absence. The remains of these abandoned farms coupled with the moss that hangs from the branches give these parts a haunting, funereal feel. Elsewhere, in places such as the Big Meadows (a lush green meadow on top of a mountain) or Old Rag Mountain, the entirety of the Shenandoah's panoramic view overwhelms the senses with its vibrant beauty.

- Shenandoah National Park is home to a black bear refuge that hosts the densest population of black bears in the United States.

- People lived in the park until 1979, when the last person residing in Shenandoah passed away.

- President Herbert Hoover built a home in the park as a "Summer White House."

- The Shenandoah salamander is a rare species that resides only in the park. The lizard is lungless and breathes through its skin.

- Shenandoah is also home to bobcats, white-tailed deer, skunks, chipmunks, coyotes, foxes, opossums, squirrels, raccoons, moles, and shrews.

STATE: VIRGINIA
ARTIST: JACQUELIN DE LEON

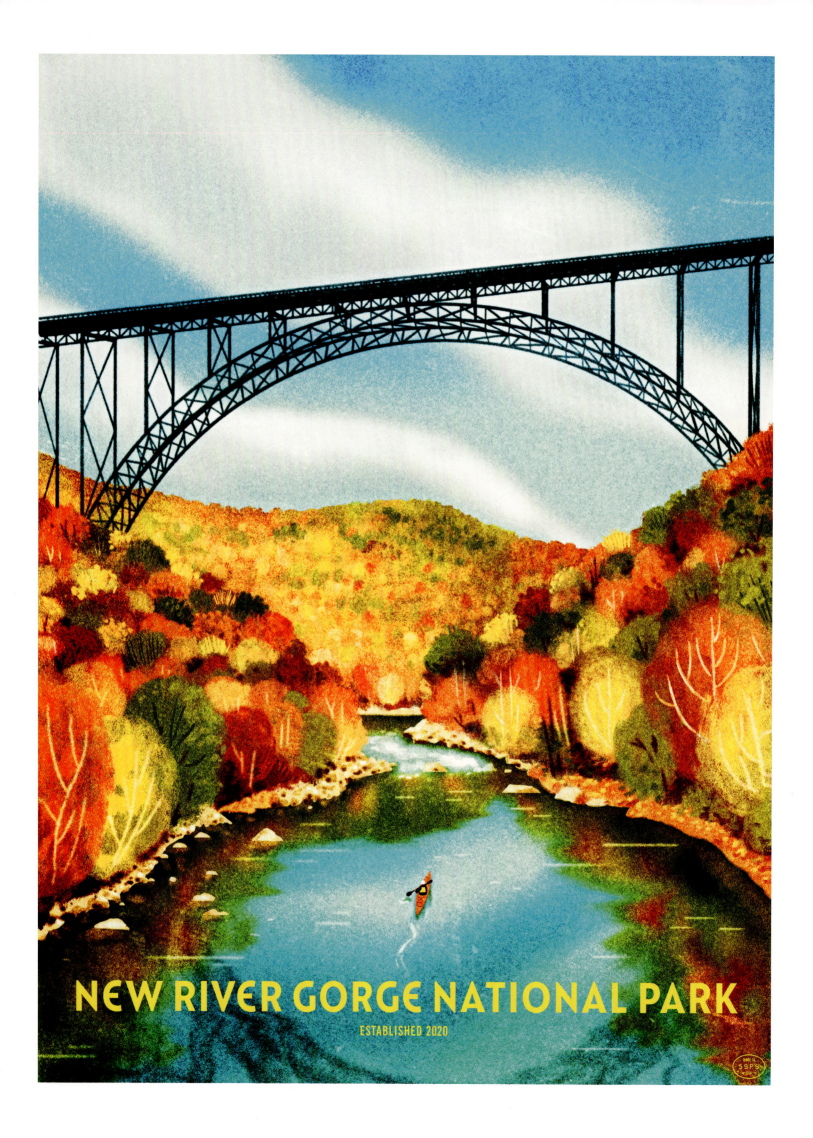

NEW RIVER GORGE NATIONAL PARK

All my memories gather 'round her
Miner's lady, stranger to blue water
Dark and dusty, painted on the sky
Misty taste of moonshine, teardrop in my eye

—John Denver

New River Gorge is a celebration of nature, history, and the spirit of adventure. Though millions of years old, the ferocious New River continues to carve out the longest and deepest river gorge in the Appalachian Mountains.

The West Virginia stretch of the New River is a whitewater rafting mecca. The fifty-three miles of free-flowing river beginning at Bluestone Dam and ending at Hawk's Nest Lake features an array of possibilities for rafting enthusiasts. The southern section of the river offers smoother jaunts and long pools, while the lower gorge offers some of the most challenging Class V rapids in the country.

Towering 876 feet above the river stands one of the longest and highest single-span bridges in the world. The 1,700-foot-long bridge attracts bungee and BASE jumpers from around the world, and is considered a go-to spot for daredevils. New River Gorge National Park and Preserve comprises more than 72,000 acres of land and offers activities for adventurers of all stripes, including rock climbing, hiking, biking, camping, and fishing.

The park is home to more than sixty-three species of mammals and forty-eight species of amphibians, including the famed hellbender, a large blotchy salamander that grows up to forty inches long. Abandoned human settlements nestled within the gorge date back to the mining boom of the late eighteenth century. Mines and mining towns born during the fervent rush of American industry now lay overtaken by foliage. The soulful spirit of Appalachia echoes throughout this deep river gorge.

- Ironically, the New River is widely believed to be one of the world's five oldest rivers.

- The New River Gorge Bridge is the fifth-longest and second-highest single-span bridge in the world.

- The New River Gorge Bridge is so popular with daredevils that the county designated the third Saturday of October annual "Bridge Day" in their honor.

- The hellbender salamander—also referred to as "mud dog," "snot otter," and "lasagna lizard"—has become a mascot for the area.

- The New River begins in North Carolina and travels through Virginia before reaching West Virginia, where it feeds into the Kanawha River.

STATE: WEST VIRGINIA
ARTIST: BRAVE THE WOODS

GREAT SMOKY MOUNTAINS NATIONAL PARK

The Smoky Mountains are a rare jewel. . . .Why not have a place where you can still see the stars? There is value to keeping things primitive.

—*James Dawson*

Human beings have long imagined other worlds that exist just above the clouds. You need only visit Great Smoky National Park to understand why. Here you can stand atop the nearly 1,500-foot-high trail dubbed the Chimney Tops and gasp at the expanse of mossy green hills. At night, a hazy fog appears, hanging softly in the trees, making each moment feel mystical and exciting. In the morning, this signature fog somehow mutes each eyeful of color, making the landscape look like a vintage Polaroid.

Trout, shiners, suckers, and bass populate the naturally occurring streams and the more than one hundred waterfalls in the park. Laurel Falls, perhaps the most well-known waterfall in the park, contains an endless rush of water that feeds into the brooks and streams swirling through the hollows and hills of this living, breathing marvel of nature. Spruce Flats Falls is like a series of imperial escalators where pearl white rapids flow down four separate levels of rock, plummeting a total of thirty feet. There are new worlds here, hidden below the waterfalls, hidden beneath the fog.

- In 2019, Great Smoky National Park saw 12.5 million visitors, making it the most visited national park in the United States of America.

- Great Smoky is a geological marvel. The sedimentary rocks here were formed millions of years ago by the accumulation of silt, sand, and gravel.

- There are 140 different types of trees throughout Great Smoky. Some of the most common include the red maple, the yellow birch, the yellow buckeye, and the white oak.

- Great Smoky National Park is one of the largest protected areas in the United States where black bears still thrive. There are more than 1,500 black bears in the park.

- The Smoky Mountains are estimated to be between 200 and 300 million years old, making them among the country's oldest mountain ranges.

STATE: NORTH CAROLINA, TENNESSEE
ARTIST: CHRIS TURNHAM

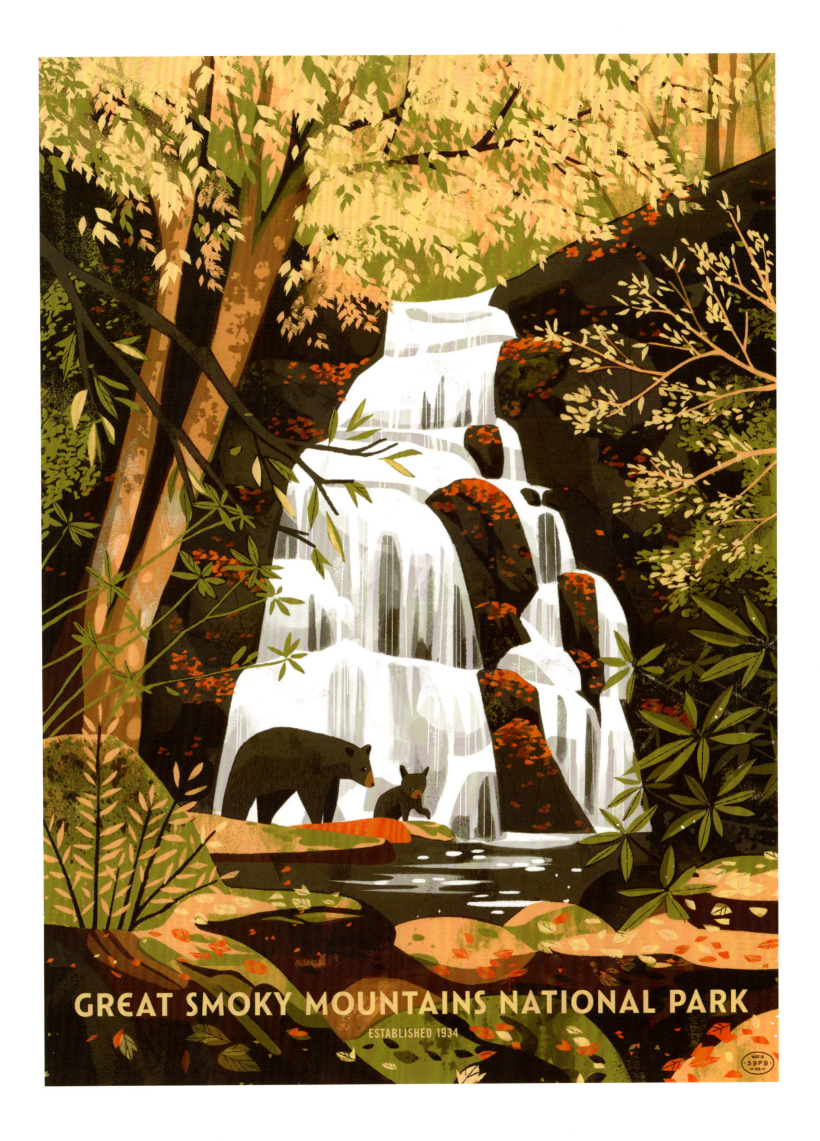

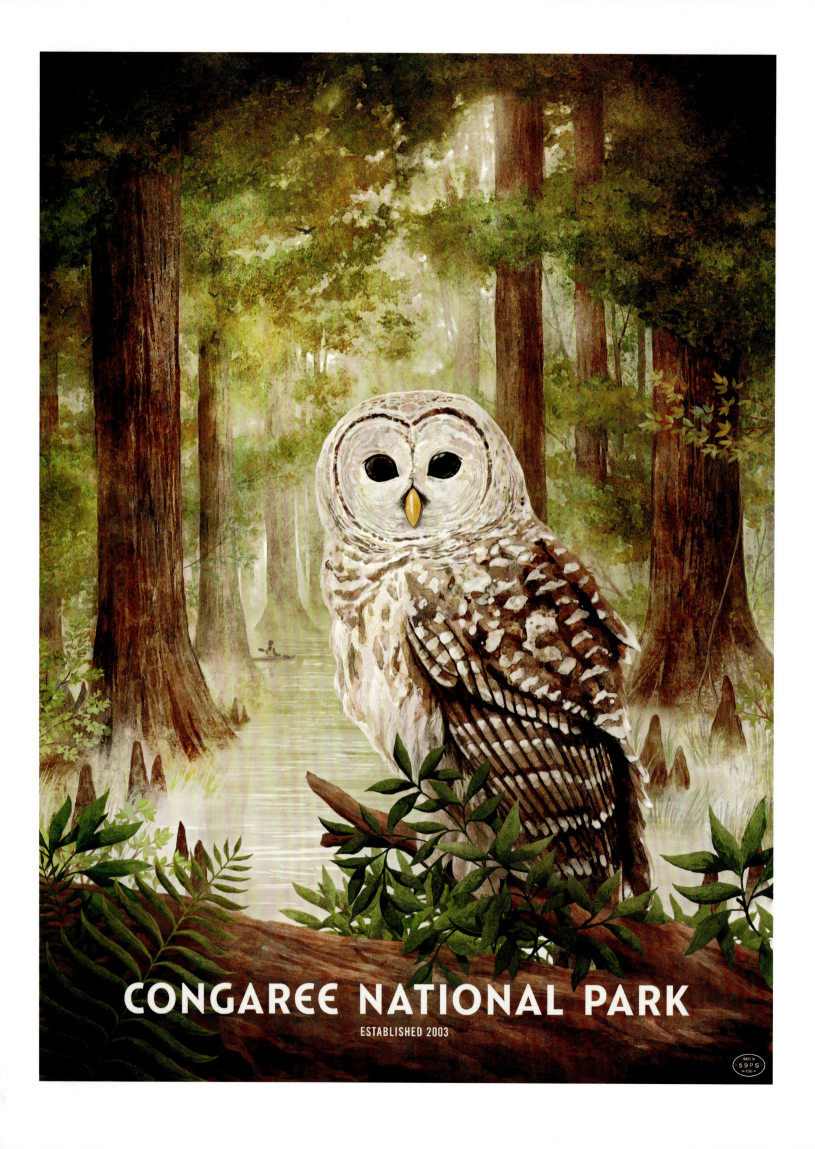

CONGAREE NATIONAL PARK

The thick black, slow unsigned stream almost without current, which once each year ceased to flow at all and then reversed-spreading, drowning the land and subsiding again, leaving it still richer...

—*William Faulkner*

Just a short drive from Columbia, South Carolina, is a forest where the roots of hulking oak trees sprout from the shallow floodwaters. Though parts of the park are covered in cloudy water, green with mud, Congaree isn't technically a swamp. A person navigating between the trees in a small canoe will never see an alligator or a snake, and the swampy floor only occurs in certain areas, and only during certain seasons. This type of area is considered a *floodplain* or *bottomland* hardwood forest. The forest is filled with deciduous and evergreen hardwood trees. They thrive in the kind of nutrient rich muck produced by the seasonal floods that occur when the Congaree River swells.

Congaree is the last bottomland hardwood forest in the country. Less than 1 percent of these original bottomland hardwood forests still exist. Oaks, sweet gums, tupelo, and bald cypress are plentiful here. The bald cypress lives for hundreds of years. Designated an old-growth forest, the area conserves some of the tallest tree species in the world, including a 169-foot-high loblolly pine, and cypress trees that are more than 500 years old. These trees also make the area hospitable to a multitude of rare birds, including the haunting barred owl. If this park had not been protected, these forests might have disappeared for good, taking with them the enduring mysteries that they provide.

- Bottomland hardwood forests like Congaree once stretched along all of the southern floodplain rivers, equaling nearly fifteen million acres of trees.

- The bald cypress is the most prized tree in Congaree. The oldest documented bald cypress is 1,700 years old.

- The unique climate of the park is hospitable to many mammals, including deer, wild dogs, armadillos, opossums, otters, turkeys, and wildcats.

- At nighttime during the fall and spring, visitors can partake in so-called owl prowls, nocturnal walks which allow them to tour the forest and listen to the eerie hoot of the barred owl.

- Late night owl prowlers can also marvel at the glow-in-the-dark fungi that grow on the cypress trees. According to local legend, knobby wood growths on the trunks of the cypress trees are in fact elves that come alive and dance at night.

STATE: SOUTH CAROLINA
ARTIST: AARON POWERS

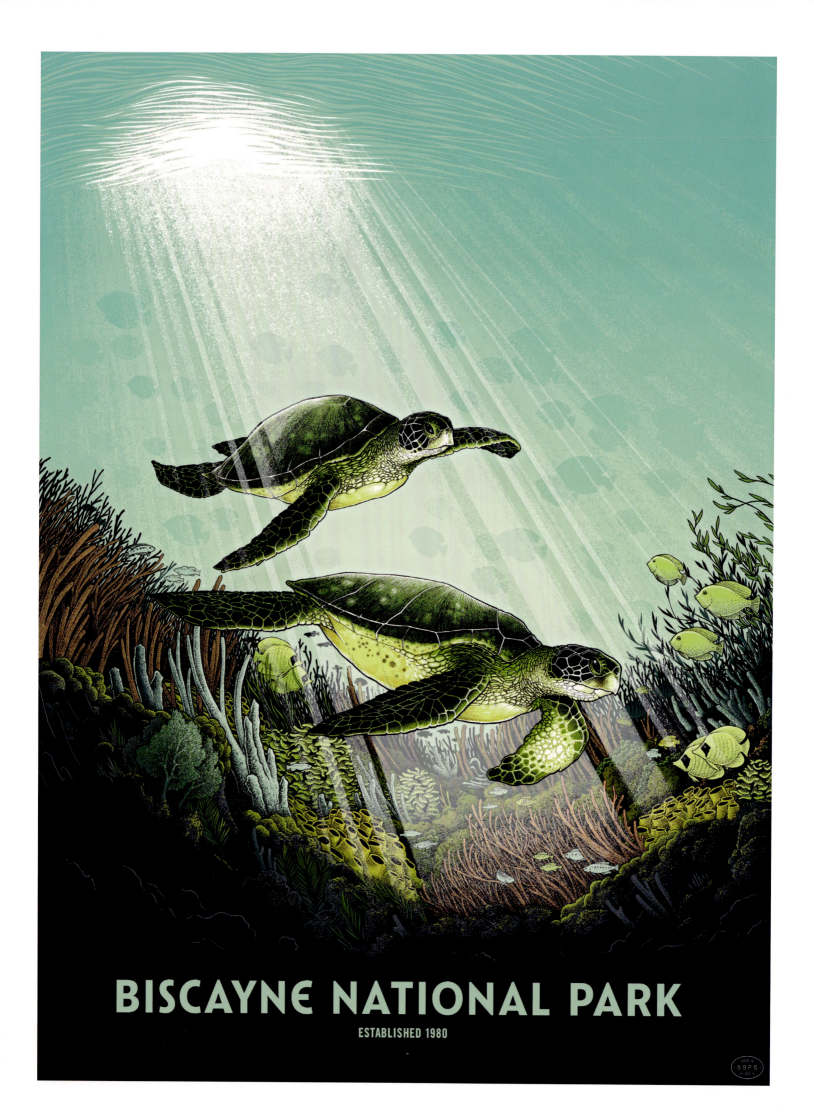

BISCAYNE NATIONAL PARK

In the sea, Biscayne, there prinks
The young emerald, evening star,
Good light for drunkards, poets, widows,
And ladies soon to be married.
By this light the salty fishes
Arch in the sea like tree-branches,
Going in many directions
Up and down.

—*Wallace Stevens*

Between the tip of Florida and the Bahamas, just along the keys, is an aquatic wonderland called Biscayne National Park. The thirty-five-mile-long lagoon of Biscayne Bay hosts bottlenose dolphins and Florida manatees. A kaleidoscope of sea life can also be found making a home among the bustling coral reefs. Colonies of spiky polyps, sponges, and sea whips occupy the coral where nearby pork fish and gobies swim alongside laconic schools of giant sea turtles.

Above sea level there are naturally occurring spindly mangroves that sway in the sea breeze, providing a home for mollusks and crustaceans. Biscayne Bay shelters a plethora of endangered species, including swallowtail butterflies and smalltooth sawfish. Ninety-five percent water, Biscayne is one of the largest marine parks in the national park system. The explosion of sea life around every bend is likely to inspire awe in even the most seasoned snorkelers. Home to brown pelicans, roseate spoonbills, and tricolored herons, Biscayne National Park is a haven for bird-watchers as well. Flamingos and bald eagles live on the park's many small islands.

- Almost the entirety of Biscayne National Park is underwater save for small keys only accessible by boat.

- Despite being mostly water, Biscayne is home to four different ecosystems: mangrove trees, Biscayne Bay, the northernmost islands of the Florida Keys, and coral reefs.

- Biscayne Bay is also a haven for endangered reptiles, including American alligators, crocodiles, and multiple species of sea turtle.

- Biscayne Bay protects both of the East Coast's largest stretches of mangrove trees and one of the world's most extensive coral reefs.

- Rare species abound in Biscayne Bay National Park, including uncommon vegetation. The bay is even home to rare cacti.

STATE: FLORIDA
ARTIST: JUSTIN SANTORA

DRY TORTUGAS NATIONAL PARK

There is a special place, at the end of nowhere, but on the way to everywhere, a place of explorers, pirates, smugglers, soldiers, prisoners, and scientists. … Though pain and suffering contributes to its fascinating history, it is also a place of beauty, vivid colors, peace, solitude, and happiness.

—*L. Wayne Landrum*

Accessible via a two-hour boat trip off Key West, this collection of tiny islands is located in the Straits of Florida. The waters around Dry Tortugas were once such a fertile source of sunken treasure that they made the Key West area one of America's wealthiest cities per capita.

This national park is 99 percent water, save for a few tiny ultra-remote islands. Fort Jefferson remains the largest brick masonry structure in the United States. In 1908, President Theodore Roosevelt designated the area a federal bird sanctuary. During low tide, when the sandbar is not submerged, visitors can walk along the thin strip between the bush and the Garden Key and watch for the more than 300 species of birds residing there. Rare species include the black-capped roseate tern, the neon-billed red-footed booby, and the stout red-necked phalarope.

 The water surrounding Garden Key hosts some of the most vibrant and colorful coral reefs in the United States and houses myriad species of fish and turtles, including the leatherback, loggerhead, and hawksbill sea turtles. History comes to life at Dry Tortugas. There might not be any buried treasure left, but the diversity of marine life rewards anyone with the gumption to explore the park's depths.

- The Garden Key Lighthouse was constructed in 1824 in response to the more than 200 shipwrecks that occurred in the surrounding waters.

- Ponce de León gave the name Dry Tortugas to the area due to the multitude of sea turtles that he encountered during his time there. He visited the island during his fabled search for the Fountain of Youth.

- Barracudas, sharks, and wahoos are common to the area surrounding Dry Tortugas.

- People began referring to the island as "Devil's Island" during a period when Fort Jefferson was being used as a prison.

- The area around Dry Tortugas was a favorite fishing spot of acclaimed American author Ernest Hemmingway.

STATE: FLORIDA
ARTIST: OWEN DAVEY

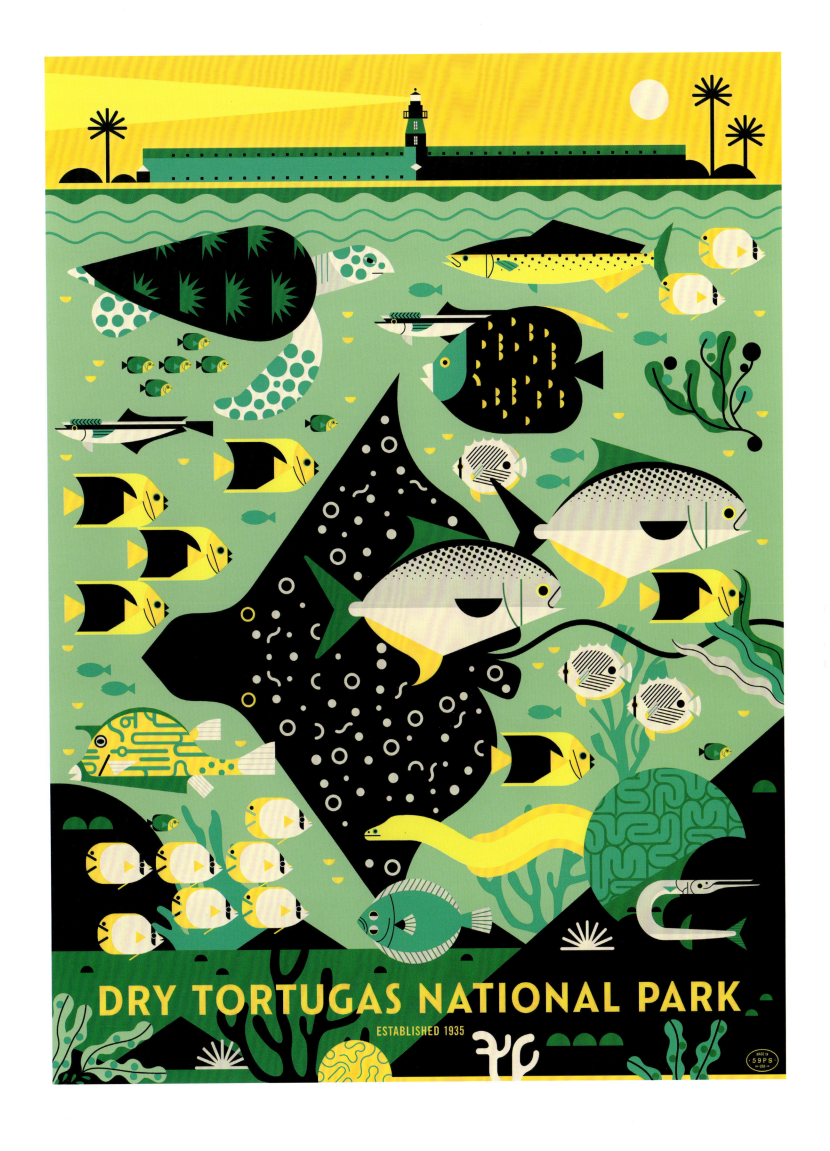

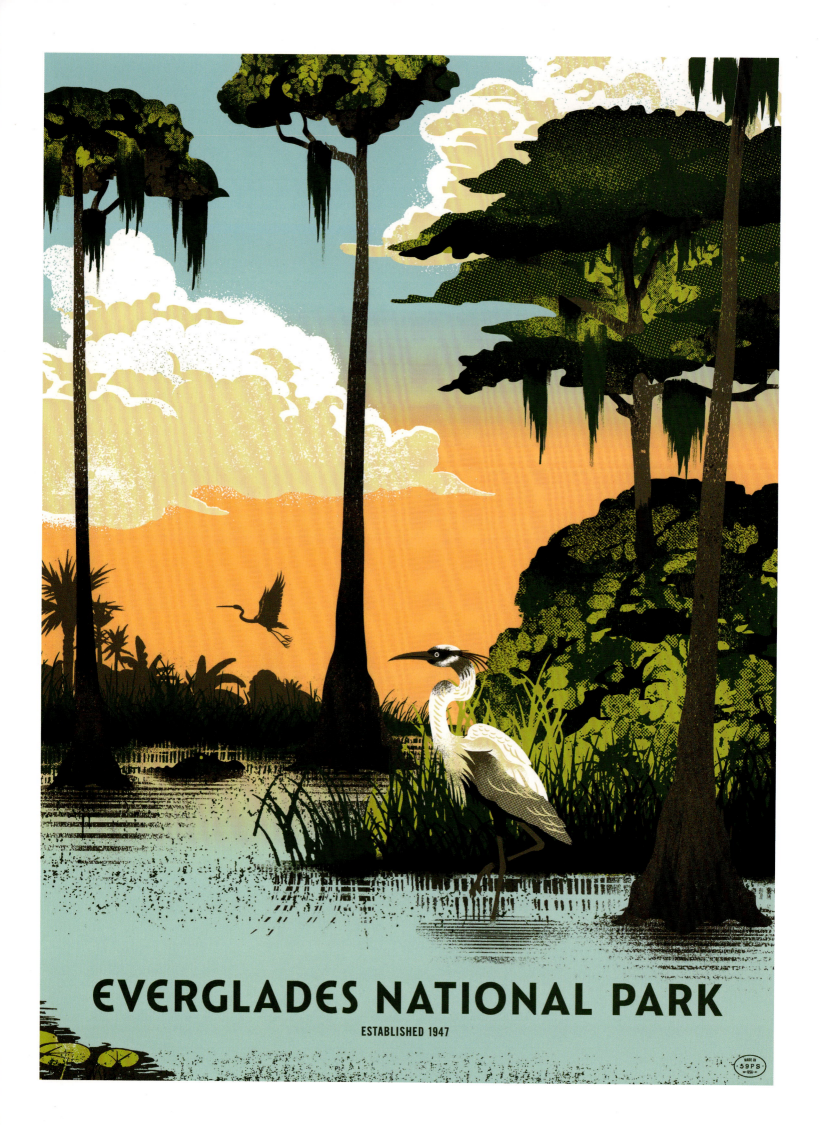

EVERGLADES NATIONAL PARK

The miracle of the light pours over the green and brown expanse of saw grass and of water, shining and slow-moving below, the grass and water that is the meaning and the central fact of the Everglades of Florida. It is a river of grass.

—*Marjory Stoneman Douglas*

Miles and miles of forests, marshes, and hammocks. Interspersed small islands, many of them never discovered. An abundance of wispy mangroves thriving in the shallow brackish water. This is the Everglades—the embodiment of that southern gothic drawl you must roll up your pants and trudge through a swamp to truly understand.

The Everglades is where oddities go to survive and thrive. The mixture of ocean water from the Florida Bay and the water of the Okeechobee River creates these swampy forests that make up the largest tropical wilderness in the United States. The result is one of the most complex and interconnected ecosystems in the world. It is a protected biosphere, a World Heritage Site, and a Wetland of International Importance. Thus, the Everglades is arguably the most carefully protected area in the United States. It hosts nine distinct ecosystems.

The sloughs and prairie marshes feature imperceptibly slow-moving muddy swamps made of fresh water. Often the only dry area in the park, the tropical hammock of hardwood forests host live oak trees that form a canopy which allows plants like wild coffee and saw palmetto to thrive. The pinelands give shelter to a variety of rare birds. Cypress trees and mangroves are home to small mammals and reptiles. The wet prairies of the coastal lowlands are home to rare bird species like the unmistakable wood stork. The sea here is home to dolphins and other larger water mammals, and the estuarine in the bay is home to even more bird species, including spoonbills and bald eagles. Rare living creatures, such as the Florida panther and the West Indian manatee, find a haven in the Everglades. All misfit life-forms are welcome here.

- The Everglades was the first national park established to protect an ecosystem rather than geological scenery.

- The Everglades contains the largest mangrove forest in the country and the third largest in the world.

- Preferring different atmospheres, alligators and crocodiles rarely live together. The Everglades is the rare exception, a place where the two reptiles coexist.

- One in three Floridians relies on the Everglades for fresh drinking water.

- The journalist/author Marjory Stoneman Douglas was known as the Everglades' staunchest defender. After writing a book about the area, she dedicated much of her life to conserving the Everglades and convincing people it was "more than just a swamp."

STATE: FLORIDA
ARTIST: TWO ARMS INC.

VIRGIN ISLANDS NATIONAL PARK

The Caribbean is an immense ocean that just happens to have a few islands in it. The people have an immense respect for it, awe of it.

—*Derek Walcott*

Virgin Islands National Park encompasses nearly 15,000 acres of pristine beaches, tropical forests, and vivid seascapes. Concentrated primarily on St. John, the smallest of the main islands in the Caribbean archipelago known as the Virgin Islands, this national park treats visitors to some of the most picture-perfect beaches in the world. Stretches like Trunk Bay and Honeymoon Beach greet visitors with glistening shorelines where iguanas totter along the sandbars.

The inland tropical rainforests are home to deer, pigs, wild donkeys, and myriad species of ferns and trees. Kapok trees found throughout the island can grow more than 200 feet tall. Some of the forests on St. John have only recently regrown after being cleared to make way for sugar plantations during the eighteenth century. The Reef Bay Sugar Factory was one of the many sugar plantations on the island that produced sugarcane, molasses, and rum for export to the United States and Europe during the eighteenth and nineteenth centuries. A steam-powered engine, still, and boiling room remain preserved inside the factory structure.

In 1733, the island was home to one of the most impactful slave rebellions of the time. Preserved plantation sites throughout the park offer visitors stirring insights into the history of the island. Snorkeling enthusiasts worldwide flock to the Caribbean Sea waters to explore the area's astounding coral reefs. At night, the neon pinks, oranges, and purples of these reefs light up the abyss. Stingrays drift along the ocean floor in the company of skittering crabs and conch. Natural beauty, stirring wildlife, and historical perspective are among the many gifts these islands bestow upon their visitors.

- Trunk Bay has been voted the best beach in the world by National Geographic.

- Bats are the only mammals native to the island of St. John.

- Christopher Columbus coined the name Virgin Islands in reference to the story of Saint Ursula and the 11,000 virgins who followed her.

- The summit of Bordeaux Mountain Trail reaches 1,277 feet in elevation, making it the highest point in the park.

- The park encompasses 60 percent of the island of St. John and the majority of Hassel Island.

LOCATION: VIRGIN ISLANDS
ARTIST: STUDIO MUTI

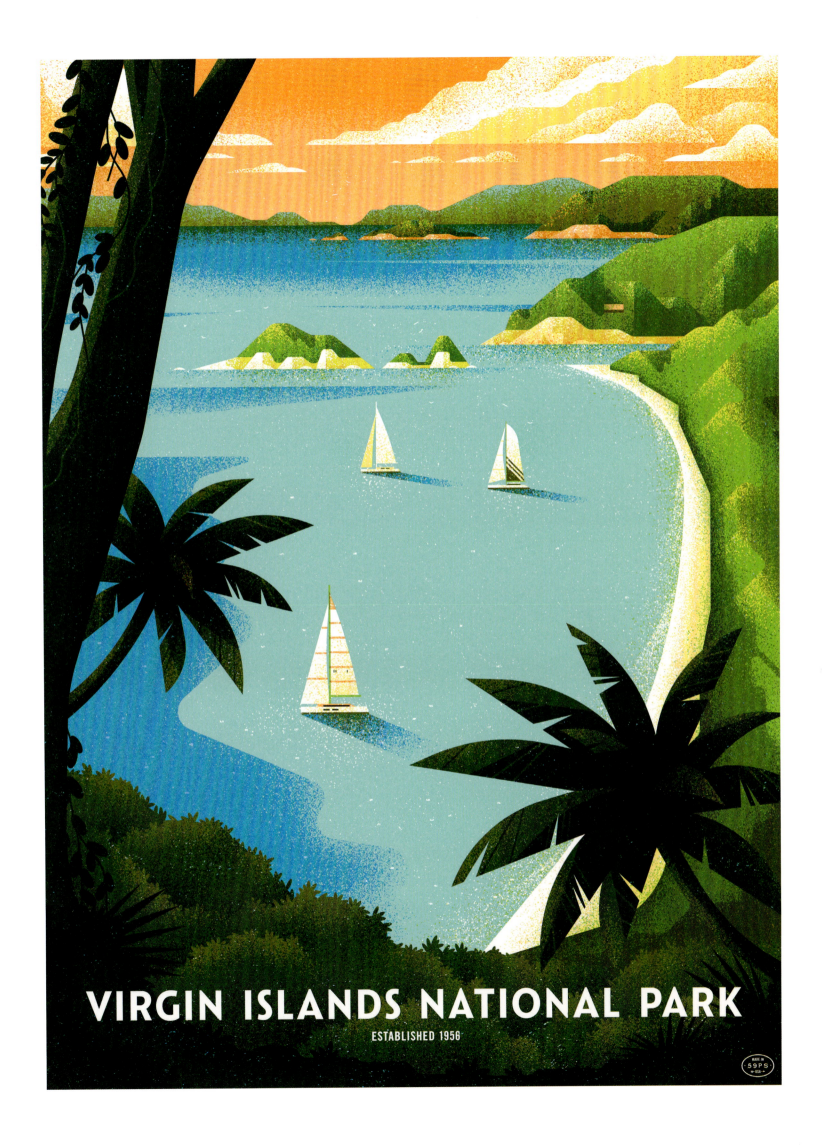

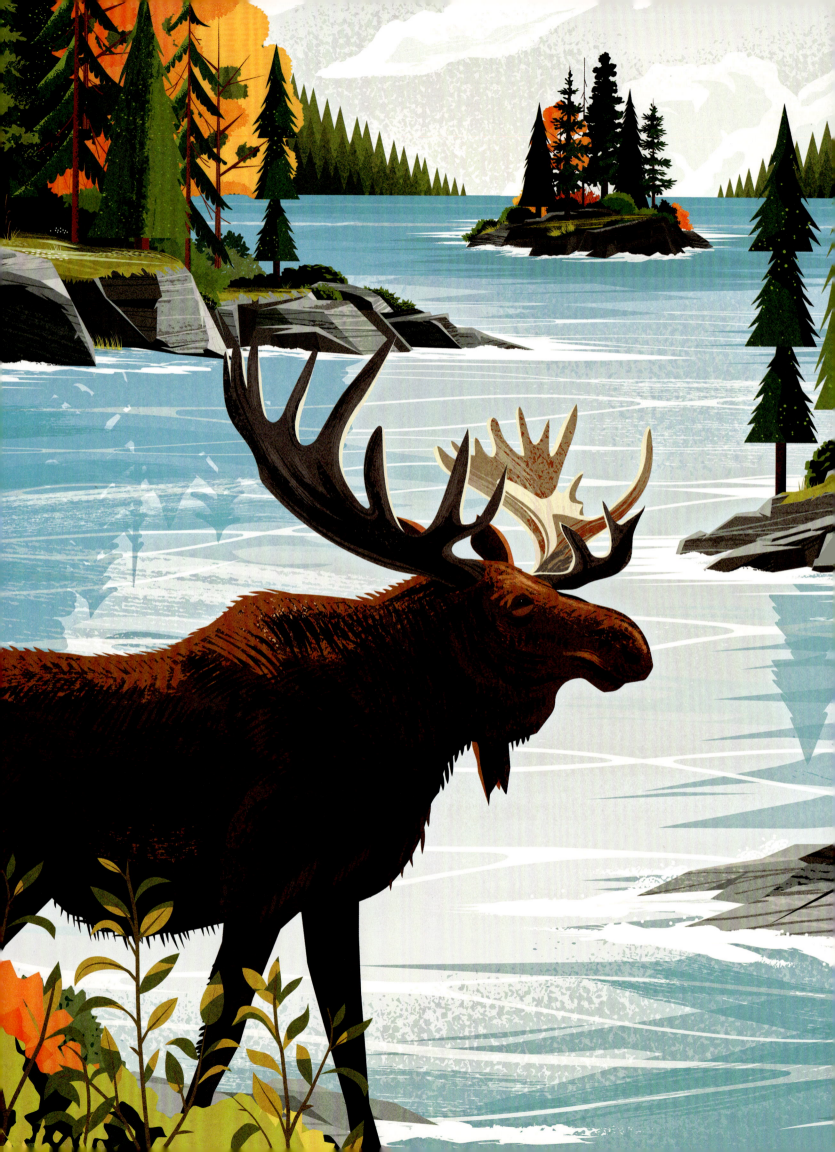

THE
MIDWEST

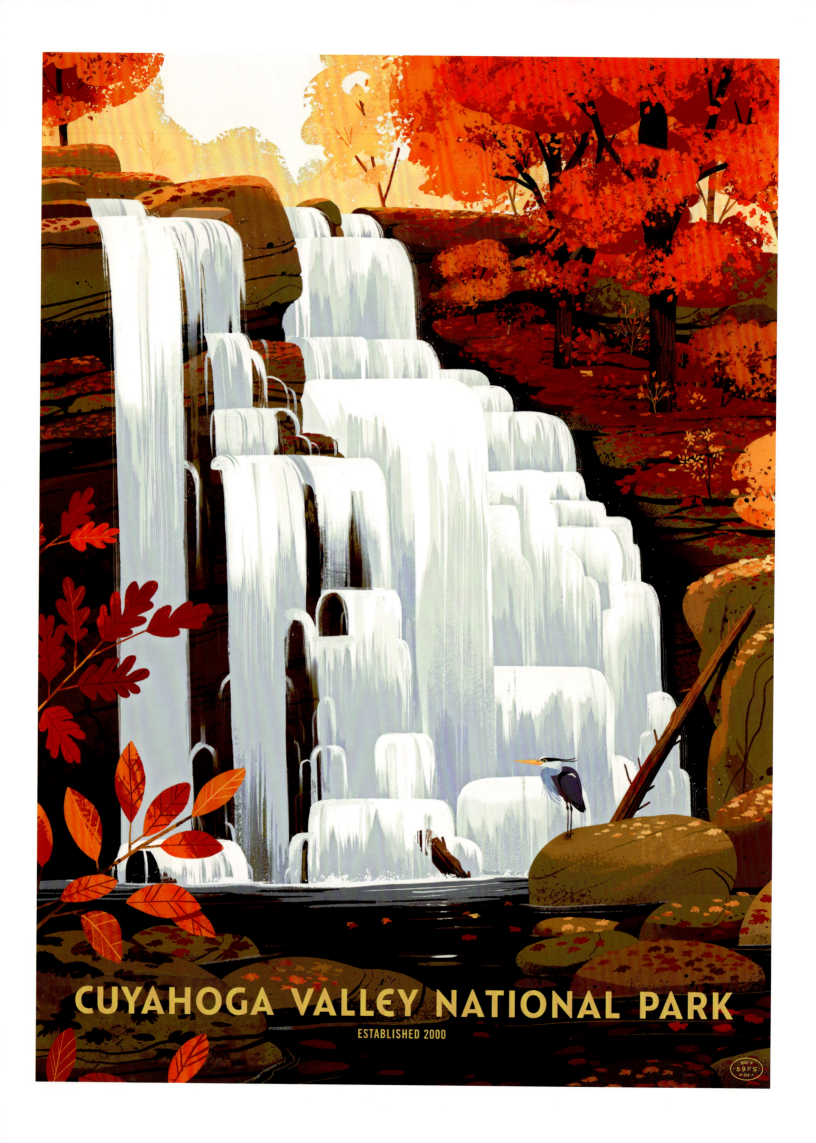

CUYAHOGA VALLEY NATIONAL PARK

It's the Cuyahoga River that puts the cleave in Cleveland.

—Mark Winegardner

There are a multitude of ways to see the Cuyahoga Valley National Park. The sinuous Cuyahoga River flows through the park's lush woody floodplains, its rolling and sprawling hills, and its winding ravines. Similarly, the historic Towpath Trail follows the route of the Ohio and Erie Canal. Built by more than 4,000 laborers in the early nineteenth century, the canal connected Ohio with the rest of the nation. Cuyahoga is also the rare park that can be enjoyed via locomotive. The Cuyahoga Scenic Railroad is one of the oldest and longest recreational railroad jaunts in the country, perfect for seeing the yellow blaze and scarlet rouge of the woodlands' oak and maple leaves during autumn.

The nearby town of Brandywine is a former historic settlement that once hosted a thriving distillery and gristmill, and which now hosts a bed and breakfast that has striking views of the park's most beloved waterfall: Brandywine Falls. The falls is a sixty-foot drop where cascading wisps of whitewater roar down outcroppings like the flow of a bride's veil. Surrounded by the bustle of modern life, the banks of the Cuyahoga are a protected escape, a serpentine invitation to a journey without a destination.

- Cuyahoga was originally designated a national recreation area in 1974. In 2000, it was designated a national park. It is the only national recreation area to become a national park.

- Cuyahoga Valley is Ohio's only national park. However, it is one of three parks located in the Great Lakes Basin.

- The Cuyahoga is remarkably peaceful for a river. Despite stretching eighty-five miles, it covers little distance because of its many winds and twists.

- It is widely believed that the name Cuyahoga means "crooked." Some people dispute this, claiming that the word translates to "elm."

- Twenty different species of reptile live in the park, including turtles, snakes, and chubby copper-colored lizards called skinks.

- The park is home to forty-three different species of fish. River otters also live in the park.

STATE: OHIO
ARTIST: KIM SMITH

ISLE ROYALE NATIONAL PARK

A stranger invited me to lunch.... The stranger explained how he had traveled the world over but he believed Isle Royale was simply the finest place on earth. I recall thinking I was lucky indeed—this man spared me the need to look any farther.

—Rolf Peterson

It takes a certain kind of adventurer to explore a place as remote as Isle Royale National Park, but those who make the trip always come back for another visit. In fact, Isle Royale might have the most return visitors of any national park. Isle Royale is a forty-five-mile-long island of glacier-scarred volcanic rock. It is the most remote national park in the contiguous United States, located deep in Michigan's Lake Superior.

The island is covered in a garland of coniferous birch, cedar, and aspen trees. Located seventy-three miles north of the Houghton area of Michigan, the island can only be accessed by boat or plane. The nearly 9,000 miles of park consists of one large island and 200 smaller ones that include 166 miles of hiking trails. Because the surrounding waters of Lake Superior were once especially treacherous for trade ships, Isle Royale is dotted with historical lighthouses such as the 50-foot Rock Harbor Lighthouse and the 117-foot Rock of Ages Lighthouse. The difficult waters also made the island a hub for shipwrecks. Today, the remains of those wrecks can be visited by adventurous scuba divers.

Isle Royale also has abundant wildlife. Moose weighing as much as a thousand pounds wander the island with careless abandon, the true leaseholders of this remote wilderness. They can often be seen feeding in the lakes and ponds of the island or roaming through the shady forests. The moose are no longer alone here, however. These days, gray wolves stalk them for food. Though the island may be remote, it is full of life. Isle Royale has long been considered the best-kept secret of the national park system.

- The gray wolf population of Isle Royale is believed to have migrated to the island via an ice bridge from the Canadian mainland in the winter of 1948.

- The wolf population on the island has ranged from two to as many as forty-eight.

- Isle Royale's gray wolves are the only predator that eats the island's moose population.

- Isle Royale is the third-largest island in the contiguous Unites States behind Padre Island, Texas, and Long Island, New York.

- The highest elevation on the island is 1,394 feet at the top of Mount Desor.

STATE: MICHIGAN
ARTIST: DAVID DORAN

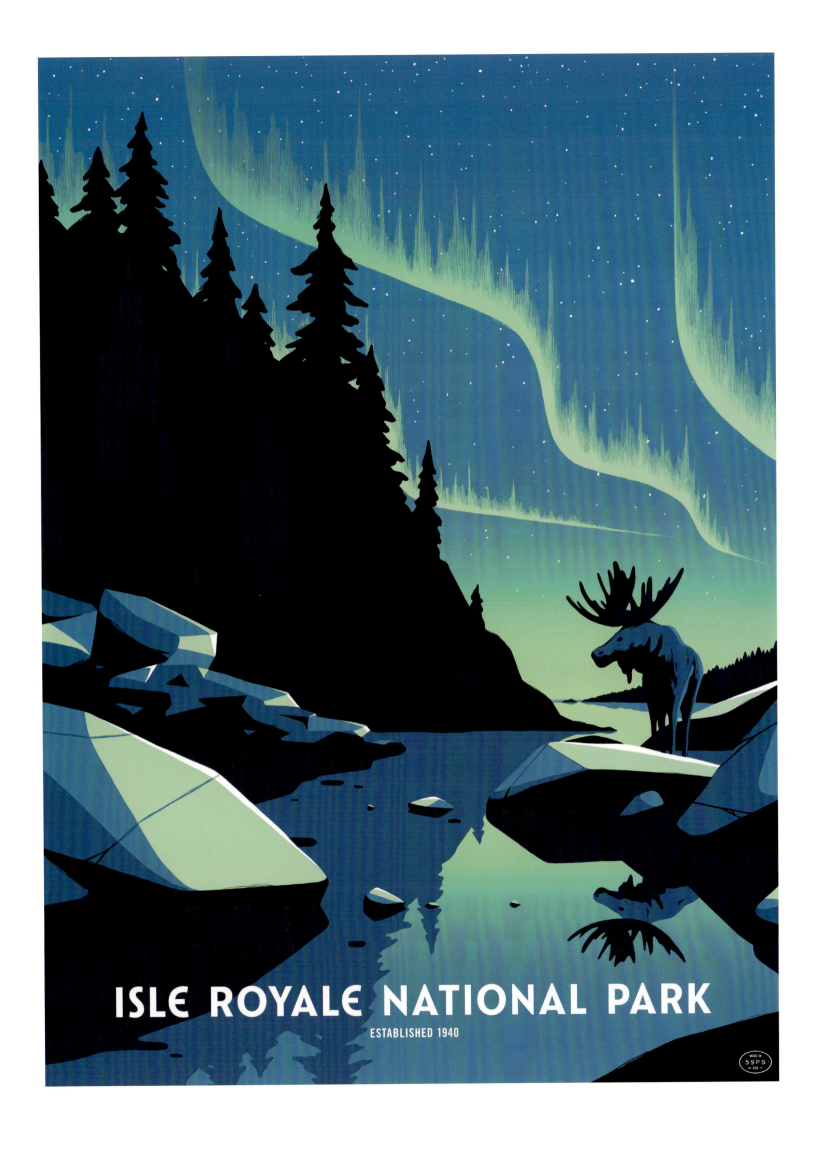

INDIANA DUNES NATIONAL PARK

The Dunes are to the Midwest what the Grand Canyon is to Arizona and Yosemite is to California. They constitute a signature of time and eternity.

—Carl Sandburg

Indiana Dunes National Park runs along the southern shore of Lake Michigan. The twenty-five-mile stretch of sand, lake, and greenery was known as Indiana Dunes National Lakeshore until February 15, 2019, when it was officially upgraded to a national park. The 15,000 acres of land includes sand dunes, prairies, wetlands, forests, swamps, bogs, marshes, and a river.

The park includes fifteen miles of lakeside beaches where visitors can sun themselves on the pristine sand. Here, the dunes stretch for miles, and some swirl up so high that they have been named. Mount Baldy is a slowly eroding dune that moves four feet per year. Mount Tom, in the connecting state park, soars 192 feet high. The West Beach 3-Loop Trail takes you on a three-and-a-half-mile tour of these dunes in their various stages of development, ending with a view of the Chicago skyline.

The nearby prairies, forests, and marshes are some of the most biodiverse spaces in the country. More than 370 bird species frequent the area, including kingfishers, blackbirds, and green herons. Over 1,100 species of flowering plants can be found within the many ecosystems of the park, including rare plants like Mead's milkweed and Pitcher's thistle. white-tailed deer, cottontail rabbits, and red foxes roam the hardwood forests surrounding the dunes. Similarly, humans of all varieties gather in the Indiana Dunes National Park because it offers recreation tailored to every interest, from hiking and bird-watching to simply laying on the beach and soaking up sun.

- The study of ecology was born in this park, the brainchild of scientist Henry Chandler Cowles. Ecology is the study of organisms and how they relate to each other.

- Cowles Bog, a swampy wetland area in the park, is named in honor of Henry Chandler Cowles.

- Indiana Dunes National Park is the first official national park in the state of Indiana.

- The park offers many options for activities, including hiking, swimming, biking, horseback riding, and snowshoeing.

- The park is also a haven for orchids. It has more native orchid species than the state of Hawaii, including autumn coralroot, little white lady's slipper, and large twayblade.

STATE: INDIANA
ARTIST: SIMON MARCHNER

GATEWAY ARCH NATIONAL PARK

Let us hope that the Arch somehow survives—that it becomes, far in the future, a mysterious structure like the Great Pyramids or Stonehenge, that leads onlookers to wonder about the people who produced it and ask themselves what strange compulsions led to its creation.

—Tracy Powell

Gateway Arch National Park is unlike any other national park in the United States. Its purpose is not to protect an ecosystem or a geological anomaly; instead, it is meant to protect our history. Gateway Arch is a monument to our triumphs and to our mistakes as a nation. It is intended as a welcoming sign, as a symbol of westward expansion, and also as a reminder of the horrors of slavery.

At 90.9 acres, it is the smallest national park in the United States; upgraded from a national monument to a national park in 2017, it is also one of the newest. The arch is located in St. Louis, Missouri, on the Mississippi River. It was designed by architect Eero Saarinen and structural engineer Hannskarl Bandel in 1947. The 630-foot-high monument is a catenary arch, meaning that, unlike more traditional flat or horseshoe arches, it hangs in an oval shape. Visitors can enter the inside of the arch and take a tram system to the top where observation windows offer striking views of the city.

The park also includes the St. Louis Old Courthouse, which hosted the original Dred Scott case; the decision in that case allowed slave owners to maintain ownership of slaves even after traveling to free states. The decision was later upheld by the Supreme Court and became one of the inciting incidents of the Civil War. Gateway Arch reminds us of the contradictions in our founding, including both our great promise and our great capacity for evil. It reminds us never to forget who we once were, and who we might yet become.

- At 630 feet high, the Gateway Arch is the tallest national monument in the country.

- The arch is eighty-five feet taller than the Washington Monument.

- The seven lightning rods on the arch make it impervious to a lightning strike.

- During good weather, the arch offers thirty miles of outward visibility.

- Most expected that the arch would fall. Construction of the arch had to be unbelievably precise. Had measurements been $1/64$ th of an inch off, the arch would never have connected in the center.

STATE: MISSOURI
ARTIST: STEVE SCOTT

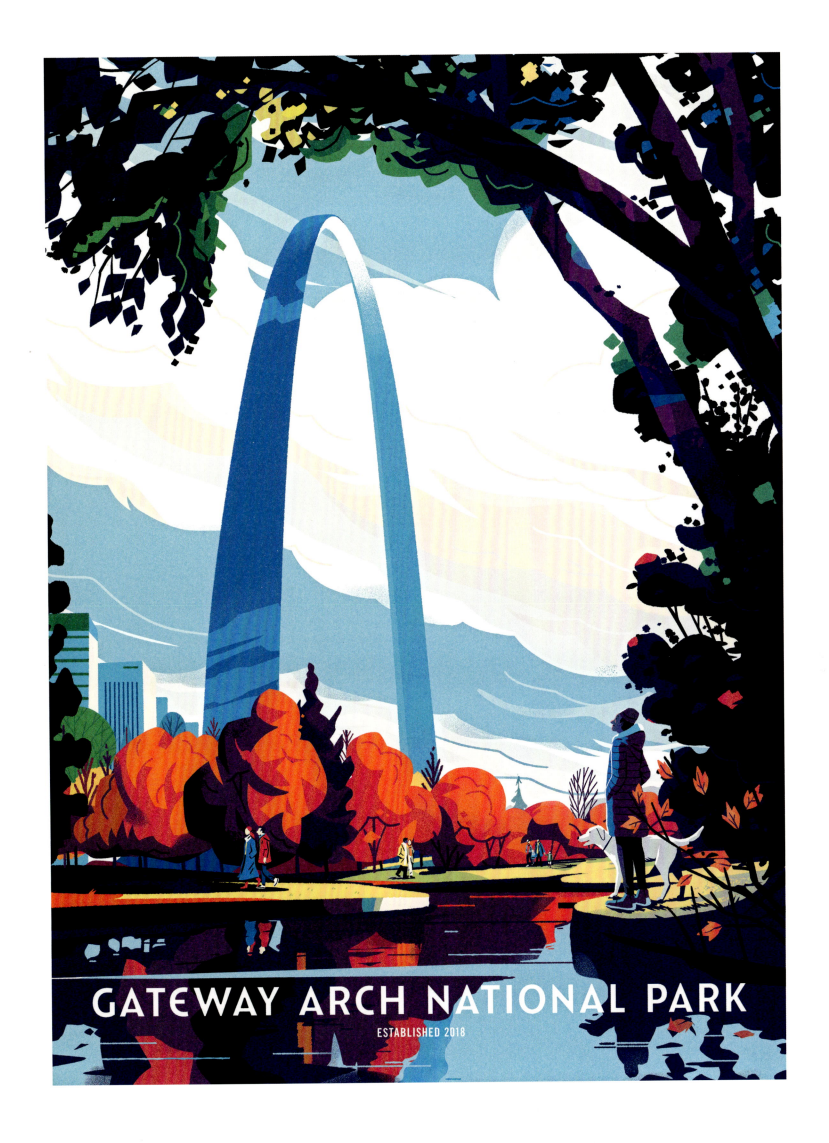

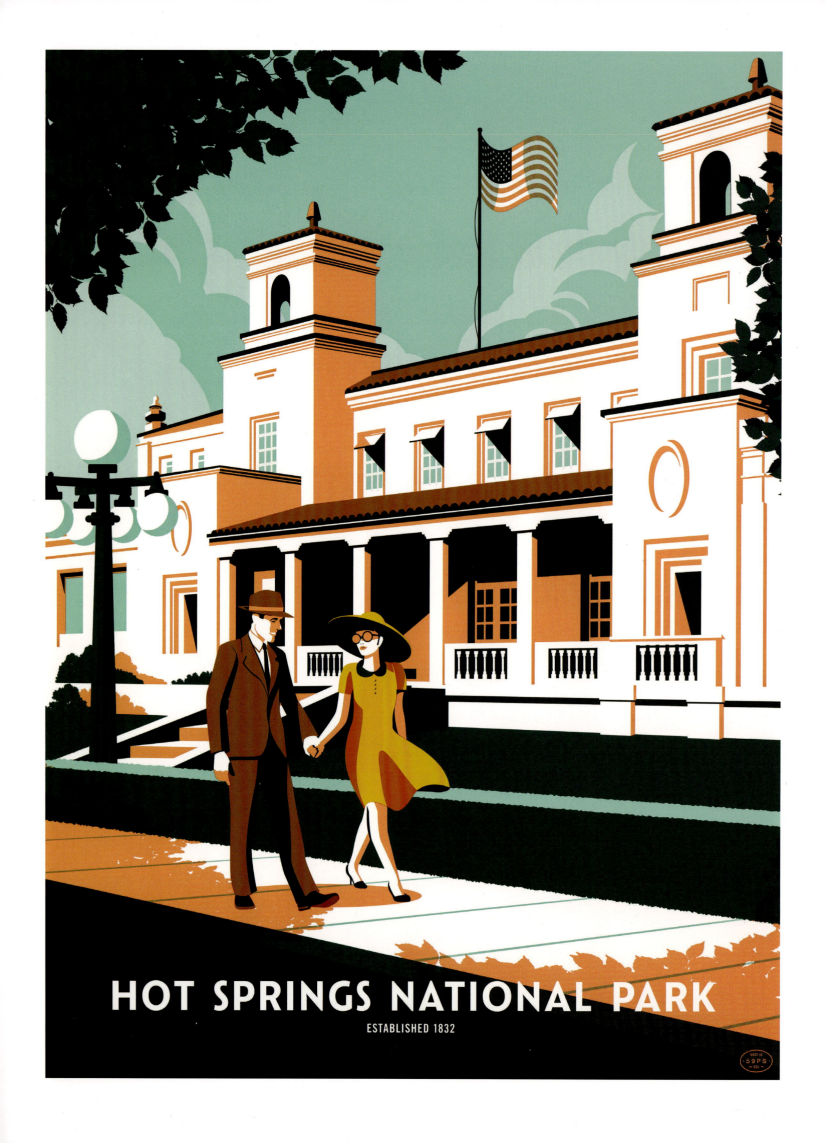

HOT SPRINGS NATIONAL PARK

There must be quite a few things a hot bath won't cure, but I don't know many of them.

—Sylvia Plath

Hot Springs National Park is not the first place that comes to mind when people think of our national park system. For one thing, it's small; for another, it's located only sixty miles from the state's capital. Still, this historical national park attracts around one million visitors annually.

Deeded to the United States as part of the Louisiana Purchase, Hot Springs Mountain is part of the Ouachita Mountain Range. From the south slope of the mountain, 47 steaming, bubbling thermal springs produce over 7,000 gallons of water a day. In the early nineteenth century, scientists believed that the springs offered untold health benefits. People seeking the healing powers of the springs flocked to the area. The town of Hot Springs sprouted up around the influx of tourists, becoming the first "spa town" in the United States. Everyone from the boxer Jack Dempsey to President Harry Truman to the gangster Al Capone visited the hot springs and bath houses.

The remnants of these health spas can still be seen on Bathhouse Row in the town of Hot Springs. Nowadays, the surrounding area is teeming with natural beauty. The hot springs won't cure the diseases that they were once thought to remedy, but they are a rich source of sulfur; they are good for your skin; and they are believed to reduce stress.

- The park's hot springs bubble up at a temperature of 143 degrees.

- The Native Americans in the region were the first to bathe in the hot springs. They called the area "the Valley of Vapors."

- Natives believed a spirit residing within the springs heated the water with his breath.

- The land was bought as part of the Louisiana Purchase and was set aside for recreation by the government long before the idea of national parks existed.

- At only 5,550 acres, Hot Springs is the second-smallest national park behind Gateway Arch National Park.

STATE: ARKANSAS
ARTIST: TELEGRAMME PAPER CO.

VOYAGEURS NATIONAL PARK

What a way to travel—no trains to catch, no traffic to annoy us, no towns to reach by evening, no appointments to remember! We wander anywhere our whims take us, through these lakes. Freedom surrounds us. We are finding more than peace here. This is an authentic and profound release from modern intricacies.

—Florence Page Jacques

A mere five-hour drive from the Twin Cities brings you to the northern border of Minnesota. This is where more than 900 islands–surrounded by glinting sapphire lakes–make up Voyageurs National Park. The main island is accessible only by boat. Boating is the appropriate way to experience Voyageurs, as kayaking is integral to the history of the park.

The park's name is derived from a title given to a group of traders who regularly traversed the island. During the eighteenth century, beaver fur was in high demand due to its use for haberdashery. The lake surrounding Voyageurs is one of the largest habitats for beavers in the country. The native Ojibwe hunted the beavers for their fur. Some of the most dependable customers were the French Canadian traders—the voyageurs—who came from nearby Canada in cargo canoes. These traders were rumored to be remarkably strong, vigorous despite their short stature, and whimsical. Legend had it that they often sang as they rowed. Due to their tireless work ethic and charm, these traders became the backbone of the North American fur trade.

Today, the waters they frequented entertain fishermen and kayakers who come for the beautiful scenery of the great north. Kayak tours take visitors along the old routes of the fur traders. The park consists mainly of four lakes: Rainy Lake, Kabetogama Lake, Namakan Lake, and Sand Point Lake. Rainy Lake is by far the largest, with the largest shoreline. The smell of fresh pine trees permeates the air in this unspoiled landscape of pristine lakes and islands. It's enough to make you sing while you take in the sights.

- The pioneer voyageurs were said to average 150 pounds and to be of average height, yet they were capable of rowing a remarkable sixteen hours per day.

- Since the voyageurs regularly smoked their tobacco pipes once for every hour of rowing, they measured distance of travel by how many pipes smoked.

- Fishing in Voyageurs National Park is second to none. The main lakes in the park are filled with walleye, northern pike, muskellunge, smallmouth bass, and crappie.

- Strawberries, raspberries, and blueberries grow wild in the forests surrounding the lakes of Voyageurs.

- Wildlife commonly found in the park includes beavers, moose, wolves, deer, foxes, snowshoe hares, muskrats, black bears, and weasels.

STATE: MINNESOTA
ARTIST: PLAID MTN.

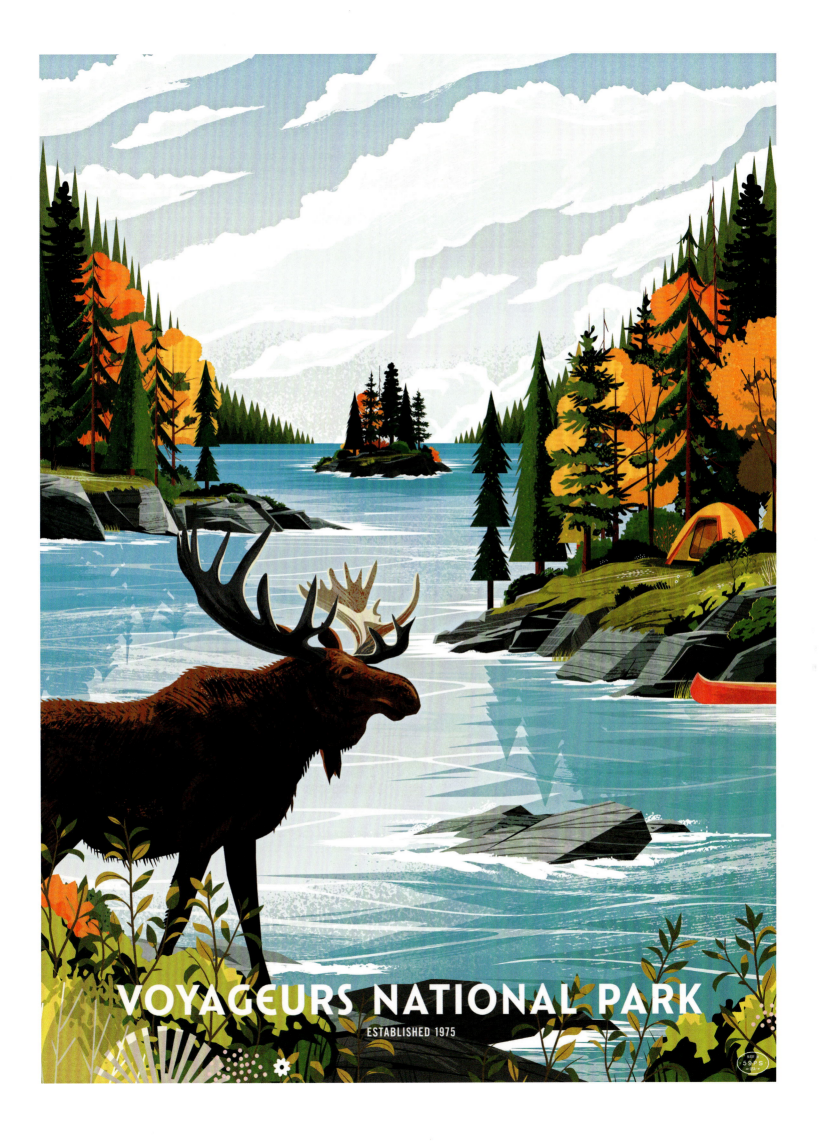

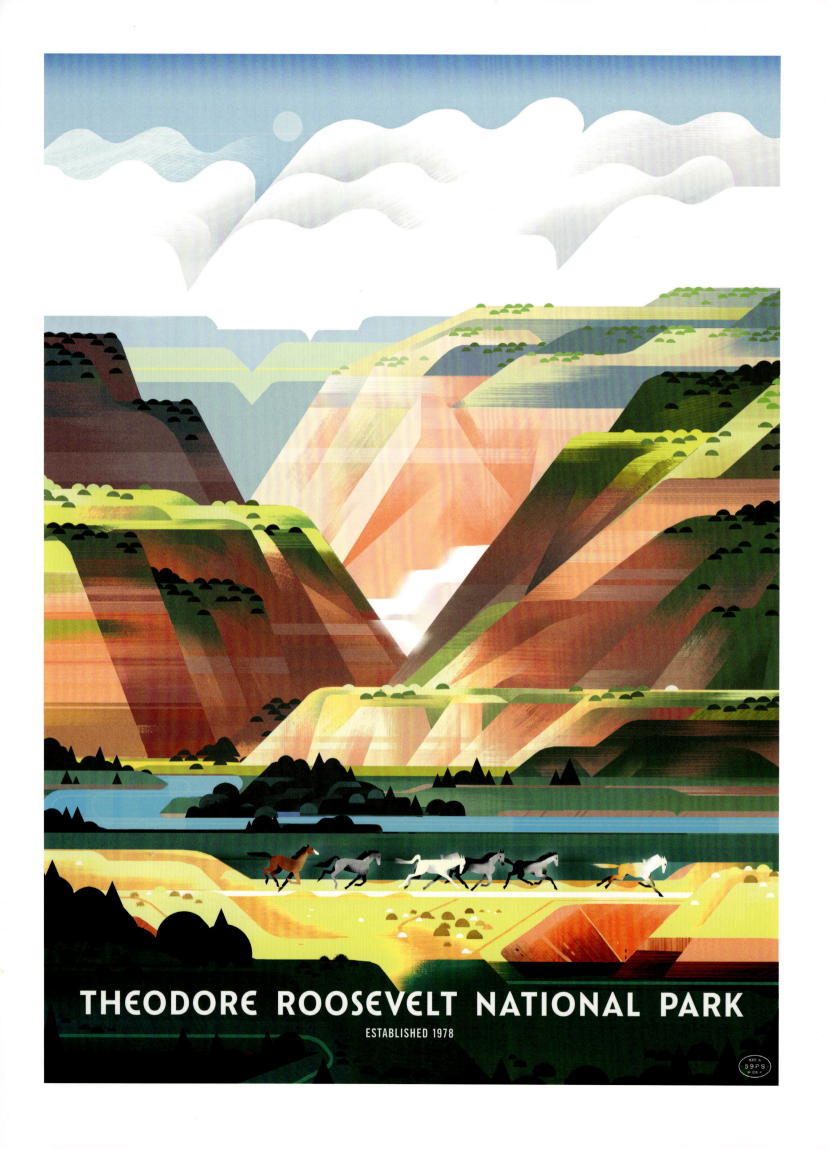

THEODORE ROOSEVELT NATIONAL PARK

From the low, long veranda, shaded by leafy cotton-woods, one looks across sand bars and shallows to a strip of meadowland, behind which rises a line of sheer cliffs and grassy plateaus. This veranda is a pleasant place in the summer evenings when a cool breeze stirs along the river and blows in the faces of the tired men, who loll back in their rocking-chairs . . . gently to and fro, gazing sleepily out at the weird-looking buttes opposite, until their sharp outlines grow indistinct and purple in the after-glow of the sunset.

—Theodore Roosevelt

Theodore Roosevelt loved this strip of North Dakota's badlands so much that he made his home here. Theodore Roosevelt National Park is an amalgamation of many traits of the most beloved national parks in the country: It has the eerie alien-like badlands, buttes, and hoodoos found in places like Canyonlands, Badlands, and Bryce, but it is also teeming with wildlife and lush greenery. Bison roam the grasslands near the Little Missouri River.

The park is separated into three sections. Elkhorn Ranch is the most underdeveloped section of the three and contains the stone foundation that remains from Roosevelt's actual ranch. Here, billowing groves of cottonwood trees contrast against the stark and colorful badlands. The North Unit of the park is a hub for hiking and watching wildlife. Elk, bison, and prairie dogs frolic alongside wild horses. The South Unit contains Roosevelt's fully preserved cabin, known as the Maltese Cross Cabin. Visitors can see where the former cowboy-turned-president lived, including a replica desk where he wrote his books. Visitors can even gawk at his original monogramed luggage. Nearby, the Painted Canyons are stained in vivid greens and reds that change color as the sun sets. It's easy to see how the raw natural beauty of this park inspired Roosevelt to become one of the most outspoken and powerful conservationists of all time.

- Theodore Roosevelt National Park is the only national park named after a president.

- The park has one of the country's largest deposits of petrified wood.

- There are more than 400 different plant species in the park, including elm, cottonwood, and juniper trees.

- At 3,507 feet, the summit of White Butte has the highest elevation in the park.

- The park is also known for so-called cannonball concretions, which are perfectly smooth and round rock formations. These ball-shaped rocks are so round and smooth that it's hard to believe they formed naturally.

STATE: NORTH DAKOTA
ARTIST: ELLE MICHALKA

BADLANDS NATIONAL PARK

Yes, I say the aspects of the Dakota Badlands have more spiritual quality to impart to the mind of America than anything else in it made by man's God.

—Frank Lloyd Wright

At the entrance to Badlands National Park, the flatlands of southwestern South Dakota are broken up by the dramatic drop known as the Big Badlands Overlook. The pinnacles and eroded buttes that make up Badlands National Park were built up over millions of years of deposition, only to begin eroding away 500,000 years ago from rivers and rainfall. The result is a spiky wonder of cartography. The corrugated cliffs and gullies are marked by palettes of vivid colors. The stripy red hue that circles the rocks is the result of iron oxidation from the burning of lignite coal, though it looks like the work of a giant spray can. Elsewhere, the sandstone can take on hues ranging from bright pink to deep blue and burnt orange.

In the lowlands, natural concretions range from jaunty rock formations that resemble a human nose to long-sliced stones that look like a split loaf of bread. Nearby, the largest mixed-grass prairie in the entire park system hosts an array of wildlife, including vultures, butterflies, and snakes. Winds, rain, and melting runoff have been carving out this prairie since the beginning of recorded time. Bison, pronghorns, and bighorn sheep roam freely throughout the park—so freely, in fact, that they regularly cause traffic jams: a gentle reminder that there's too much beauty around you to rush.

- The Badlands was formed by erosion that began hundreds of thousands of years ago. The erosion is still happening. It is estimated that the Badlands continues to be eroded by one inch per year.

- Though "Badlands" refers to this particular park, it can also refer to any rocky landscape with a similar appearance.

- The name was coined by the Oglala Lakota people who called the harsh craggy rocks *mako sica*, or "land bad." The name was reinforced years later by French travelers who described the area as "bad lands to traverse."

- Though their presence in the area was once in danger, there are now estimated to be 1,200 bison in Badlands National Park.

- The black-footed ferret was believed to be extinct in the wild in 1987, but they were reintroduced beginning in the 1990s. Now, the Badlands is one of three states with a self-sustaining population of wild black-footed ferrets.

STATE: SOUTH DAKOTA
ARTIST: CAMP NEVERNICE

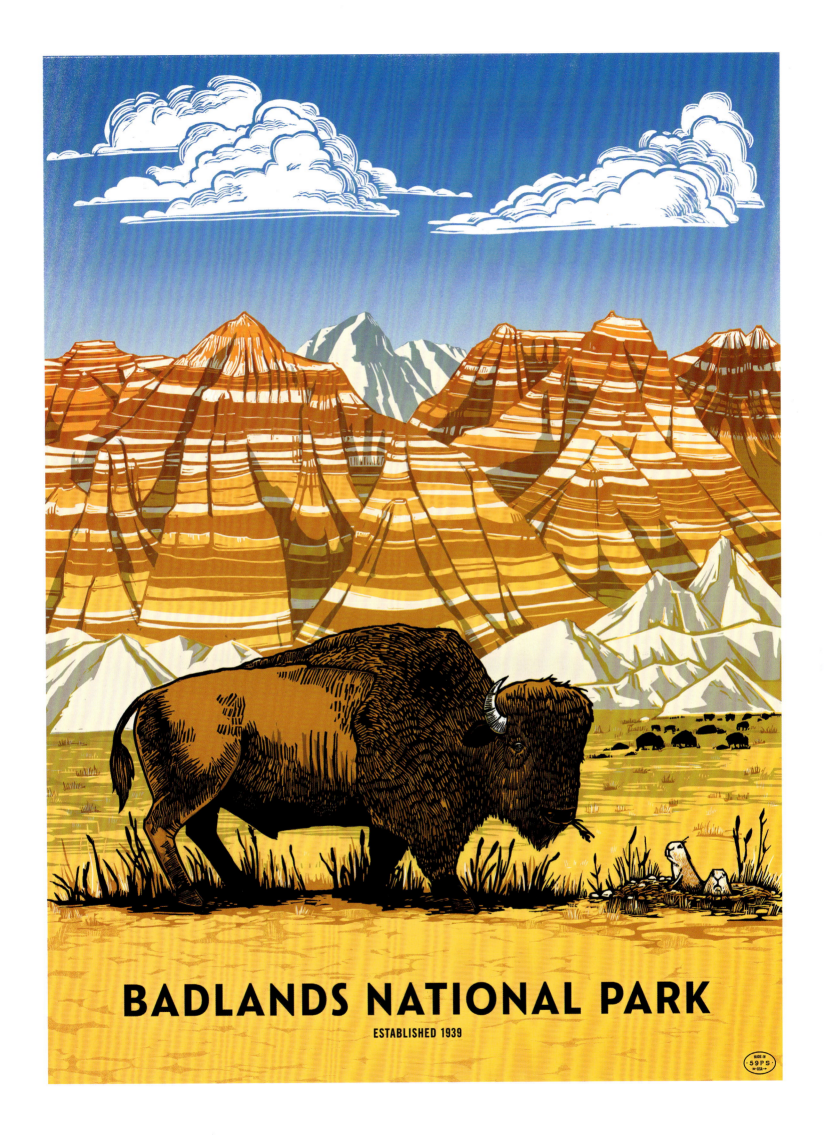

WIND CAVE NATIONAL PARK

We did not think of the great open plains, the beautiful rolling hills, the winding streams with tangled growth, as 'wild.' . . . To us it was tame. Earth was bountiful and we were surrounded with the blessings of the Great Mystery.

—*Luther Standing Bear*

The Lakota Sioux of South Dakota considered the narrow caverns of Wind Cave National Park to be a sacred place. Settlers may not have even discovered it if not for the wind that whistles through the craggy passageways. One day, two hunters noticed that the deer they were hunting appeared to be distracted by a faint whistling sound. One of them noticed that the sound appeared to be coming from a small hole in the ground. When he knelt close to the hole, a gust of wind erupted from the ground and knocked off his hat. This marked the discovery of one of the oldest caves in the country.

There are over 149 miles of complex mazelike passageways in the Wind Caves. Rare honeycomb calcite formations called "boxwork" and needly snowflake-like formations called "frostwork" adorn the ceilings. The cave is said to "breathe" because atmospheric pressure can cause the holes in the cave to expel sporadic gusts of air.

Aboveground, the rolling hills and flatlands are considered the largest mixed-grass prairie in the United States. Bison roam these prairies freely, unaware of the singing caves under their hooves. In fact, the Wind Cave bison herd is one of the last free-roaming bison herds in North America. The prairies are also home to bugling elk and scampering prairie dogs. At just below 34,000 acres, Wind Cave National Park may be a relatively small national park, but the mysteries preserved beneath the ground are seemingly endless.

- Wind Cave was the first cave to be made a national park.

- Wind Cave National Park was inaugurated by Theodore Roosevelt as the country's seventh national park.

- It is estimated that only 5 percent of the cave has been mapped.

- It is so dark inside of Wind Cave that the human eye never fully adjusts.

- Wind Cave is the seventh-longest cave in the world.

STATE: SOUTH DAKOTA
ARTIST: JONATHAN BARTLETT

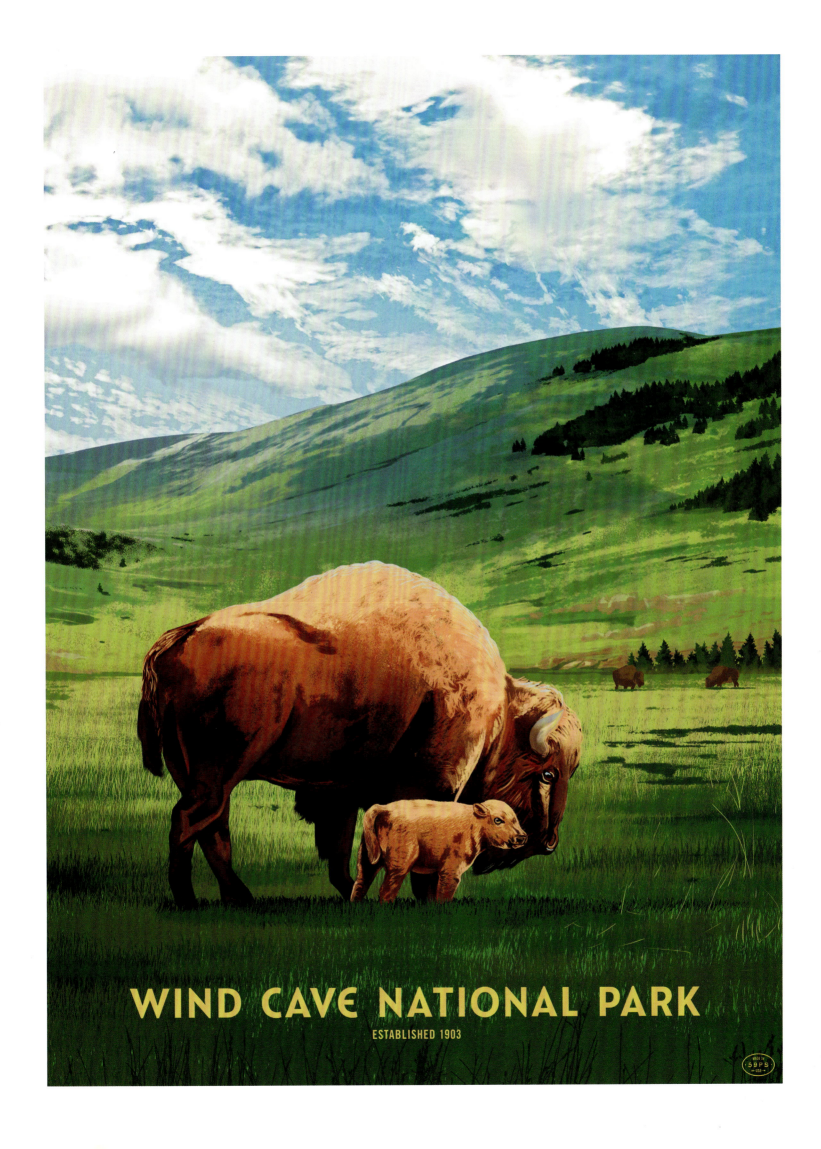

THE
SOUTHWEST

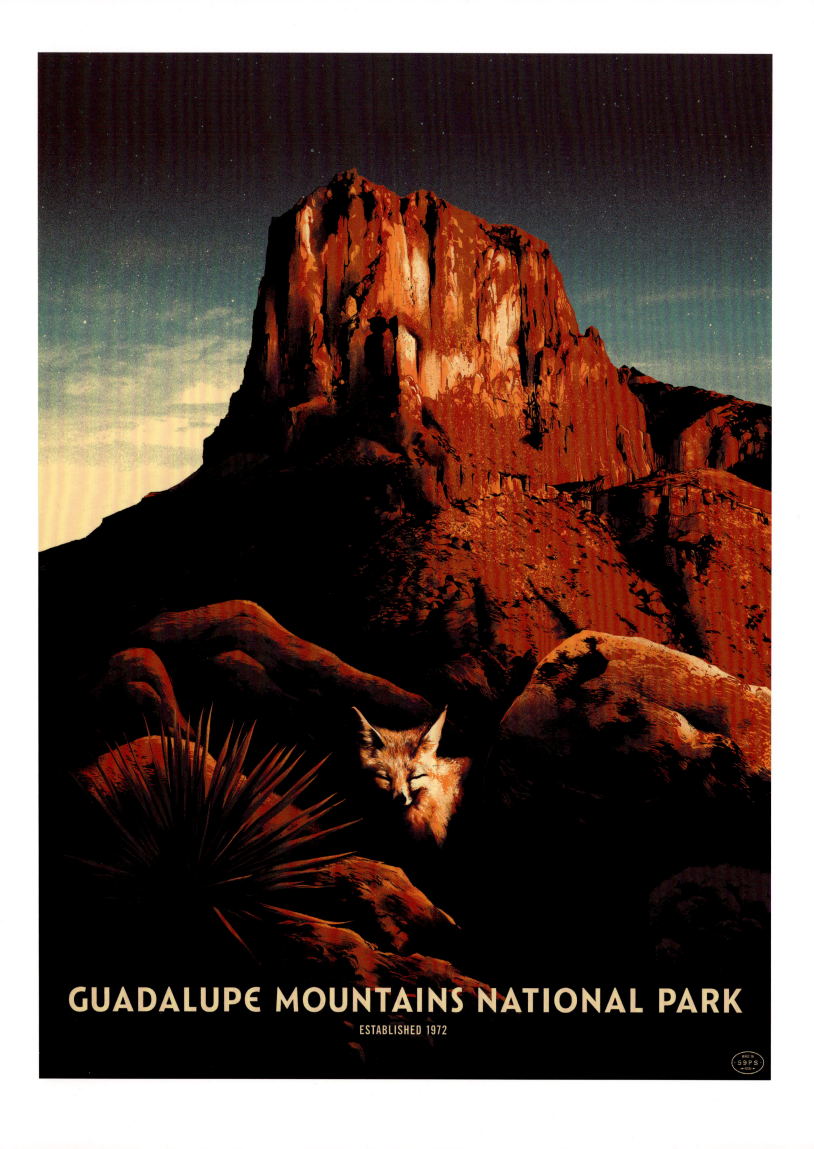

GUADALUPE MOUNTAINS NATIONAL PARK

At the top, the salt flats to the south look like distant glaciers in their whiteness and a metal pyramid commemorating the highest point in the state stands defiantly in the wind.

—Sam Martin

Guadalupe Mountains National Park sits astride the path of a long-abandoned stagecoach route in the desert of West Texas. The tallest peaks in the great state of Texas are here in the Chihuahuan Desert. Once, the flatlands and cliffs of the park were covered in water. Guadalupe Peak, formed from the remnants of an underwater reef, juts up into the clouds, reaching a height of nearly 9,000 feet. At the southern terminus of the range, the 8,085-foot-high El Capitan, constructed primarily of long-desiccated sponges and algae, is equally breathtaking.

Eccentric rock formations like the Devil's Hall consist of a natural rock staircase that leads to a tight hallway, resembling an ancient haunted temple. It gets hot in this park. The salt flats are desolate; desert shrubs slouch in the dry heat. Fortunately, there's an oasis around every corner. Moisture from the mountains collects in natural streams and springs. Smith Springs, a peaceful pond shaded by bigtooth maples and littleleaf walnut trees, makes for the perfect picnic spot. Kit foxes, coyotes, mountain lions, and bobcats stalk the valleys and cliffs of these mountains. What seems at first like an endless desert is revealed to be a great myriad of ecosystems, from verdant forests to heaping sand dunes. Walk in any direction and Guadalupe becomes a different park.

- Rock art, baskets, and pottery found in the Guadalupe Mountain area date back as far as 10,000 years.

- Guadalupe Peak is the highest point in the Guadalupe Mountains and in all of Texas. It stands 8,751 feet high.

- The area is a haven for snakes, including bullsnakes, coachwhips, and five different species of rattlesnake.

- Wallace Pratt, an American geologist, donated the 6,000 acres of land used to establish the park.

- The park is home to many different bird species, including barn owls, great horned owls, golden eagles, woodpeckers, turkey vultures, and greater roadrunners.

STATE: TEXAS
ARTIST: MATT TAYLOR

BIG BEND NATIONAL PARK

The valley was surrounded by sparsely vegetated mountains spiked with pink rock formations that rose on all sides in rugged spires and cliffs. At the far end of the valley, beyond the winding road, our eyes settled on a cleft in the ring of mountains—the Window—and through this window we could clearly see another world.

—Etta Koch

Over the course of millions of years, the Rio Grande's mighty waters carved their way through the limestone walls of these towering canyons deep in the beating heart of Texas. Named for its location at the bend in the Rio Grande, the huge landmass that makes up this park stretches 800,000 acres in total. Separated mainly into three districts—the river, the mountains, and the desert—Big Bend is a living temple dedicated to the natural power of the elements.

Hike the valleys of Big Bend with the Chisos Mountain Range looming in the background and take in rock formations so varied in size, shape, and appearance that they rival the clouds. Balanced Rock in the Grapevine Hills, though sturdy, always appears to be on the brink of crashing down. Canoe along the Rio Grande and its tributaries and see red-eared slider turtles tottering along in the shadow of the Santa Elena Canyon.

At night, the wildlife comes alive with black-tailed jackrabbits, roadrunners, and mountain lions roaming the desert. Whether you are interested in dinosaur bones or the stars, Big Bend National Park offers a gateway to the wonders of the American desert.

- Big Bend National Park is the only national park in the country that contains a border crossing.

- Terlingua was once a ghost town located within Big Bend National Park. The abandoned mining town that hosted the nation's first-ever chili cook-off now features a beloved restaurant and live music.

- The entirety of the Chisos Mountain Range is contained within Big Bend National Park, making it the only mountain range housed completely within a national park.

- Not only is Big Bend a certified Dark Sky Park, it is said to have the least light pollution of any national park in the lower forty-eight states.

- For a desert, the temperatures in Big Bend can vary greatly, sometimes hitting one hundred degrees, sometimes falling below freezing. The varied temperatures make it hospitable to a large diversity of plant life, including wildflowers and more than sixty different species of cactus.

STATE: TEXAS
ARTIST: BRAVE THE WOODS

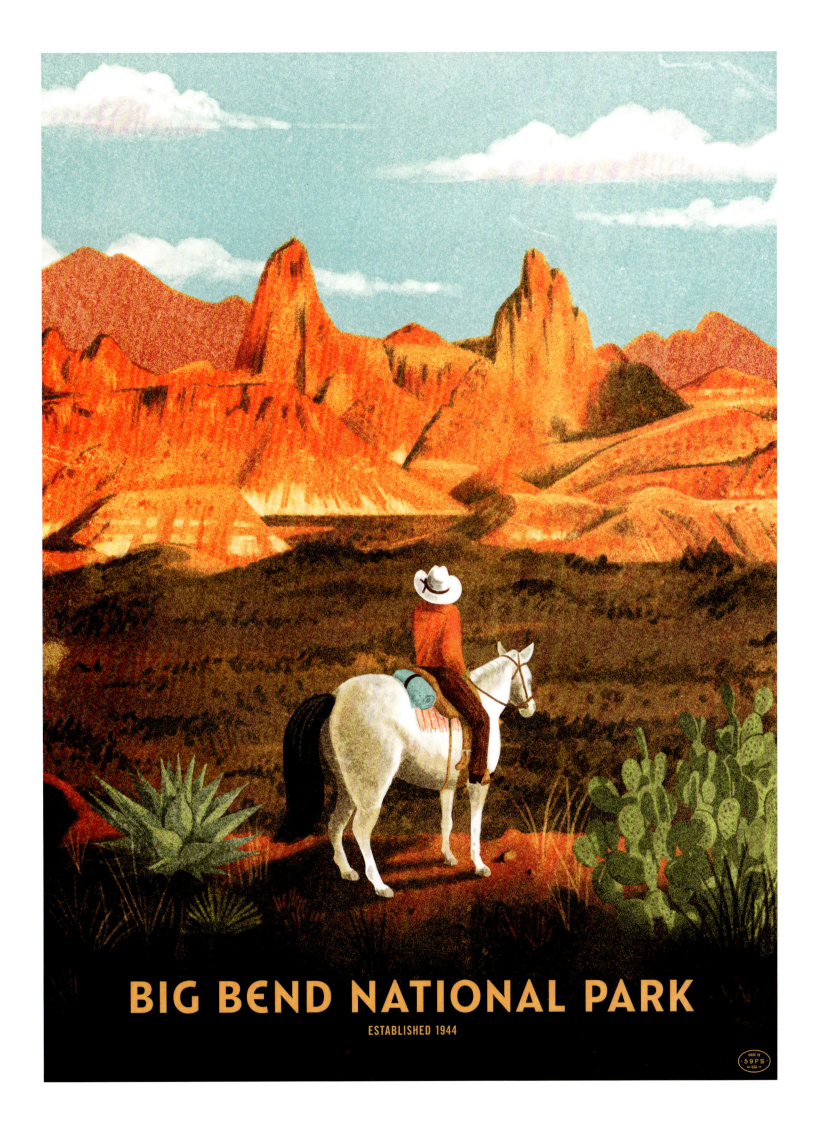

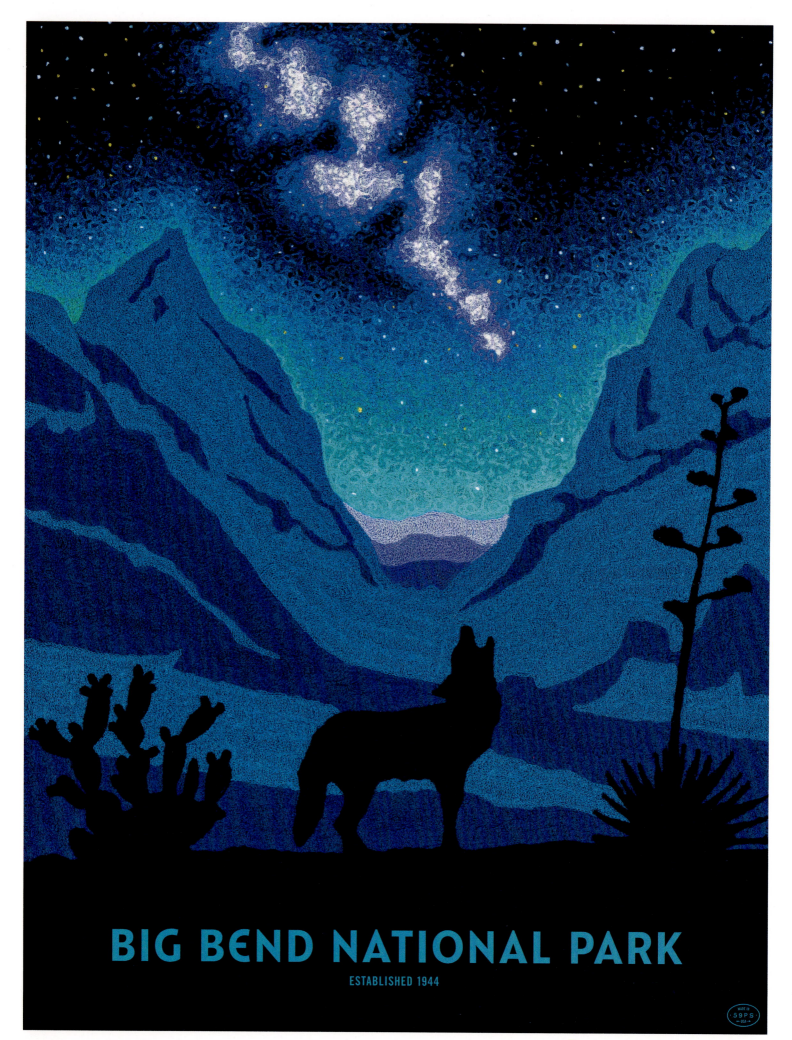

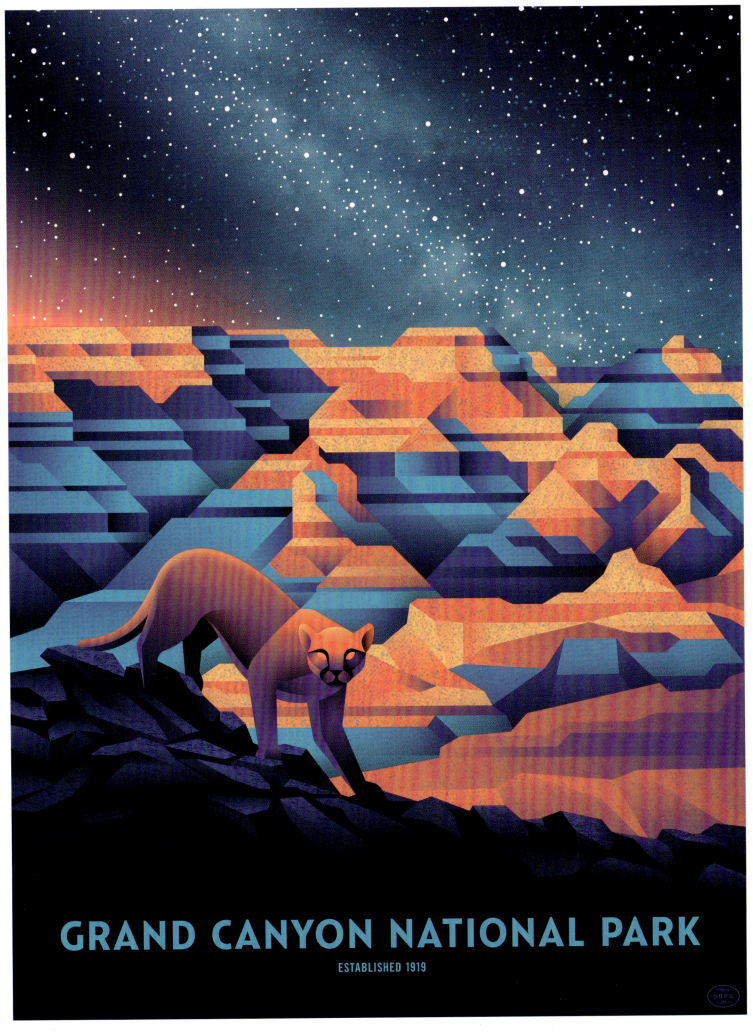

GRAND CANYON NATIONAL PARK

Crying. Acceptable at funerals and the Grand Canyon.

—*Ron Swanson*

One of the Seven Natural Wonders of the World, this nearly two-million-square-mile gorge carved out by the incessant rush of the Colorado River leaves few who see it unchanged. The mile-deep gullet of shimmering rock can bring even the most stoic visitors to tears. Only a three-and-a-half-hour drive from metropolitan Phoenix, the view from the canyon's famous South Rim offers sweeping landscapes and panoramic vistas. The even higher North Rim offers an equally enrapturing look at the vivid palette of the upper cliffs, ranging from magenta to cider orange.

Mule rides into the canyon's depths reveal the shrubs, pine forests, and grasslands that thrive within. Inside the depths of this red rock coliseum, the landscape is always shifting; jutting cliffs give way to limestone deposits before being suddenly broken up by crashing waterfalls. The ninety-eight-foot ever-flowing milky mane of Havasu Falls collects in a tranquil turquoise plunge pool. From small native villages to rushing tributaries, there's no dull spot in Grand Canyon National Park; everywhere you gaze, you find a feast for the eyes.

- Having received more than six million visitors in 2017, Grand Canyon National Park is the second most visited national park in the United States.

- A village belonging to the Havasupai tribe has existed in the area known as Cataract Canyon for more than 800 years.

- Since it can only be accessed by helicopter or by mule hike, the depths of the canyon are the only place in the United States where mail is delivered via mule.

- The canyon is full of reptiles, including six different species of rattlesnake. The Grand Canyon pink rattlesnake takes on a pink hue similar to the color of some of the surrounding rocks.

- Only eight species of fish reside in the Grand Canyon. Two of them—the humpback chub and the razorback sucker—are endangered.

STATE: ARIZONA
ARTIST: DKNG STUDIOS

PETRIFIED FOREST NATIONAL PARK

I'm planning to be buried in the Petrified Forest…. It's the graveyard of civilization that's shot from under us. The world of outmoded ideas. They're all so many dead stumps in the desert. That's where I belong and so do you, Duke. For you're the last great apostle of rugged individualism.

—Alan Squier (Leslie Howard) to Duke Mantee (Humphrey Bogart) in "The Petrified Forest"

During his lone visit to the park, Albert Einstein repeatedly asked the same question: "How?" Petrified Forest National Park is a magical place. Nothing here feels of this world. All 220,000 acres of the forest are above 5,000 feet, yet millions of years ago this place was a swamp. Logs that fell into the swamp absorbed the mud and minerals from within. Eons of natural fossilization occurred. The interior of the wood often resembles a kaleidoscope of color, with amethyst, jasper, and quartz swirling like tie-dye.

Attractions in the park are aptly named; for instance, Agate Bridge is a fossilized fallen tree. The Crystal Forest is crowded with logs that contain clear quartz and purple amethyst crystals. Agate House, a hut made from petrified wood, has been fully restored and is bursting with reds and yellows. Blue Mesa is a collection of cornflower blue pyramids. The crags, buttes, and gnarls of the painted desert burst with bright orange and fiery reds.

Landscapes are knurled like frozen lava. The Petrified Forest has become a rich source for dinosaur bones and fossilized footprints. Petrified Forest National Park instills visitors with an understanding of the power of time, reminding us all of the deep beauty present even in the bones of the things around us.

- The fallen trees and stumps of the Petrified Forest are believed to date from the Late Triassic epoch, approximately 225 million years ago.

- Petrified Forest National Park is the only national park that closes at night. It is gated, and camping is prohibited.

- The park is home to many different species, including coyotes, pronghorns, bobcats, prairie dogs, and reptiles like the Arizona tiger salamander.

- The colors of the forest's petrified wood are made of three major minerals. The whiteish colors come from quartz. The blues, purples, and blacks come from manganese. The oranges, reds, and browns come from iron.

- Archaeologists have uncovered evidence of people inhabiting the forest dating as far back as 10,000 years ago.

STATE: ARIZONA
ARTIST: KEVIN HONG

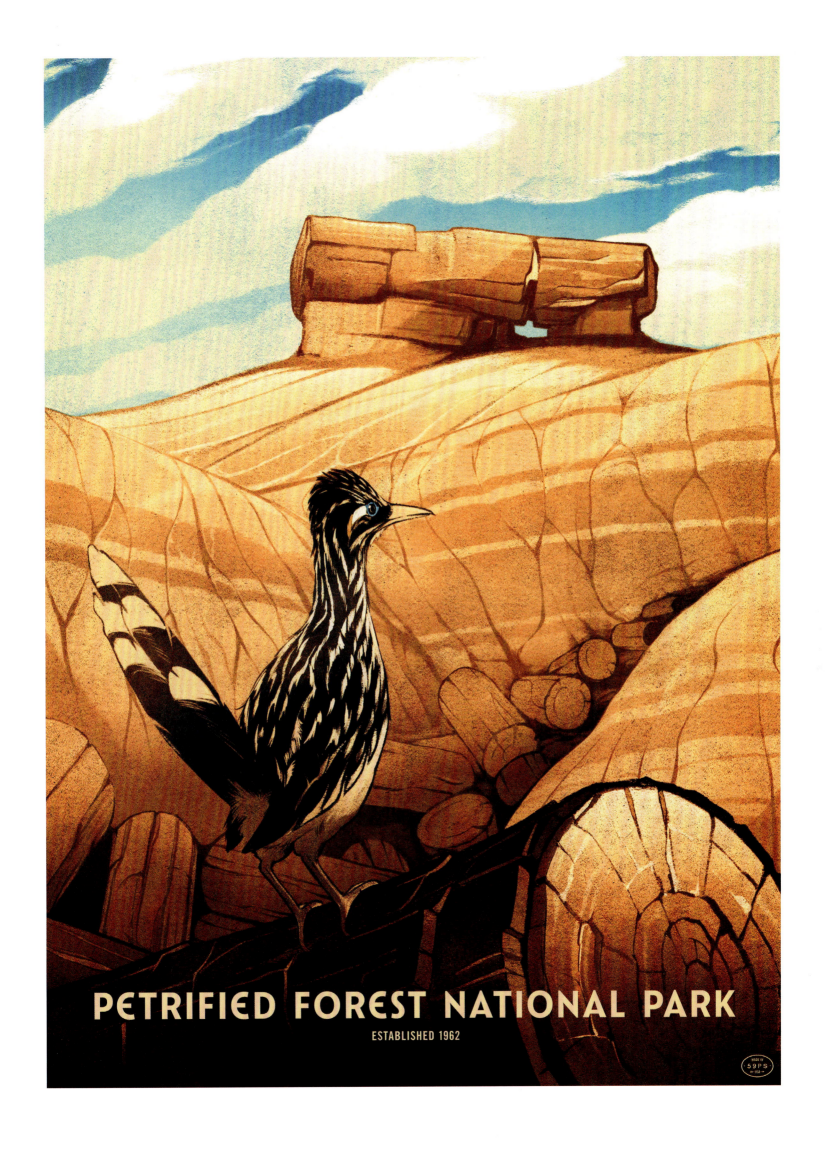

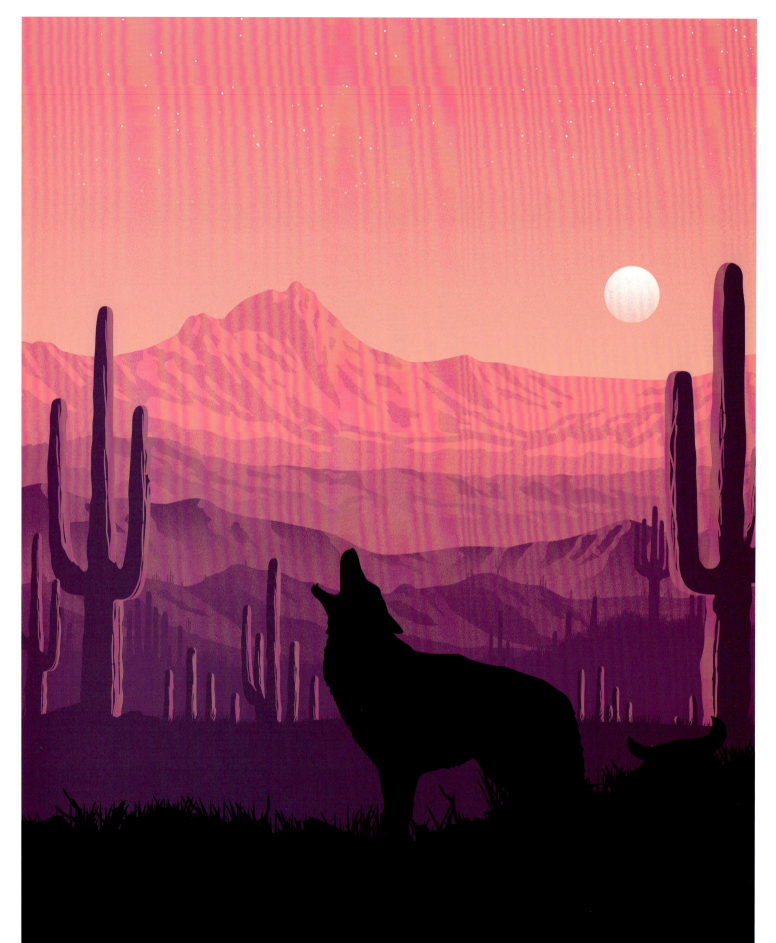

SAGUARO NATIONAL PARK

A walk took me to the heart of the giant cactus forest, the big-spined trunks seeming magnified in the moonlight, and casting strange shadows. The cactus forest completely captivated me. Mountain ranges and peaks rose over the cactus-trees and the edge of the world and came into life, like ships at sea.

—Charles Frederick Holder

The temperature fluctuations between daytime and nighttime in the southeastern Arizona area of the Sonoran Desert are extreme. Only the strong and resolute survive. The giant saguaro cactus, its regal arms jutting upward, is desert tough. The Sonoran Desert is the only place in the world where the saguaro grows, and 91,000 acres of mountains and desert are protected to preserve this iconic cactus. Ultradry heat makes the desert terrain a haven for cacti of all shapes and sizes, from the agave to the prickly pear to the dangerously sharp cholla cactus. A cactus's prickly spines aren't just for show: Water is scarce in the desert, and the sharp spines are a defense mechanism against creatures looking to pilfer the water cacti store away. In fact, saguaro cacti—rugged and imposing though they may be—are 80 to 90 percent water. When the occasional downpour hits the Sonoran Desert, the saguaro drink deep, allowing them to grow up to fifty feet tall and live for up to 150 years.

Saguaro National Park is split by the city of Tucson, Arizona, into two districts: the Tucson Mountain Western District, and the Rincon Mountain Eastern District. The park also features the world's smallest owl, the elf owl, which lays its eggs in tiny holes pecked by woodpeckers in cacti. The Harris hawk regularly perches atop the saguaro cacti to scope out its prey. Javelinas, medium-sized animals resembling wild boars, scurry in groups, searching for rare water sources in the desert, while mountain lions stalk the cliffs. Humans have also left their mark on the desert landscape. The short cliffs of Signal Hill in the Tucson Mountains feature geometric petroglyphs from the fourteenth and fifteenth centuries. As the sun beats down on the desert, the saguaros stand tall, defiant in their ability to survive.

- The park was declared a Natioanl Monument in 1933 by Herbert Hoover. In 1961, John F. Kennedy expanded the park to include the Tucson Mountain range.

- It is illegal to harm a saguaro cactus.

- The act of shooting a hole in a cactus, known as "cactus plugging," is also illegal and can result in a fine or even jail time.

- Only at age thirty-five does the saguaro cactus reach the height of an average human, and only then does it begin flowering. At age seventy-five, it grows its first arm.

- During the first eight years of their lives, saguaro cacti only grow between one and two inches tall.

STATE: ARIZONA
ARTIST: NICK SLATER

CARLSBAD CAVERNS NATIONAL PARK

I don't know how to describe the magnificence of Carlsbad Caverns without making it sound like a cartoon or a drug trip or a cartoon of a drug trip. The only thing I can say is that it is one of those dear places that make you love the world.

—Sarah Vowell

If you're not a spelunker, then you've likely never experienced the sheer exhilaration of entering a cave and encountering nature's shrouded mysteries for the first time. Fortunately, the public cave known as Carlsbad Cavern in Carlsbad Caverns National Park requires no ropes, pulleys, or special gear: You can walk right up to it and venture inside. Located in southwestern New Mexico's Chihuahuan Desert, Carlsbad Caverns National Park features 120 natural caves, numerous canyons, and one of the world's best-preserved fossilized reefs.

The Big Room is a 4,000-foot-long, 625-foot-wide limestone gallery of rare geological phenomena. The cavern was described by actor Will Rogers as "the Grand Canyon with a roof over it." A craggy passageway dubbed the "Bat Cave" is home to most of the area's bat population. Guadalupe Room is a sweeping section of the cave known for its ultra-slim stalactites called "soda straw" stalactites. Mystery Room is a small section of the cave known for an unidentifiable noise that cannot be heard anywhere else in the park. Each step inside these caves holds the possibility of discovery, and new rooms and sections are consistently unearthed by the scientists and adventurers who continue to explore this underground treasure trove.

- Though Carlsbad Cavern is the most well-known cave in the park, Lechuguilla Cave, which stretches out over 140 miles, is the largest.

- At 8.2 acres, the Big Room in Carlsbad Cavern is the largest accessible cave chamber in North America.

- Bats love the caves of Carlsbad Caverns. Seventeen different species of bat reside in the park.

- Because so many bats reside in the caves, the nineteenth century saw the mining of these caves for bat guano, which was used for fertilizer.

- Visitors can now descend into some of the caves via elevator; previously, people were lowered down inside a large bucket.

- Inside the King's Palace section of the caves is a deep hole dubbed the Bottomless Pit. Upon its discovery, it was believed to be literally bottomless. Eventually, it was determined to be 140 feet deep.

STATE: NEW MEXICO
ARTIST: KILIAN ENG

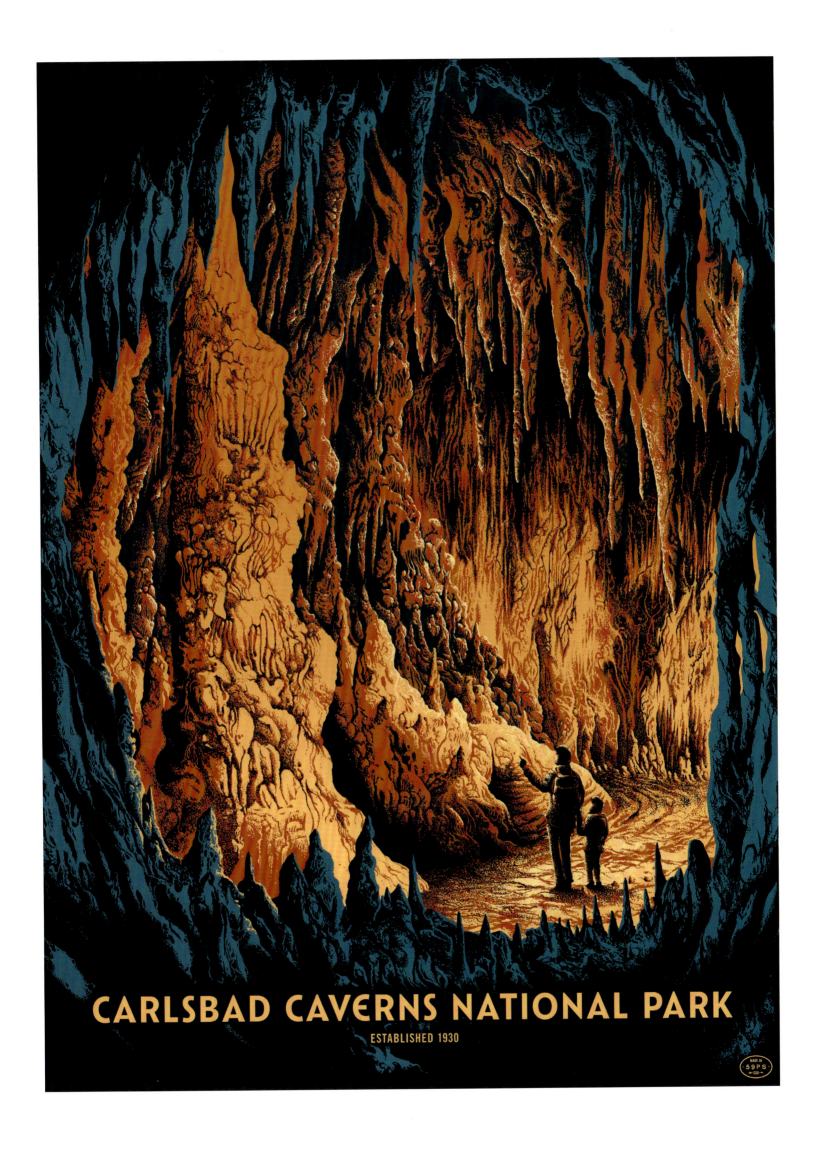

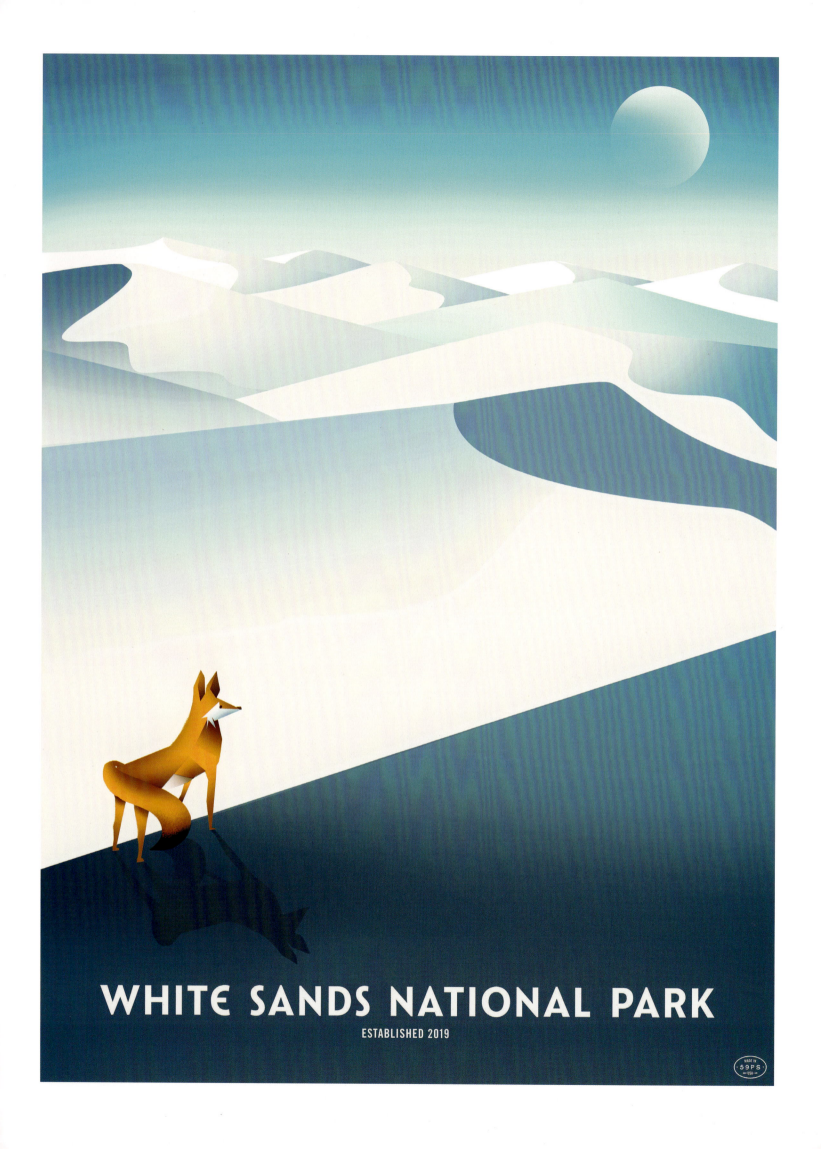

WHITE SANDS NATIONAL PARK

The sand is made of gypsum—whatever that is—and is as bright as the fallen snow. Brighter, actually. It's really quite unbelievable that anything can be so bright.

—Geoff Dyer

White Sands National Park is as stunning as it is haunting. Located in central New Mexico, the park features the world's largest gypsum dune field. These blinding white dunes are a marvel of nature so foreign to the human eye that visitors regularly get lost while exploring them. Large gypsum dune fields are uncommon because gypsum sand is water soluble and thus is usually dissolved or washed away by rainwater.

White Sands' location in the isolated Tularosa Basin of New Mexico protects the dunes from rain and keeps them intact. These dunes are otherworldly. They look more like snow than sand, and feel like powdered sugar. Despite a desert climate that averages ninety-seven degrees Fahrenheit in the summer, the sand remains cool due to its reflective hue. Visitors often treat the dunes like mountains of snow and use plastic sleds to slide down the winding slopes.

The park encompasses more than 275 square miles of powdery dunes that stretch up to sixty feet tall. Desert succulents, cacti, and yucca can be found throughout the park, along with myriad species of rodents and reptiles. Perhaps most surprising of all, ninety-three African oryx reside at White Sands, their twirling horns glinting in the desert sun.

- The Tularosa Basin was once home to Lake Otero. Before drying out, Lake Otero was larger than the state of Rhode Island.

- Though the gypsum sand remains cool in the summer sun, the risk of sunburn is high in the dunes due to the sand's reflectivity.

- White Sands was established as a national monument by President Herbert Hoover in 1933 and redesignated as White Sands National Park in 2019.

- The alien-like atmosphere of White Sands has made it a sought-after location for film shoots. Many movies, including Young Guns II and Transformers, were shot on location at White Sands.

- White Sands is flanked by military installations. White Sands Missile Range (formerly White Sands Proving Grounds) and Holloman Air Force Base are located on either side of the park.

STATE: NEW MEXICO
ARTIST: MARIANNA TOMASELLI

THE
WEST

BLACK CANYON OF THE GUNNISON NATIONAL PARK

The Black Canyon stands as a monument to the rugged, violent, and wonderful landscape of western Colorado.

—*Duane Vandenbusche*

Michelangelo worked on the Sistine Chapel for over a decade, Leonardo da Vinci took nearly fifteen years to perfect the *Mona Lisa*, and Brahms's first symphony was the result of twenty years of persistence. The colossal 2,000-foot-deep Black Canyon was formed more than two million years ago by the Gunnison River that runs through it, a testament to the power of concentrated effort.

A tributary of the Colorado River, the Gunnison is known for its relentless speed. Colorado's Gunnison River slopes thirty-four feet per mile through the canyon, making it one of the steepest rivers in the nation. The flow of the Gunnison is so mighty that humans weren't able to explore the bottom of Black Canyon until the early twentieth century, after they built the Gunnison Tunnel and Diversion Dam to slow the speed.

Every year that the Gunnison rushes along the Black Canyon walls, a human hair's width of rock is eroded. The currents and undertow of the Gunnison are still so rapid that it's unsafe for rafters, and only a few kayakers attempt to brave the waters each year. For this reason, few human beings ever reach the bottom of the canyon, preferring instead to look down from any of the five overlooks on the North Rim. Thanks to the mighty Gunnison, Black Canyon is the deepest, narrowest, and darkest canyon in the country.

- Only fifteen people per day can receive permits to hike down Black Canyon. The ultra-steep descent is considered an expert Class 3 hike. It takes an estimated two hours to descend, and four hours to climb back up.

- The name Black Canyon derives from the darkness in the depths of the canyon. In fact, parts of the gorge only receive thirty-three minutes of sunlight per day.

- The extreme high and low elevation allows a diversity of plant life to thrive around the canyon, from the juniper trees that grow along the canyon rim, to aspen, ponderosa pine, sagebrush, and desert mahogany.

- Six species of owl live in the park, including the great horned owl. There are eight species of hawk, including the rough-legged hawk, and two species of eagle, including the golden eagle.

- The tallest part of the canyon, dubbed Painted Wall, stands 2,250 feet high, making it the tallest cliff in Colorado and the third-tallest cliff in the contiguous United States.

STATE: COLORADO
ARTIST: JEFF LANGEVIN

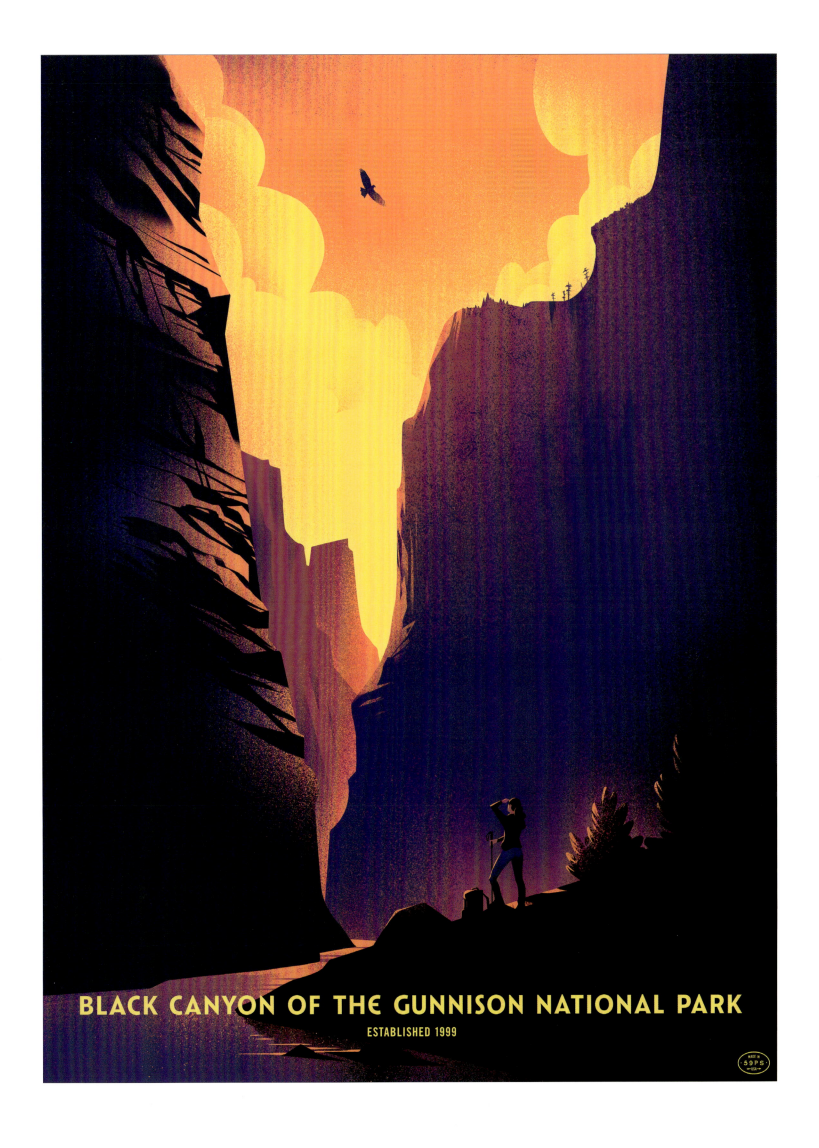

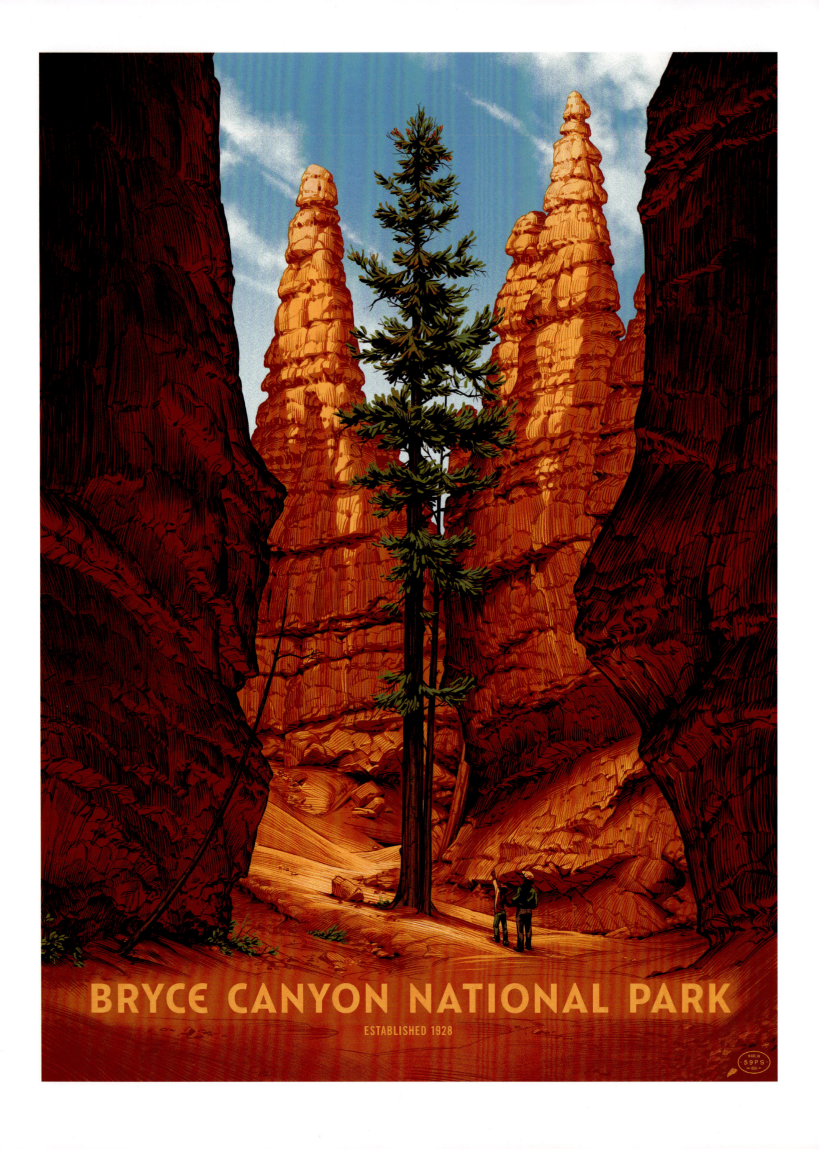

BRYCE CANYON NATIONAL PARK

This canyon is a hell of a place to lose a cow in.

—*Ebenezer Bryce*

Southern Utah's Bryce Canyon National Park has the highest concentration of hoodoos—remarkable, mushroomlike rock formations—in the world. The 35,835-acre park also features a collection of natural amphitheaters, the largest of which, Bryce Amphitheater, measures twelve miles long and three miles wide. If you begin at Sunset Point on the rim of the main amphitheater and journey to the Queens Garden trail, the many hoodoos that stretch along the way will make the landscape feel like an alien planet.

The ethereal rocky landscape is broken up by the sweet-smelling ponderosa pines that dot these trails. The eighteen-mile scenic drive to Rainbow Point offers the perfect opportunity to see a vast majority of the park at once, including thirteen possible viewpoints. One of these viewpoints, Natural Bridge, looks like a huge flat-topped cliff with a hole punched in the middle. At Rainbow Point, you can look out from the southern end of the park and soak up the entirety of Bryce Canyon's unusual beauty.

- "Hoodoos," "goblins," "earth pyramids," and "fairy chimneys" are just some of the unusual geographical formations found in Bryce Canyon.

- Hoodoos vary greatly in height: Some are no taller than the average person, while others reach as high as a large building. The largest hoodoos in Bryce Canyon measure up to 200 feet tall.

- One of the most popular sights in the park is a sequence of rock layers called the Grand Staircase. These layers, which resemble steps, are named for the color of the rock in each section. For instance, the top section is known as the Pink Cliffs.

- One section of the White Cliffs is dubbed "Mollie's Nipple." It was named by an early pioneer in tribute to his new wife.

- The desert climate of Bryce Canyon makes it a perfect sanctuary for reptiles, including the striped whipsnake, the tiger salamander, and the Great Basin rattler.

STATE: UTAH
ARTIST: CLAIRE HUMMEL

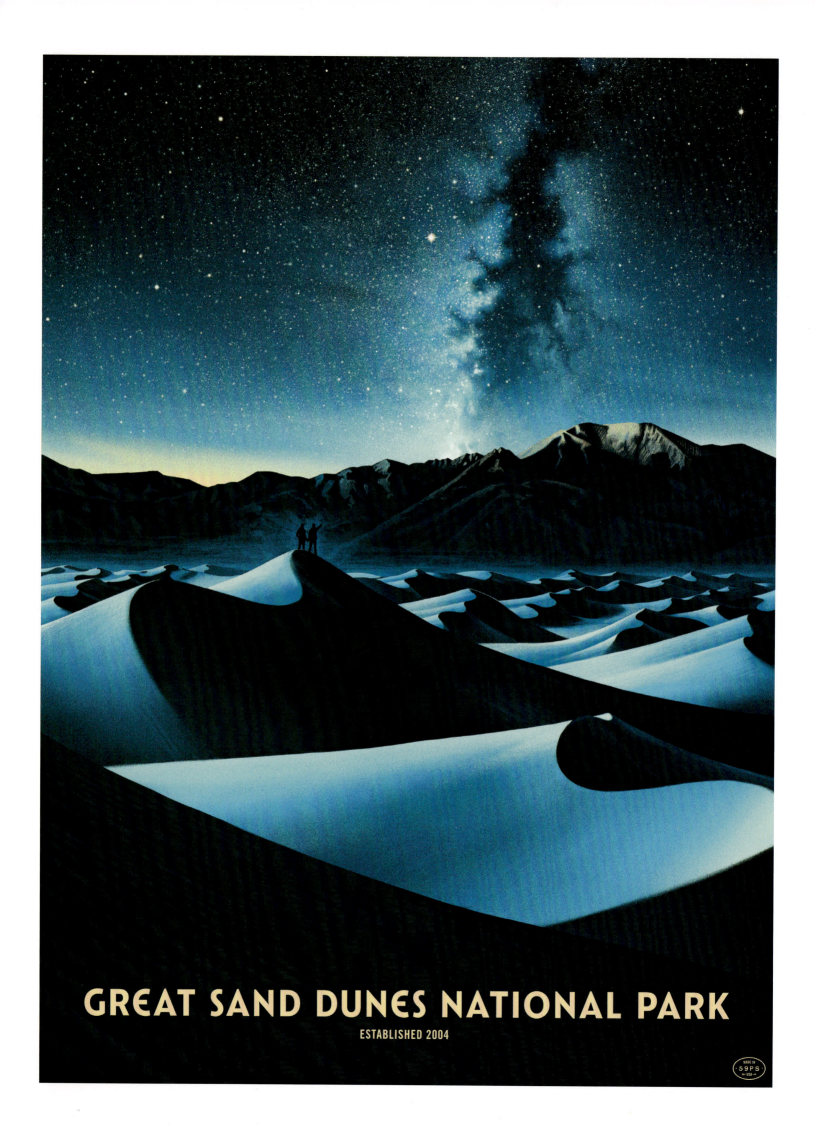

GREAT SAND DUNES NATIONAL PARK

The sand-hills extended up and down the foot of the White Mountains. . . . Their appearance was exactly that of the sea in a storm.

—Zebulon Pike

Nestled in the Colorado Rockies in central Colorado is the San Luis Valley. In the east of the valley sits Great Sand Dunes National Park and Preserve. The park contains over thirty square miles of mysterious and surreal sand dunes, some soaring as high as 750 feet before plummeting back to earth. Located at the foot of Sangre de Cristo mountain range, the park is estimated to hold more than 1.2 cubic miles of sand.

The winds that blaze through the peaks of the Rockies mold these earth castles and earth pyramids one grain at a time. The dunes constantly shift and reshape. Sometimes they even avalanche. Melting snow high in the mountains forms a lake, cascades through meadows and forests, and ultimately lands in Medano Creek, a wide and shallow stream at the base of the dunes. This unique journey causes natural waves that form every thirty seconds, giving the effect of a beach-like wave pool.

The juxtaposition of tundra with rich forests and warm wetlands creates a profusion of flora and fauna in the park. Yucca and prickly pear cactus grow right beside pine trees and myriad wildflowers. Bighorn sheep, pronghorns, and marmots prance alongside salamanders, toads, and frogs. Just like the soaring heights and swooping lows of the dunes, Great Sand Dunes National Park is a place where the earth can change right before your eyes.

- The Great Sand Dunes is home to the circus beetle, so named because it often stands on its head.

- The dunes so resemble an alien planet that NASA tests space vehicles here.

- The two Viking crafts that first landed on Mars were originally tested on the Great Sand Dunes.

- The native Ute people's term for Great Sand Dunes is Saa waap maa nache, which translates to "sand that moves."

- Designated an International Dark Sky Park, the Milky Way is visible from Great Sand Dunes National Park, particularly during moonless nights from midsummer to late fall.

STATE: COLORADO
ARTIST: NICOLAS DELORT

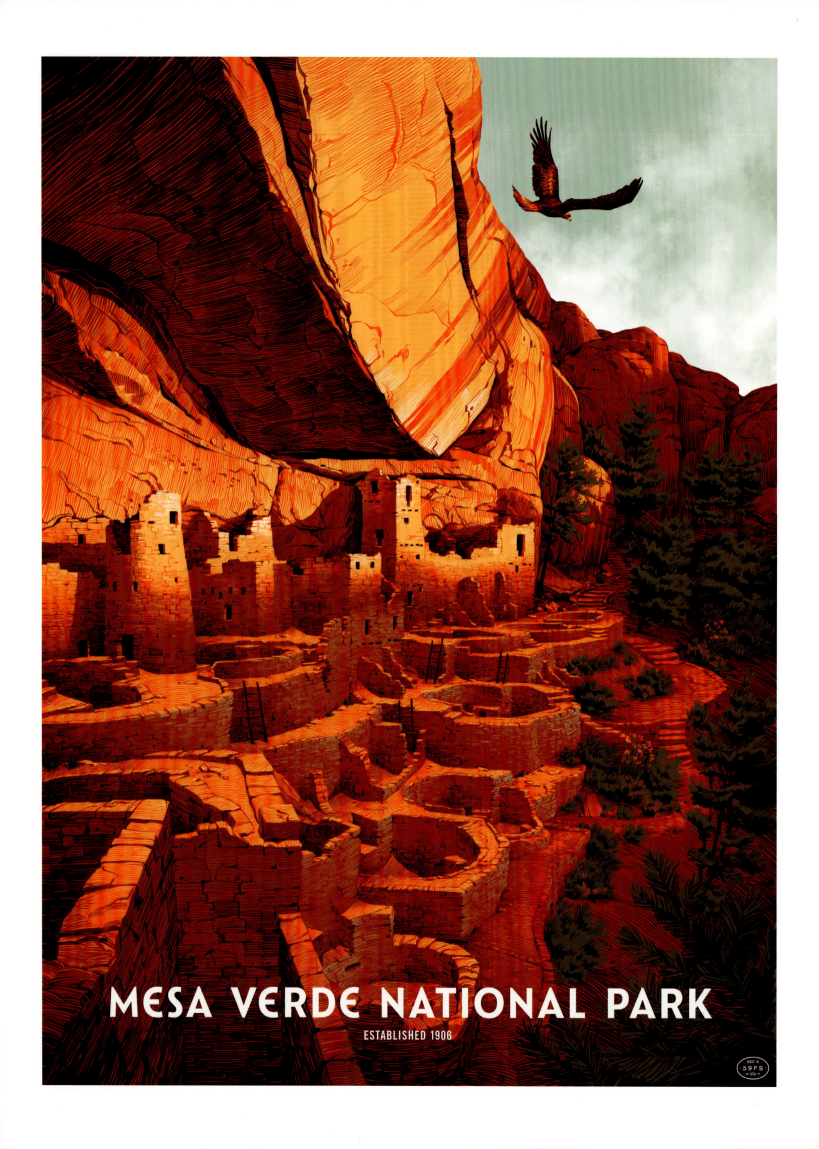

MESA VERDE NATIONAL PARK

The Mesa Verde community's ability to protect these centuries-old treasures, while eagerly sharing them with the world, represents the very best of our national parks.

—*George W. Bush*

Located in the Four Corners region of the Untied States—where Arizona meets Utah, New Mexico, and Colorado—Mesa Verde National Park is one of the best-preserved archaeological sites on earth. Its 52,485 acres boast more than 600 cliff dwellings left behind by the ancient North American nomads known as the Anasazi. Entire preserved villages are carved into these Colorado cliffs. There are small dwellings dug into the ground called *pit houses*, round meeting rooms called *kivas,* and multiroom stacked row houses called *pueblos.*

The centerpiece of the park is a cliff dwelling known as the Cliff Palace. This structure features 150 rooms as well as 26 kivas raised beneath a sandstone cliff. Other dwellings include Spruce Palace, which is built into a cave, and Balcony House, whose thirty-eight rooms are accessed by climbing a ladder and maneuvering through tunnels. Rudimentary irrigation systems and houses of worship can also be found on the mesa. According to historians, the inhabitants of these intricate villages disappeared mysteriously, but they left behind a wealth of clues that help us understand their ancient civilization, and their innovative dwellings still delight and inspire us to this day.

- Anasazi means "ancient ones" in Navajo.

- The Anasazi settled in the area around 600 AD.

- The doorways in the pueblos tend to be quite short. That's because the average person in the seventh century measured less than five feet six inches in height.

- The first person to photograph Mesa Verde was Henry William Jackson. He would later become famous for inventing the character of Uncle Sam.

- Mesa Verde is Spanish for "Green Table," a name that describes the lush juniper trees surrounding the area.

STATE: COLORADO
ARTIST: CLAIRE HUMMEL

ROCKY MOUNTAIN NATIONAL PARK

They have the extravagant beauty of youth, the allure of adolescence, and they are mountains to be loved.

—*James Michener*

Come here to celebrate the beauty of life, to see a cloud-flecked sky so deeply blue that you feel it in the pit of your stomach and a landscape so rich in scent that it tingles the tip of your nose.

Rocky Mountain National Park contains some of the most treacherous paths that settlers braved to win the West, and it also contains many of the natural treasures they fought. This includes the enormous bighorn sheep grazing in the valleys and the black bears haunting the natural caves in the backcountry. It also extends to boreal owls looking down from the cottonwood trees to trout swimming in Dream Lake.

During the summer and fall months, the park belongs to the Rocky Mountain elk. While 600 to 800 elk occupy the park during the winter, their numbers spike up to 3,200 during the fall and summer. Fall is when the male bull elk—an animal weighing up to 1,100 pounds—partakes in the surreal cacophony of grunts, shrieks, and screeches known as *bugling*. The sound of the bull elk bugling for a mate is often called "otherworldly," an adjective that perfectly describes the beauty of this legendary gateway to the West.

- Trail Ridge Road cuts a forty-eight-mile-long path through the Rockies. The road's highest point reaches 12,183 feet, making it the highest road in the United States.

- Over 280 bird species call Rocky Mountain National Park home, including the electric colored western tanager, the short and stout American dipper, and the curiously named pygmy nuthatch.

- The diverse elevations throughout the park makes it a wonderland for wildflowers. Elephantella, wood lily, and the Colorado columbine (Colorado's state flower) are just a few of the over 1,000 species of wildflowers in the park.

- Rocky Mountain bighorn sheep are the largest wild sheep found in North America. Their horns alone can weigh as much as thirty pounds.

- The park's land was acquired in 1803 as part of the Louisiana Purchase, a deal in which France sold the United States 827,000 square miles west of the Mississippi River for the price of $15 million.

STATE: COLORADO
ARTIST: RORY KURTZ

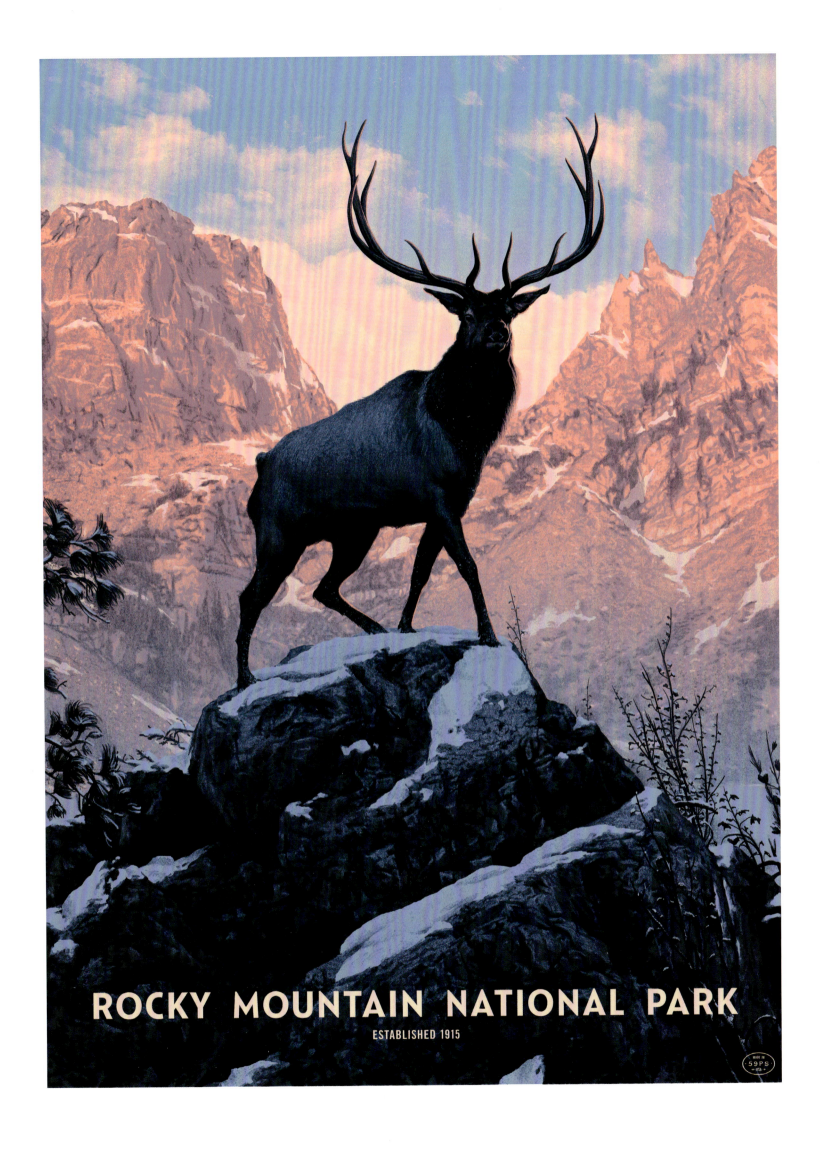

GRAND TETON NATIONAL PARK

There are few spots in the western mountain lands about which there hangs so much frontier romance.

—William Baillie-Grohman

There is nowhere this side of Scandinavia to find fresh water as blue as the lakes of Wyoming's Grand Teton. The turquoise color of Delta Lake's water is a result of the rock flour fed into the lake by the surrounding rock formation known as Glacier Gulch.

The Teton mountain range is considered the youngest of the Rocky Mountains, shooting up 7,000 feet high straight from the lowlands of the Jackson Hole valley. The Teton range and all that surrounds it look almost too immaculate to be real. The snow-dusted mountain caps are reflected perfectly by the mirror-like lakes below.

Hundreds of black bears and grizzly bears call the park home, along with elk, pronghorns, beavers, moose, and bison. Come here to simply exist, and to exist simply. Here in the Tetons of Wyoming, the busiest minds can unplug, unwind, and unburden.

- President Calvin Coolidge established the park in 1929 despite fierce opposition by his constituents.

- Initially, the park only included the Teton Range. When Franklin Delano Roosevelt made Jackson Hole a national monument in 1943, there was again fierce opposition. Ranchers led by film star Wallace Beery marched 500 cattle across the protected land.

- Grand Teton is the only national park with an airport on its premises. The Jackson Hole Airport became part of the park in 1943.

- The tallest peaks on the Teton Range host glaciers with names like Triple and Skillet.

- The park is one of the best bird-watching destinations in the country. The park contains both the largest waterfowl in the country—the trumpeter swan—and the smallest bird in the country, the Calliope hummingbird.

STATE: WYOMING
ARTIST: KIM SMITH

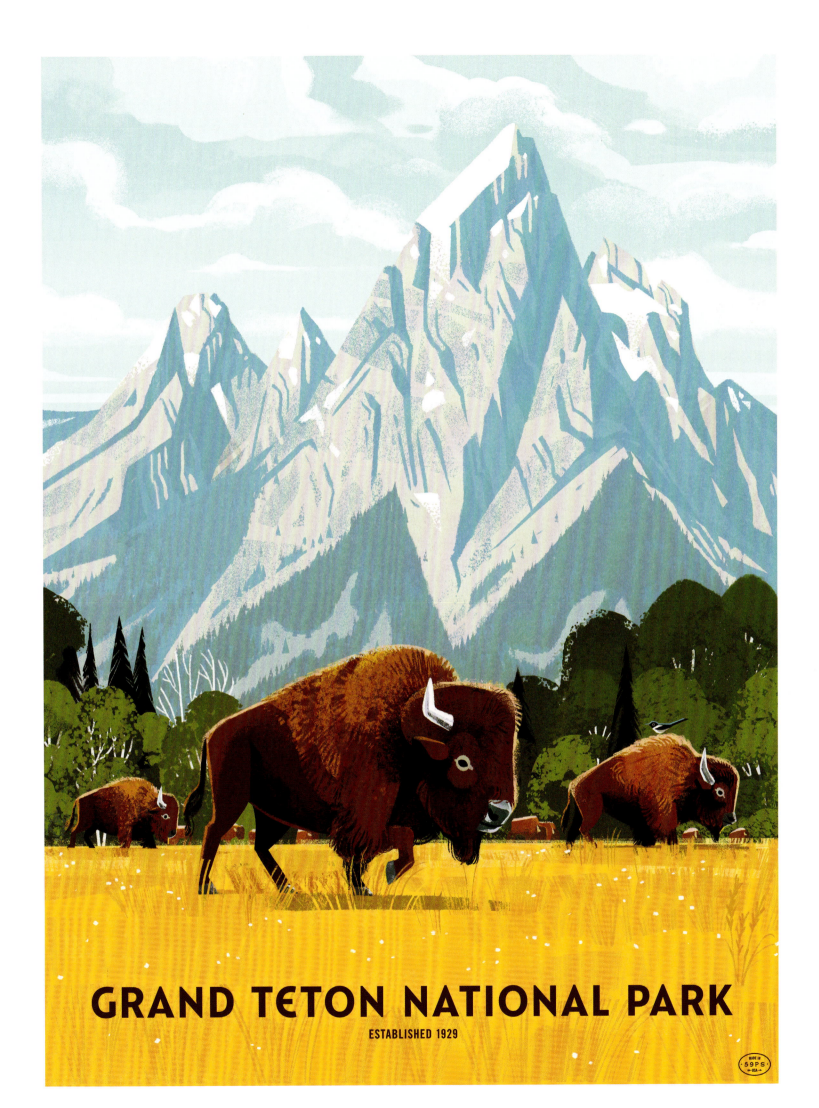

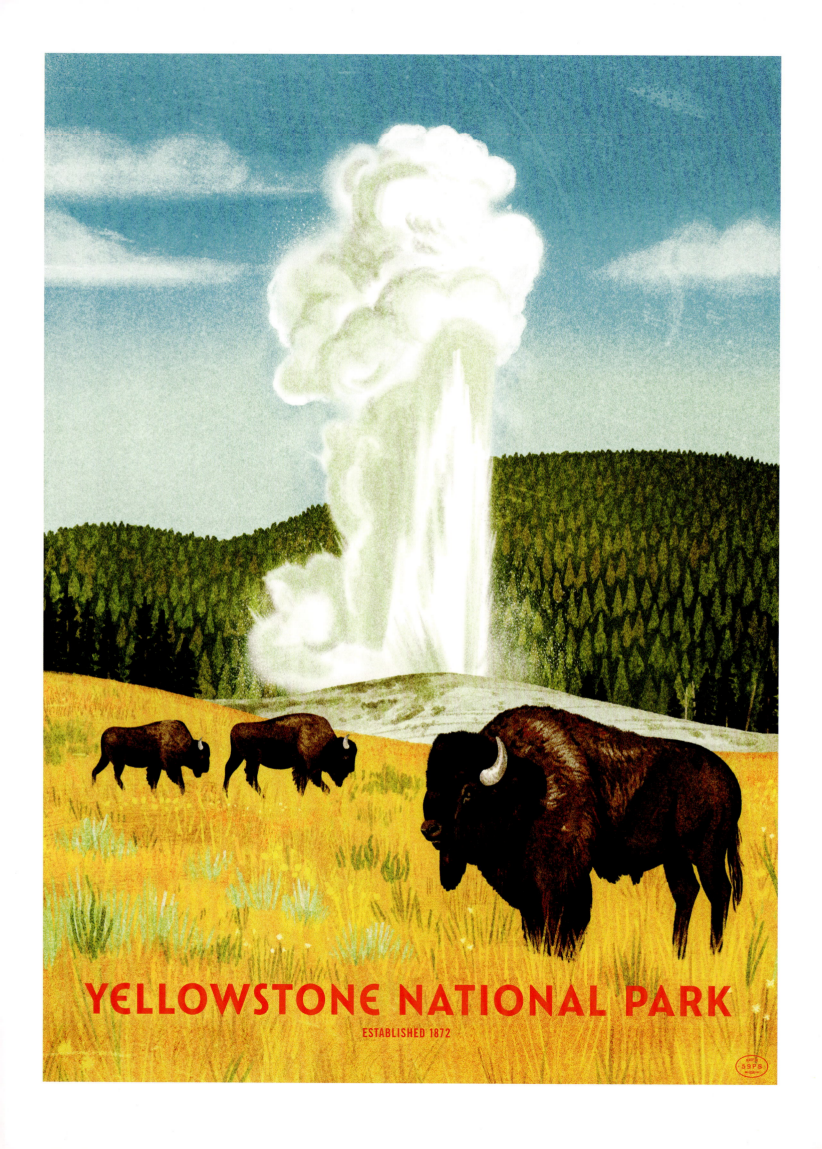

YELLOWSTONE NATIONAL PARK

I still remember traveling up to Yellowstone National Park, coming over a hill, and suddenly seeing just hundreds of deer and bison for the very first time. That new scenery gave me a sense of just how immense, how diverse, and how important the vast array of wildlife is to understanding and appreciating the world and our place in it. That's something I wanted my daughters to understand when I brought them back to the very same spot at Yellowstone a few years ago. It's something I want to preserve for our kids, grandkids, and generations to come.

—Barack Obama

Yellowstone National Park represents the American ideal. It has everything: lakes, rivers, canyons, mountain ranges, forests, wildlife, world-famous geothermal features, and even a volcano. The Yellowstone Caldera is sometimes called the Yellowstone Supervolcano. It has been 70,000 years since it last produced lava; instead, it currently expels steam from a series of geothermal vents located throughout the park. One such vent is arguably the park's most famous and reliable feature: since the year 2000, Old Faithful has erupted every forty-four minutes to two hours.

Mammoth Hot Springs is a collection of more than fifty hot springs interspersed among vibrant gorges and cliffs adorned by waxy limestone travertine formations. Visitors can peruse the scenery on elevated boardwalks that span the hot springs. Grand Prismatic Spring is a dazzling pool of sapphire that diverges into a rainbow of color along its outer rim. At Boiling River, the hot springs mix with colder river water, making it a safe place for visitors to take a dip.

Another part of the park, Lamar Valley, has been dubbed America's Serengeti; this wide-open grassy landscape is home to wolves, grizzly bears, bald eagles, and herds of free-roaming bison. At nearly double the height of Niagara Falls, the vertical widemouthed drop of Yellowstone Falls is a sight that endures. Yellowstone is sacred. It's where the buffalo roam and the eagles soar. Look out at this glorious expanse and see if you don't feel that urge felt by so many before you to write your own chapter in the already magnificent story of this nation.

- Not only was Yellowstone the first national park in the United States, it is widely considered to be the world's first national park.

- The park was inaugurated on March 1, 1872, by the 18th president of the United States, Ulysses S. Grant.

- Early explorers used Old Faithful to launder their clothing, but only regular loads: Delicates like wool would have been torn to shreds by the geyser.

- Over 1,000,000 Old Faithful eruptions have been recorded. They expel anywhere from 3,700 to 8,400 gallons of water per eruption to a height ranging from 106 feet to 185 feet. The duration of the eruption ranges from one and a half minutes to five minutes.

- Bunsen Peak is an 8,564-foot-high mountain that overlooks the Mammoth Hot Springs. It was named after volcanic theorist and inventor of the Bunsen burner, Robert Bunsen.

STATE: WYOMING, IDAHO, MONTANA
ARTIST: BRAVE THE WOODS

GLACIER NATIONAL PARK

The water from the crusted snowdrift which caps the peak of a lofty mountain there trickles into tiny rills, which hurry along north, south, east, and west, and growing to rivers, at last pour their currents into three seas. From this mountain-peak the Pacific and the Arctic Oceans and the Gulf of Mexico receive each its tribute. Here is a land of striking scenery.

—George Bird Grinnell

Glacier National Park is as representative of North America's natural beauty as New York City is of its culture. There are jagged mountain peaks, alpine glaciers, and gushing waterfalls. The wildlife here is guaranteed to astound even seasoned adventurers. Moose, grizzlies, and mountain goats wander the mountains alongside rarer species like Canadian lynx and wolverines.

The Sun Road wraps around the mountain to Lake McDonald, a ten-mile glistening lake carved by melting glaciers. Farther along the road, you'll find a series of lookouts offering remarkable views of mountains and cliff ledges which are often occupied by the mountain goats so symbolic of Glacier National Park.

The breathtaking vistas along these subranges of the Rocky Mountains are teeming with wildlife. Hundreds of grizzlies and black bears call these mountains home; however, it's the eponymous glaciers of the park that visitors find most astounding. These massive, swirling ice temples are as rare as they are precious. There were once up to 150 in the park, but they have since dwindled down to fewer than thirty. The melting glaciers are an important reminder of the fleeting nature of our nation's most awe-inspiring beauty.

- Glacier National Park, established alongside Canada's Waterton Lakes National Park, is known in full as Waterton Glacier International Peace Park.

- Established in 1932, Waterton Glacier International Peace Park is the first of its kind—a single park shared by two neighboring nations.

- The clashing of both Pacific and Arctic air makes for dramatic weather shifts in the area. The temperature has dropped as much as one hundred degrees in twenty-four hours.

- The Sun Road cuts through the middle of the park. The sometimes treacherous and twisty road provides views of fifty miles of glaciers, waterfalls, and mountain ranges.

- The largest glacier in the park, Blackfoot Glacier, is 0.7 square miles.

STATE: MONTANA
ARTIST: LAURENT DURIEUX

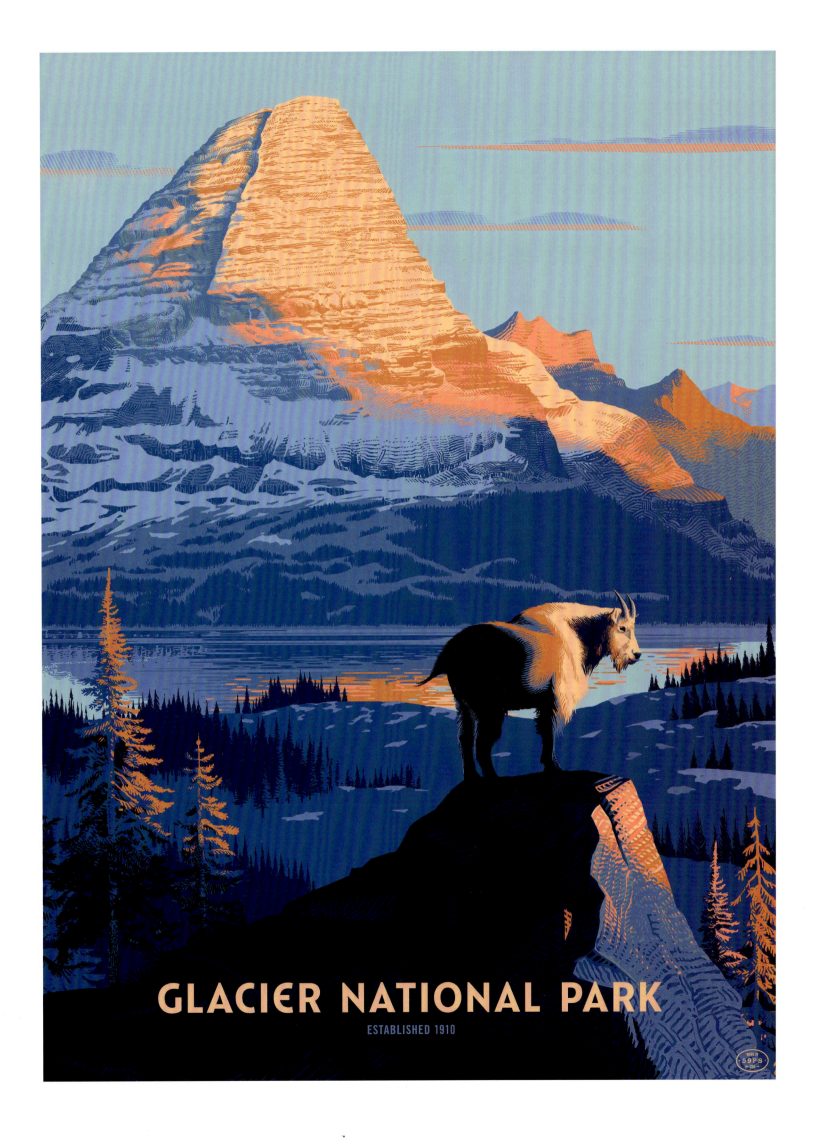

DEATH VALLEY NATIONAL PARK

How can rocks and sand and silence make us afraid and yet be so wonderful?

—Edna Brush Perkins

Sometimes we crave majesty and perfection: symmetrical rainbows and clean symphonies. Other times, we desire dissonance: clashing minor guitar chords and the harrowing abyss of a clear desert night sky. The harsh vacancy of Death Valley has inspired equal parts fear and intrigue for generations. Encompassing the Great Basin and the Mojave Desert, Death Valley is the lowest, driest, and hottest national park in the country.

Despite its name, there is plenty of life in Death Valley. Within the confines of the enormous park are some of the most stunning marvels of lowland desert that the natural world has to offer. Here, canyons, valleys, and mountains tower over swirling sand dunes, trickling salt flats, and haunting badlands. As low as 282 feet below sea level and as hot as 134 degrees, the park has many gifts to offer the brave and resilient visitor.

Ubehebe Crater is a 600-foot-deep maar volcano of billowing slate-gray ash. The area known as Racetrack Playa contains mysterious moving stones that leave trails behind them. Zabriskie Point is a series of ridges tinted astonishing shades of orange, gold, and blood red. Artist's Palette is a section of the Black Mountains featuring a plethora of colors, from cerulean to pink. The austere colors of the Mesquite Flats wax and wane in the shadow of the mountain range. Death Valley is America's darkest shadow, the place where the night sky shines its blackest. The valley's infinite stillness will give you goose bumps.

- Star Wars Episode IV: A New Hope was filmed in Death Valley. So was Star Wars Episode VI: Return of the Jedi.

- The rocks in Racetrack Playa have long been a mystery. How did they get there? Some of them weigh as much as 600 pounds.

- While the Mesquite Flats are the most famous sand dunes in the park, the Eureka Flats are the highest, with some dunes rising as high as 680 feet.

- The sand sings in Death Valley. Sand slipping down the steep dunes can produce a low warbling sound.

- In the Badwater area of Death Valley is a large salt flat called the Devil's Golf Course. The name comes from the jutting salt deposits that would make it impossible for anyone other than the devil to play golf there.

STATE: CALIFORNIA
ARTIST: CRISTIAN ERES

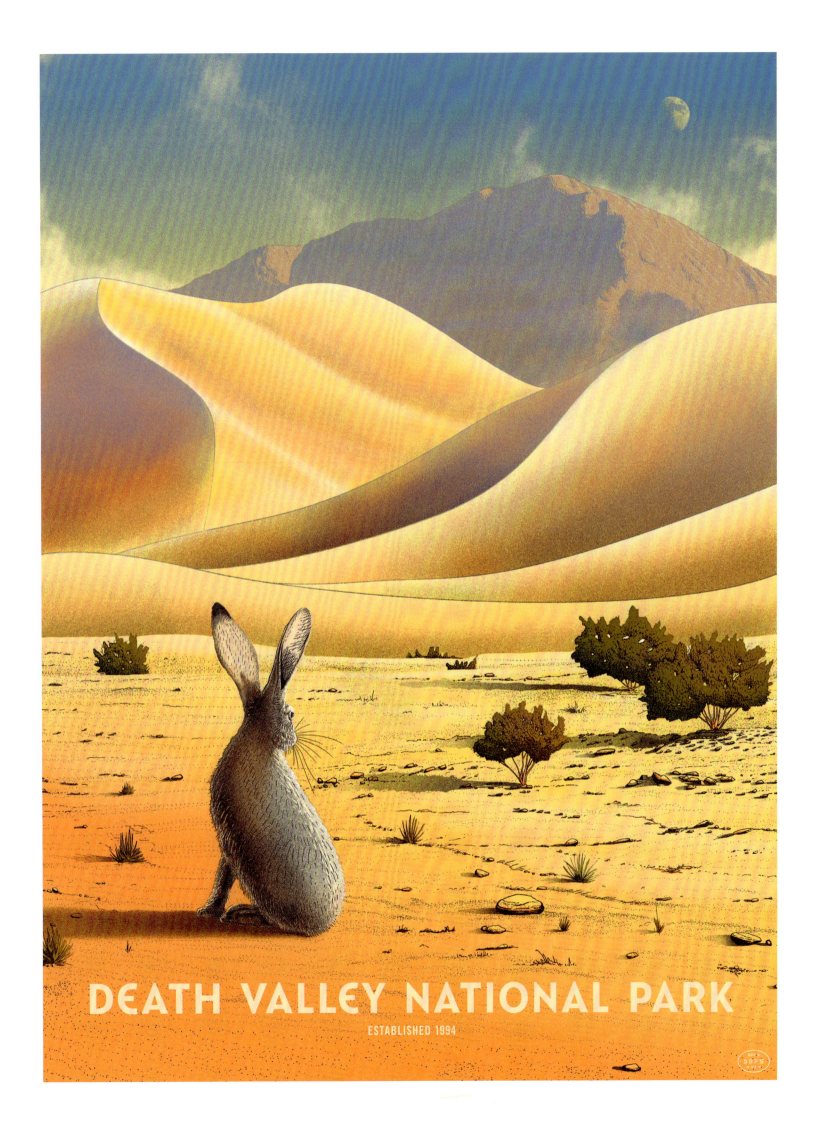

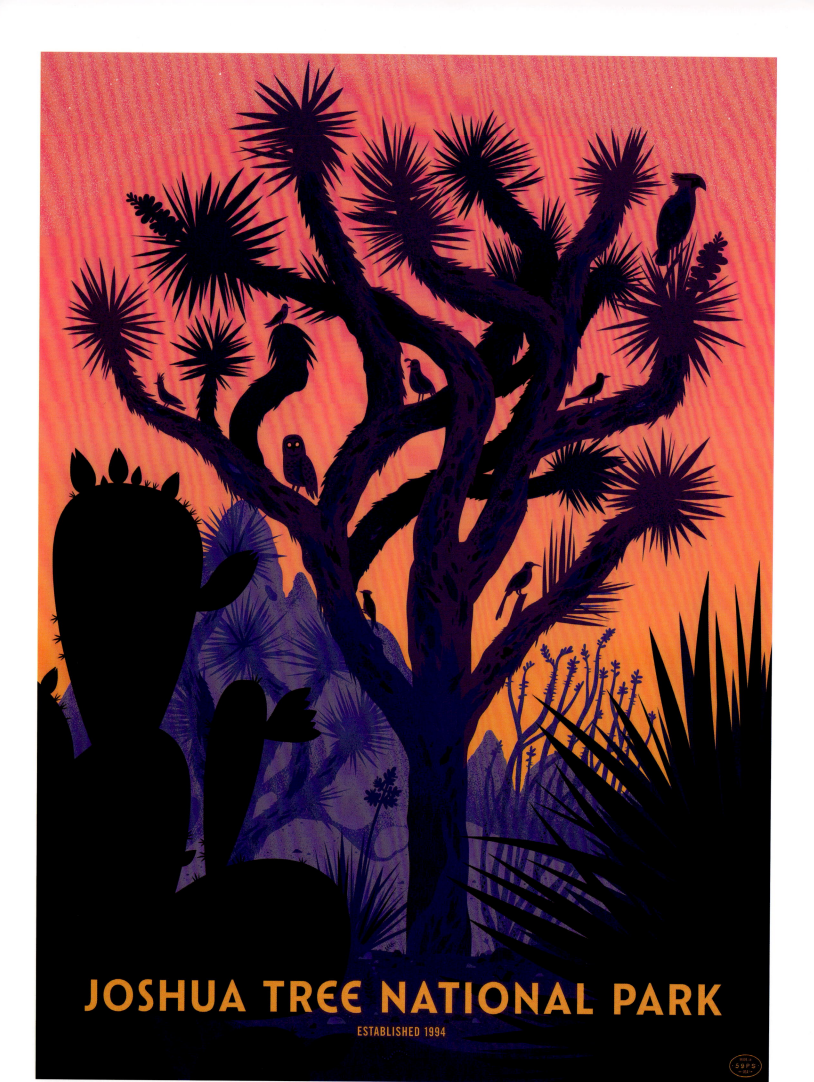

JOSHUA TREE NATIONAL PARK

It's the Joshua Tree's struggle that gives it its beauty.

—*Jeannette Walls*

Walk upon the splintered sands of the Mojave and take in the splendor of this against-all-odds ecosystem. Hike the inspiring rock formations and watch the sunset. Stay for the stars. A certified Dark Sky Park, Joshua Tree is far enough from the light pollution of nearby population centers for visitors to enjoy some of the best stargazing in the country. The unique combination of the ultradry climate of the Mojave with the high and cool elevation of the mountains yields an unreal juxtaposition of dry gulches and lush greenery.

The park is most famous for the eponymous Joshua tree, also known as the *Yucca brevifolia*. This peculiar-looking, squat tree can be found by the thousands in Queen Valley and Lost Horse Valley, the park's grassland areas. The tree was given the name *Joshua* by early Mormon settlers who believed its thick and stubby branches resembled the arms of the biblical hero as he guided his people to the land of milk and honey. By thriving in the desert climate, these trees, like the park itself, offer a testament to the endurance of nature.

- The highest point in Joshua Tree is at the top of Quail Mountain, which stands 5,816 feet high.

- Along the main east-west park road in Joshua Tree is a place known as Skull Rock. Here, a large rock formation was slowly eroded by rainwater, ultimately giving it the appearance of two hollowed-out eyes in a large skull.

- Though quiet during daylight hours, the wildlife of Joshua Tree comes alive at night. Inhabitants include bighorn sheep, lynx, and jackrabbits.

- There are six mountain ranges within the park: the Little San Bernardino Mountains, the Cottonwood Mountains, the Hexie Mountains, the Pinto Mountains, the Eagle Mountains, and the Coxcomb Mountains.

- The entirety of the park covers 789,745 acres.

- Joshua trees grow between one and three inches per year and take between fifty and sixty years to grow to maturity; mature trees reach anywhere between fifteen and forty feet in height.

STATE: CALIFORNIA
ARTIST: LITTLE FRIENDS OF PRINTMAKING

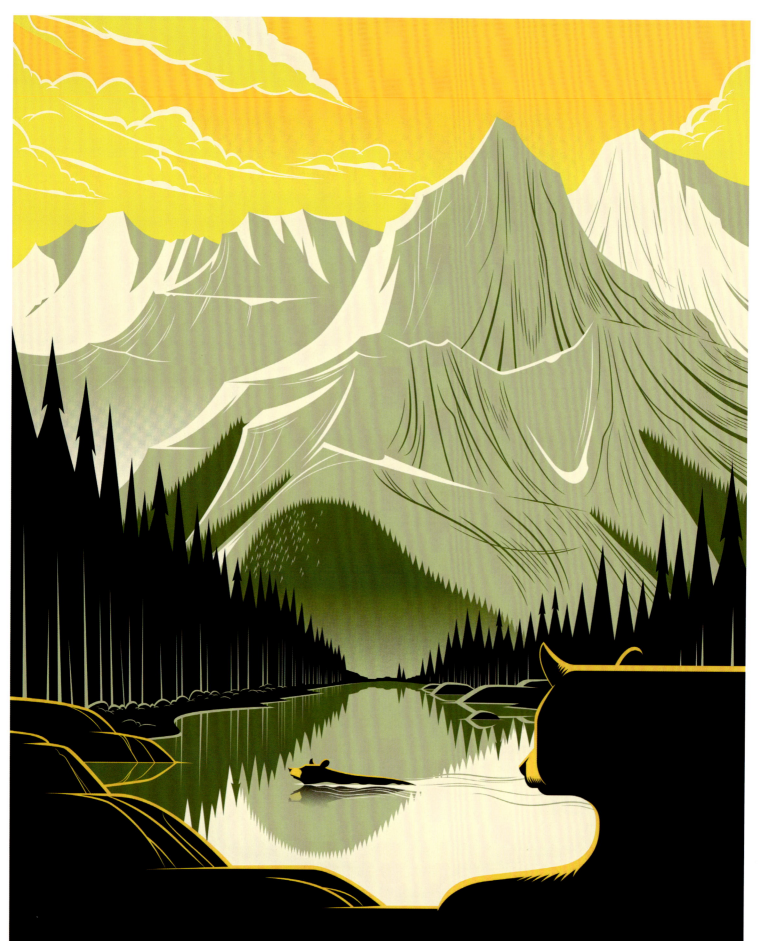

KINGS CANYON NATIONAL PARK

From the head of the valley other mountains rise beyond in glorious array, every one of them shining with rock crystals and snow, and with a network of streams that sing their way down from lake to lake through a labyrinth of ice-burnished cañons.

—John Muir

Located in the southern Sierra Nevada Mountains of California, Kings Canyon National Park comprises an intricate network of valleys, forests, and canyons. The spiky Sierra Nevada Mountains include some of the steepest peaks in the country. The Great Western Divide, a range of the Sierra Nevada Mountains, separates Kings Canyon National Park from its nearby twin Sequoia National Park. The range of mountains known as the Sierra Crest mark the eastern boundary of the park. From here, the Middle Fork Kings River carves its way through the southern portion of the park, creating the mile-deep canyon for which the park is named.

Tehipite is one of several giant granite domes where viewers can gaze out at the stunning mountain landscape from 3,500 feet above sea level. The U-shaped canyons of the park give way to meadows split by the river. Beside them, sequoia forests stretch on for miles. The elevation changes create whitewater rapids and waterfalls along the rivers of the Sierra.

Brown bears find these woods a hospitable home and can be seen climbing along the rocks and scouring the river for food. Nearby sequoia forests are home to some of the tallest living things on the planet. At 267.4 feet high, the General Grant Tree is the second-largest tree in the world. Sequoia trees may be the centerpiece of Kings Canyon, but the park's diverse terrain offers adventures for outdoor enthusiasts of every stripe.

- Kings Canyon National Park and Sequoia National Park are the only co-managed national parks in the United States.

- Conservationist John Muir was a staunch advocate for the preservation of the park. He considered Kings Canyon similar to his first love, Yosemite.

- The logging industry once had their sights set on the park's sequoia groves. In 1890, a number of these groves were protected by the establishment of Grant National Park.

- Kings Canyon National Park was established in 1940. In 1965, it was expanded to its present size of 461,901 acres.

- Kings Canyon National Park is one of only three places in the world where giant sequoia trees grow. The other two are Sequoia National Park and Yosemite National Park.

STATE: CALIFORNIA
ARTIST: ERIC TAN

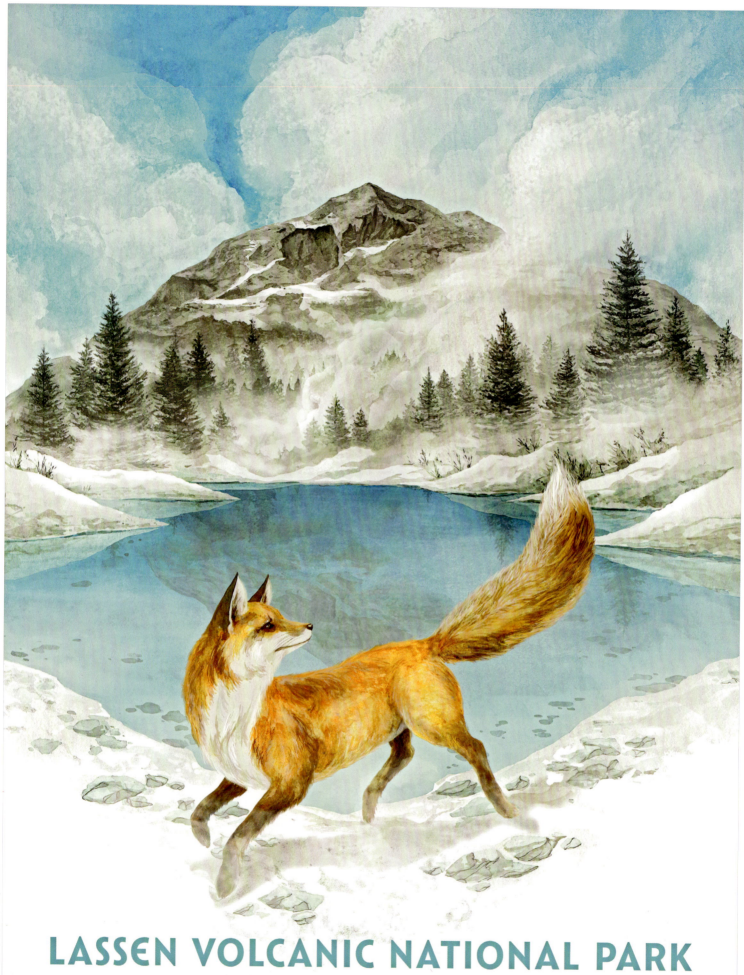

LASSEN VOLCANIC NATIONAL PARK

Lassen's Peak looks sharper from this side than any other, and views seen from among these pinnacles and rocks are some of the most picturesque imaginable.

—*William H. Brewer*

Located in the northern tip of the Sacramento Valley in California, Lassen Volcanic National Park is a volcano enthusiast's dream. Every type of volcano can be found within the confines of the park—plug dome, cinder cone, shield, and strata. This was once the most active volcanic region in America; today, only Lassen Peak, the world's largest plug dome volcano, is still active. With elevations ranging from 5,300 feet to 10,000 feet, the park offers visitors many different landscapes, including lakes, meadows, mountain peaks, volcanoes, and waterfalls.

The geothermal features throughout the park are a reminder of the lava that once covered the area. Bumpass Hell Trail is a three-mile hike along a boardwalk that brings you up close to boiling mudpots, fumaroles, and hot springs. Pools of red, yellow, orange, and green are formed from broken-down sulfuric acid. The Devil's Kitchen includes a four-mile hike through marshes and meadows to a collection of fumaroles, mudpots, and steaming earth. Elsewhere, the park includes over 27,000 acres of old-growth forests. Grassy meadows teeming with wildlife surround the beautiful, deep-blue Manzanita Lake. Ultimately, Lassen Volcanic National Park is a living example of how creation and destruction exist side by side in nature.

- After being dormant for many years, Lassen Peak erupted in 1914.

- Between 1914 and 1917, Lassen Peak erupted almost 300 times.

- On the day it erupted in 1914, a team of researchers were sent to study why the volcano appeared to be rumbling. They were there when it erupted and narrowly survived.

- Bumpass Hell is named for cowboy Kendall Vanhook Bumpass, who fell through the thin surface above a boiling mudpot and burned his leg.

- Cinder Cone is the name of a cinder cone volcano in the park. It is believed to have last erupted between 1630 and 1670.

- The park is home to more than 216 bird species, including bald eagles, golden eagles, and hummingbirds.

STATE: CALIFORNIA
ARTIST: AARON POWERS

PINNACLES NATIONAL PARK

I remember that the Gabilan Mountains to the east of the valley were light gay mountains full of sun and loveliness and a kind of invitation, so that you wanted to climb into their warm foothills almost as you want to climb into the lap of a beloved mother.

—John Steinbeck

Pinnacles National Park is located in Monterey County on the California coast, inland from Big Sur. The park is named for its high spires, which are the remains of an eroded volcano located on a fault line. These rock spires moved 200 miles from their original location as a result of the shifting fault. The pinnacles, in addition to dividing the park into its east and west sections, act as a centerpiece and attract adventurous mountain climbers year round. For many, springtime brings the main attraction— the California condors and prairie falcons that inhabit the park this time of year.

The intense desolate desert heat makes the park perfect for gliding. The temperature here rarely dips below 90 degrees and regularly hovers above 110. Fortunately, some of Pinnacles most enchanting mysteries can be found in the shadiest of places. The park features intricate cave systems, including talus caves, which are caves formed in the spaces between boulders. There are entryways to these caves on each side of the park, at Bear Gulch Cave and Balconies Cave. Year round, streams trickle through these underground palaces. At Hanging Rock, a huge boulder balances atop the tight canyon walls. Whether hiking, climbing, spelunking, or bird-watching, Pinnacles offers exhilarating sights at every elevation.

- Theodore Roosevelt established Pinnacles as a national monument in 1908.

- Pinnacles was upgraded to a national park in 2013, by President Barack Obama.

- Wildlife in Pinnacles National Park includes cougars, golden eagles, gray foxes, quail, great horned owls, wild pigs, and bobcats.

- More than 400 species of bees live in Pinnacles National Park.

- Out of the twenty-three species of bat that live in California, fourteen of them live in the caves in Pinnacles National Park.

STATE: CALIFORNIA
ARTIST: MIKE MCCAIN

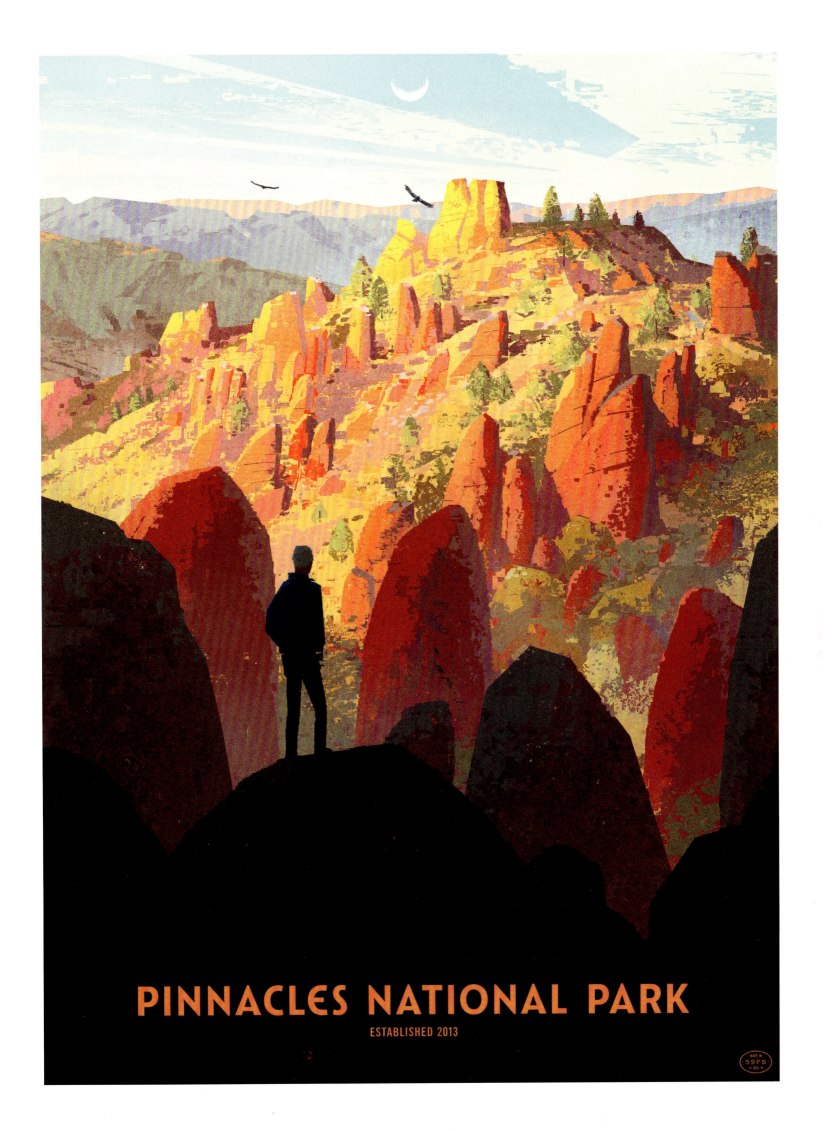

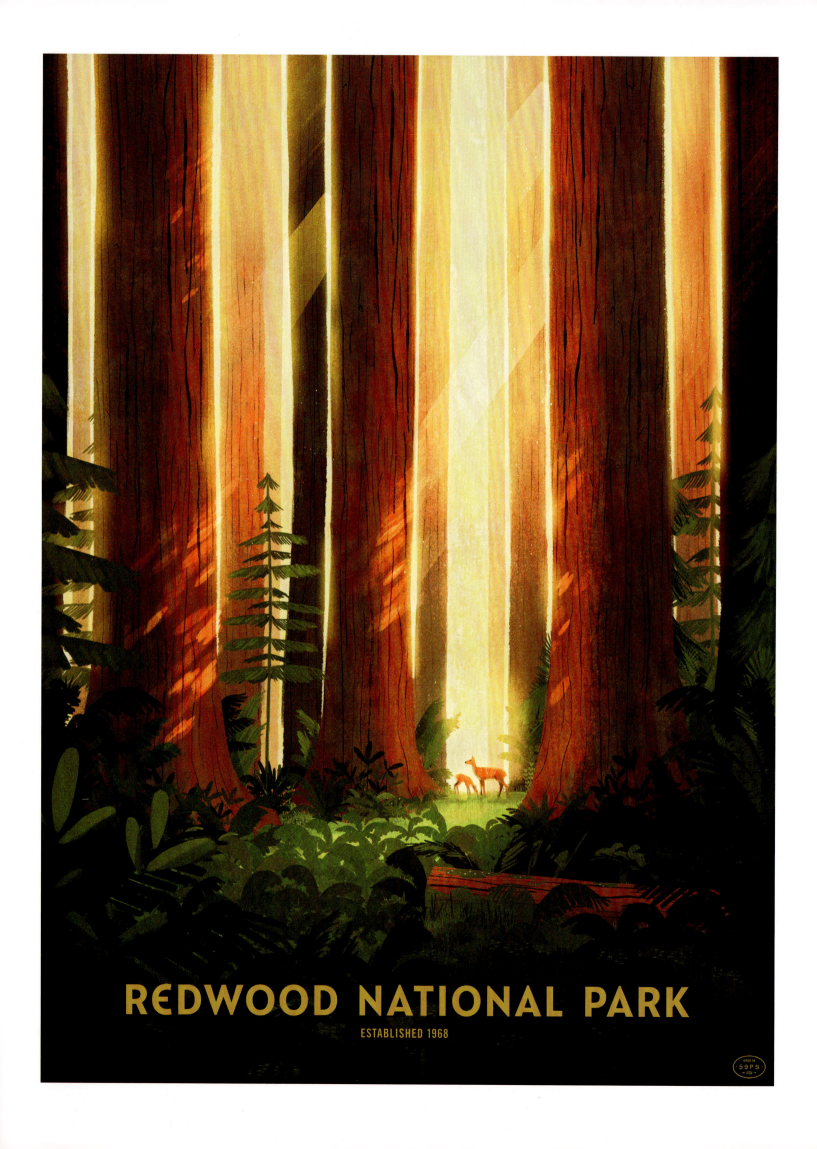

REDWOOD NATIONAL AND STATE PARKS

A murmuring, fateful, giant voice, out of the earth and sky, Voice of a mighty dying tree in the Redwood forest dense ... [T]he wood-spirits came from their haunts of a thousand years, to join the refrain; But in my soul I plainly heard. Murmuring out of its myriad leaves, Down from its lofty top, rising two hundred feet high, Out of its stalwart trunk and limbs—out of its foot-thick bark, That chant of the seasons and time—chant, not of the past only, but of the future.

—*Walt Whitman*

With your arms outstretched between two redwoods and shielded from the sky by an endless canopy, you can almost feel the pulse of this park's intricately interconnected ecosystem. Nearly half of the redwoods in the world live in Redwood National and State Parks, many of them more than 2,000 years old. You will have to journey along the California coastline to find Redwood National Park, and the drive will inspire you with breathtaking views of the Pacific Ocean. Once you've arrived at the park, you will find not only the world's tallest trees, but also the prairies, streams, rivers, and rich natural woodlands that surround them.

Many of the animal species that call Redwood National and State Parks home, such as the northern spotted owl or the Steller's sea lion, have had their existence threatened over the years, but local conservationists and charities have come together to celebrate and protect this park and, in the end, the animals persevered. Redwood National and State Parks are a testament to the will of the natural world.

- Humboldt Redwoods State Park is the oldest old-growth coastal redwood forest in the world, meaning that its 17,000 acres of redwood trees have never been logged.

- At more than 240 million years old, redwoods are believed to have existed alongside the dinosaurs.

- Redwood trees are known for their resilience. The bark of a large redwood can be up to a foot thick.

- Elk, black bears, beavers, bobcats, otters, owls, and bald eagles all call Redwood National and State Parks home.

- There are over 400 so-called "ghost" redwood trees throughout the parks. These trees remove poisons from the soil and rely on the surrounding redwoods for nutrients to survive. Unable to produce chlorophyll, their leaves are bright white.

STATE: CALIFORNIA
ARTIST: GLENN THOMAS

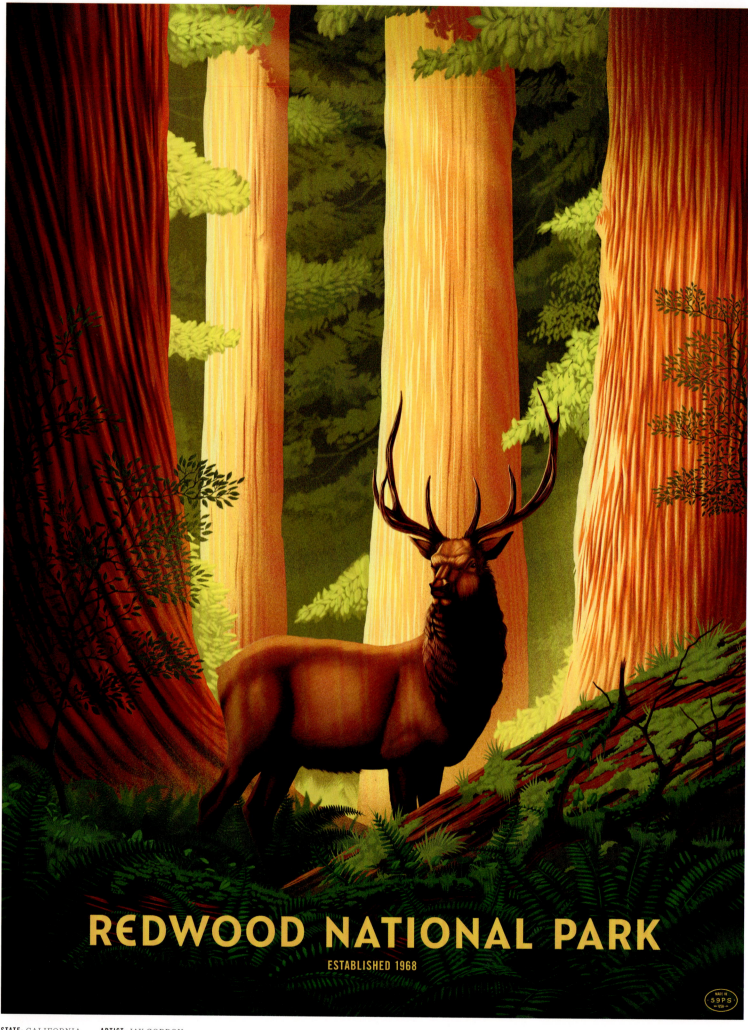

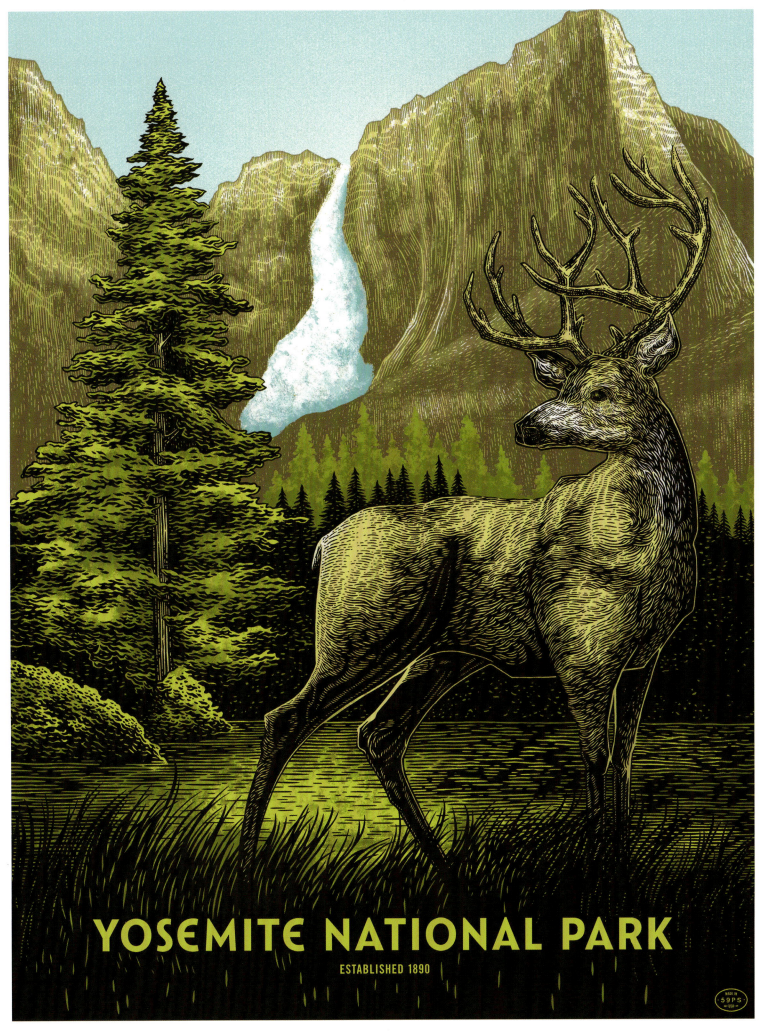

YOSEMITE NATIONAL PARK

It is by far the grandest of all the special temples of Nature I was ever permitted to enter.

—John Muir

The cliffs and valleys of Yosemite are an inspirational treasure. Lakes gleam beneath sweeping mountain ranges speckled with blue-gray stone bluffs. Snowcapped mountains tower over fields of green. Deer graze alongside the sequoia groves while wolves tramp along the banks and black bears sleep in the tall grass. Generations of artists, writers, and politicians have been inspired by Yosemite's majesty. The famous landscape photographer Ansel Adams risked life and limb to capture the natural rock formation known as the Half Dome.

Across the valley, another 3,000-foot-high vertical rock formation called El Capitan is ascended daily by rock climbers. Yosemite Falls is another jewel of this wonderful park. It is a marvel of nature, where three levels of rapids pour down between two sloping cliffs in the Sierra Nevada. Nearby, the waterfall known as Horsetail Falls absorbs the sunset's orange hue, appearing as if it's on fire. It's impossible to experience this exquisite land without feeling a yearning to connect deeper to the nation's natural treasures.

- Yosemite is considered to be the birthplace of rock climbing.

- The United States Army's famous Buffalo Soldiers are known for their service on the frontier. They also contributed greatly to the preservation of Yosemite, warding off poachers and protecting the park from forest fires.

- The decision of President Abraham Lincoln to sign the Yosemite Land Grant of 1864 is said to be the birth of the idea of the national park in the United States of America.

- Yosemite is known for its gigantic sequoia trees. Perhaps the most famous tree in the park is the Wawona Tunnel Tree, which was so wide that a tunnel was carved inside of it. At 234 feet high and 26 feet wide, the tree was large enough that a person could drive a car through the tunnel until its collapse in 1969.

- Yosemite is one of the few places in the nation where you can spot rainbows at night. These illustrious "moonbows" become visible when light from the moon refracts off the mist from rushing water at the base of certain of Yosemite's many waterfalls.

STATE: CALIFORNIA
ARTIST: DAN MCCARTHY

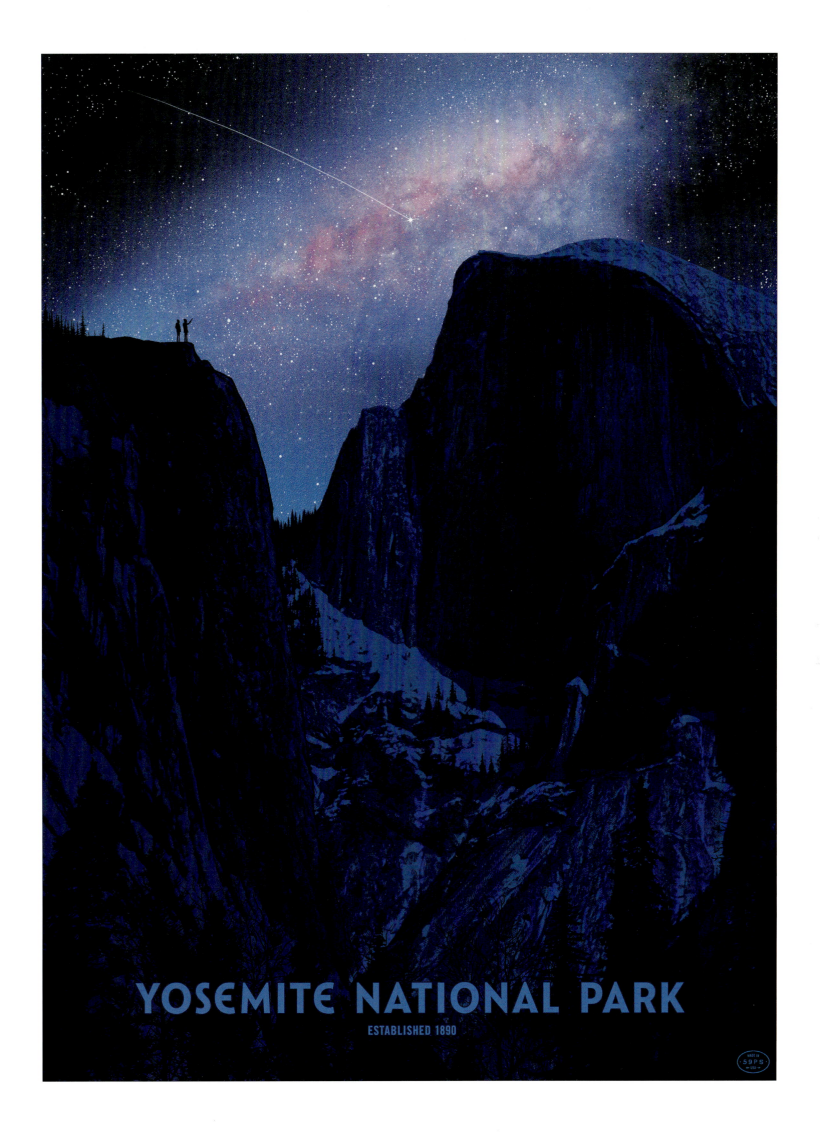

SEQUOIA NATIONAL PARK

A grove of giant redwoods or sequoias should be kept just as we keep a great and beautiful cathedral.

—Theodore Roosevelt

Sequoia National Park is located in the belly of California, right beside Kings Canyon National Park. It boasts the tallest peak in the contiguous United States and houses groves of colossal sequoia trees, but Sequoia still manages to remain something of a well-kept secret. Looking at a photograph or video of a sequoia tree does little to communicate how massive it really is. These trees are among the oldest living things on this earth. A fallen tree obstructing one of the driveways in the park was so massive that park personnel merely carved a tunnel into it so that visitors could drive on through.

The trees in this park have been alive since the days of the Old Testament. They are seemingly immune to fire, disease, and even people: Attempts at logging these sequoias failed because the trees are so large that they shatter into little pieces when they fall. As with Kings Canyon, there are few roads in the park. Visitors must either experience the park on foot or on horseback. There is as much to explore underground as on the surface: The park's extensive underground cave system includes more than eighty caves. Crystal Cave, the most famous, is a dark and enchanted castle decorated with stalactites and stalagmites of all sizes. This is a superlative place. The tallest tree, the oldest tree, and the highest peak—it's all here.

- Sequoia National Park was the first established national park in the state of California.

- Mount Whitney, which reaches an elevation of 14,505 feet, is the tallest mountain in the contiguous United States.

- The General Sherman Tree, located in the Giant Forest area of the park, is considered to be the largest living tree by volume in the world.

- The Giant Forest contains five of the ten largest trees in the world.

- Black bears, badgers, bighorn sheep, cougars, and wolverines are regularly spotted in the park.

STATE: CALIFORNIA
ARTIST: GLENN THOMAS

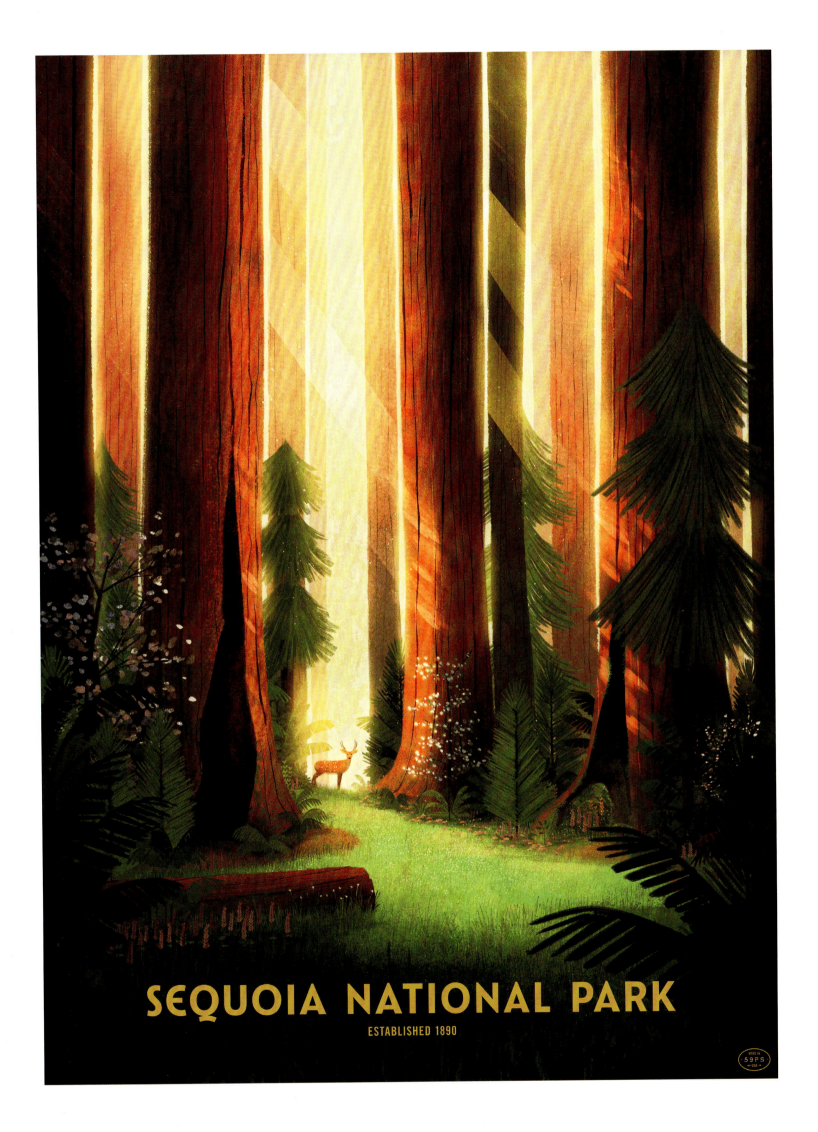

ARCHES NATIONAL PARK

Time and space. This partnership is holy. In these redrock canyons, time creates space—an arch, an eye, this blue eye of sky. We remember why we love the desert; it is our tactile response to light, to silence, and to stillness.

—Terry Tempest Williams

Arches National Park, located just four miles north of the town of Moab in southwestern Utah, boasts 2,000 naturally occurring arches. These inspiring creations are formed by erosion. Nowhere can they be found in such large numbers as in Arches National Park. The nearly 120-square-mile park is considered high desert, reaching an elevation of 5,653 feet at the top of the craggy summit known as Elephant Butte. The park offers almost every size and shape of natural arch imaginable, from the long and thin Landscape Arch, which looks like a treacherous drawbridge, to the Double Arch, which resembles two arches growing out of one another.

Each arch looks like a path to some unknown universe and forms a natural frame for stunning views of the desert. However, Arches National Park offers more than just arches; in fact, it boasts many other kinds of incredible desert phenomena. Dark Angel is a freestanding sandstone pillar that stretches 150 feet straight up in the air. The Fiery Furnace is a labyrinthian canyon with tight, mazelike walls. Balanced Rock is a 128-foot-high boulder that miraculously teeters 55 feet above an impossibly thin base. Balanced Rock is visible as you drive to the park from Moab, inviting you to enter. Arches National Park invites you to find out what lies on the other side of this larger-than-life rock formation.

- Balanced Rock is one of the most popular sites in Arches National Park, but it once had a rival "sibling" known as Chip Off the Old Block. Sadly, Chip Off the Old Block collapsed in the winter of 1975–1976.

- The boulder at the top of Balanced Rock weighs more than 3,600 tons. That's more than the weight of fourteen blue whales.

- Arches National Park was the setting for the opening scene of the film Indiana Jones and the Last Crusade.

- The most popular arch in the park is likely Delicate Arch. It's so renowned that it is the featured image on Utah license plates.

- Delicate Arch got its current name for the way it looks, seeming to be "delicately chiseled," but it has had several other names, including Cowboy's Chaps, Old Maid's Bloomers, and Salt Wash Arch.

STATE: UTAH
ARTIST: NICOLAS DELORT

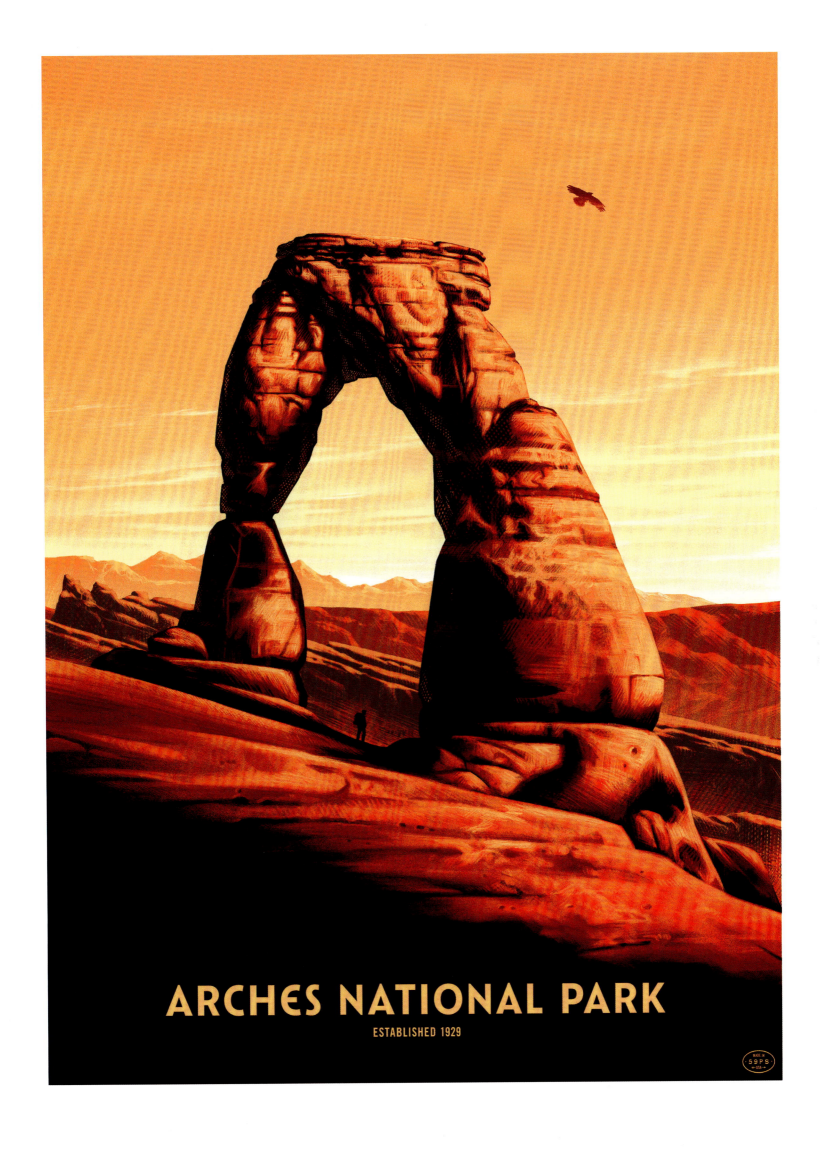

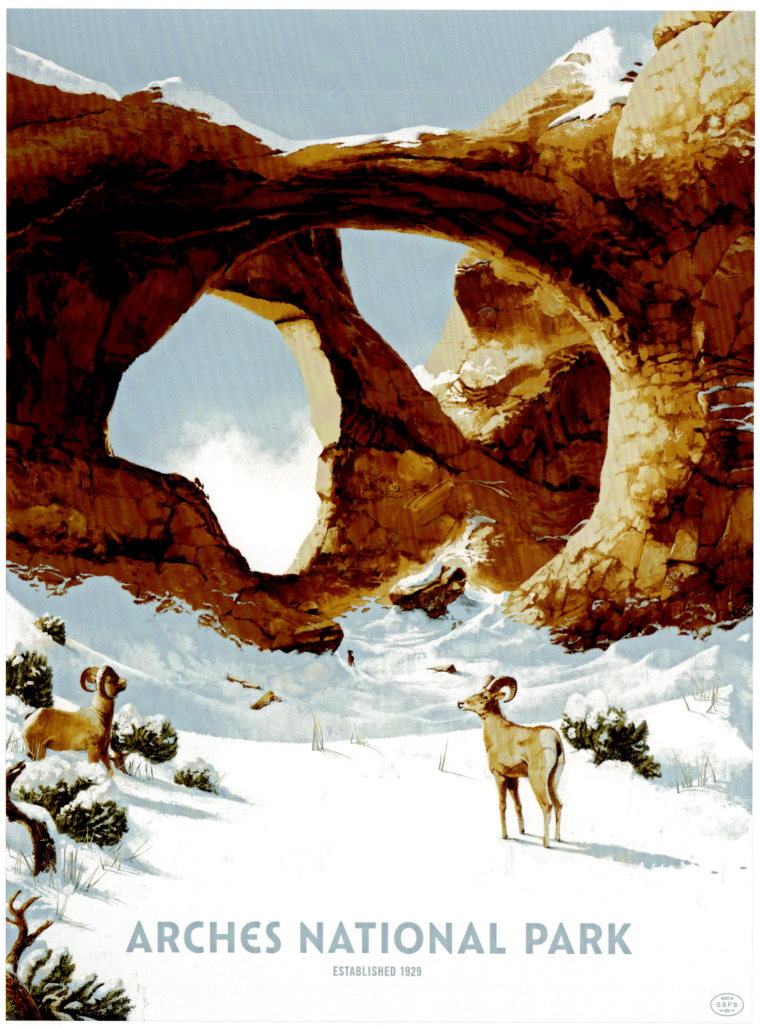

STATE: UTAH ARTIST: MARC ASPINALL

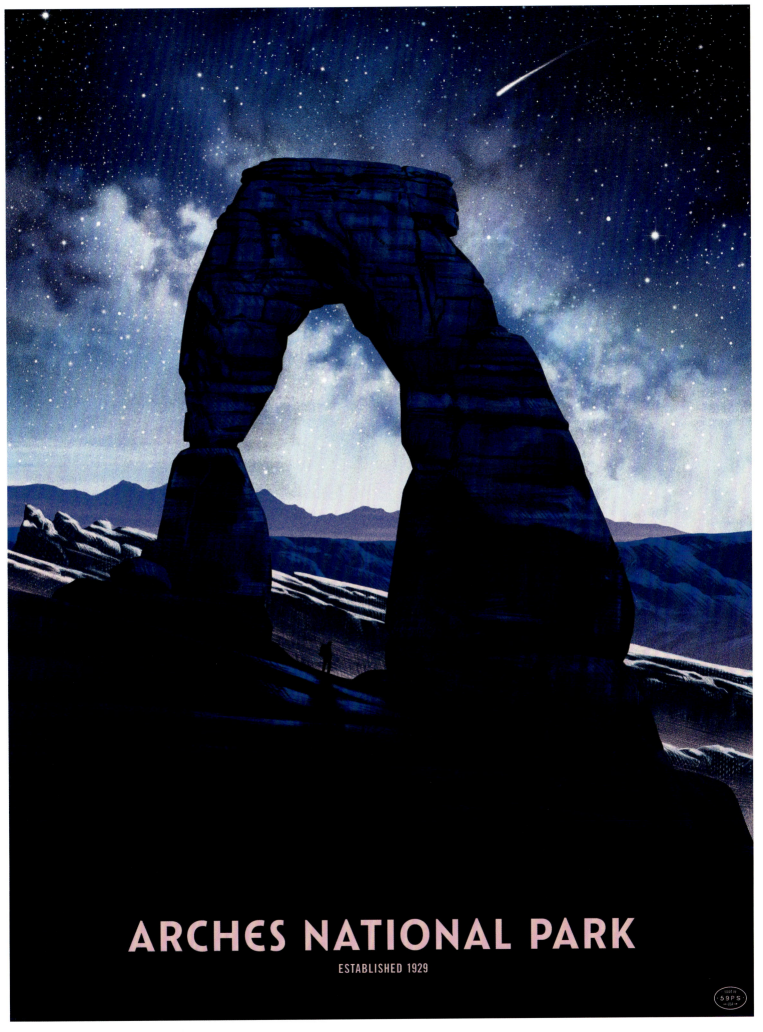

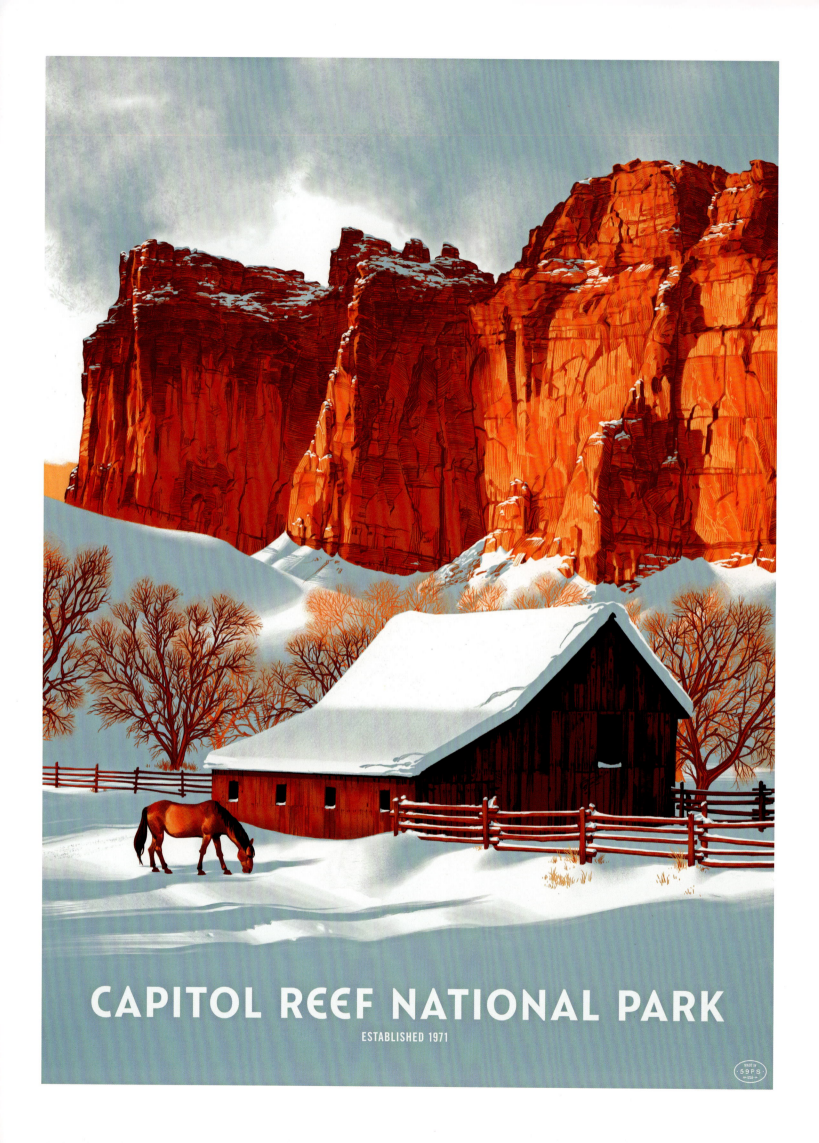

CAPITOL REEF NATIONAL PARK

Capitol Reef Waterpocket Fold the riveting signature of 70 million years.

—John Tiong Chunghoo

Named for the nautical term *reef*, meaning "barrier to passage," and for a natural dome which resembles the Capitol dome in Washington, DC, Capitol Reef National Park is a testament to nature's contrasting beauty. Greenery and gentle streams can be found alongside the towering canyons, monoliths, and ridges that make up the reef.

Fremont River and Pleasant Creek both run on the Waterpocket Fold. This defining feature of Capitol Reef is what's called a *monocline*: a wrinkle in the surface of the earth caused by a slight warping in the earth's crust. The Waterpocket Fold stretches one hundred miles long. Occurring along a fault line, the movement of the fault caused an upward shift that in turn caused the rock to slope over itself, creating a staircase-like formation.

The spires, canyons, and arches that decorate the park are the result of erosion. The park's natural arches are stunning. Cassidy Arch is a 400-foot-high behemoth, so perfect in shape that it looks man-made. The Gifford homestead, a restored farm built by early Mormon settlers, sits among the geological formations of the Waterpocket Fold, illustrating how people and the land can get along if they try.

- The Gifford homestead in Capitol Reef National Park still grows peaches, cherries, and apples yearly. For visitors, that means pie!

- Before it was called Capitol Reef, and before Franklin D. Roosevelt made it a national park, a businessman promoting the area called it Wayne's Wonderland.

- More than seventy-one species of mammal reside in the park, including bighorn sheep, gray foxes, and mountain lions.

- One of the most popular ways to experience the park is to explore the grounds on horseback.

- Hickman Bridge, one of several natural arches in the park, is 125 feet tall.

- Capitol Reef receives an average of eight inches of rainfall per year, making it more fertile for plants and wildlife than most deserts.

STATE: UTAH
ARTIST: CLAIRE HUMMEL

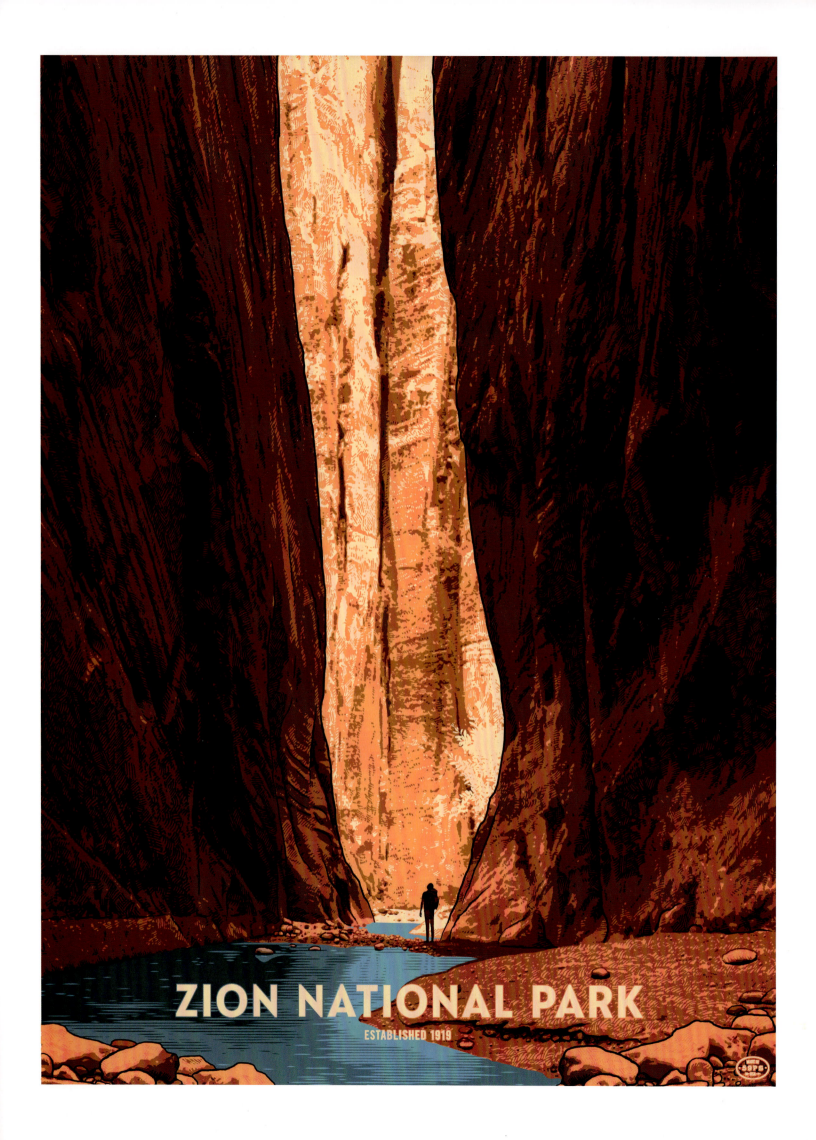

ZION NATIONAL PARK

A man can worship God among these great cathedrals as well as in any man-made church—this is Zion.

—Isaac Behunin

Early Mormon settlers were so enamored by these sandstone cliffs and valleys that they dubbed it Zion, a blessed land capable of bestowing a divine tranquility upon believers. In short, these are some gorgeous gorges. The park includes mesas, monoliths, buttes, arches, and slot canyons. The main gorges in the park, Zion Canyon and Kolob Canyon, were formed by sedimentation and erosion over 150 million years. Scenic drives along Mount Caramel Highway offer views of the canyons, but nothing compares to the view from within.

In the Narrows, the walls are so tight that they're barely wider than your outstretched arms. The trickle of water from the walls at Weeping Rock can be hypnotizing, and the canyon's jutting overhang contains lavish hanging gardens where flowing water vacillates from a slow drip to a gush depending on the season. Angels Landing is a grueling hike that rewards the tenacious with stunning views from the canyon's rim. Emerald Pools offers visitors the opportunity to stand behind a 110-foot-high double waterfall and look out at the pools below.

The park is uniquely situated at the intersection of the Mojave Desert, the Great Basin, and the Colorado Plateau, making Zion National Park a metropolis of animal life, including 289 different bird species and 79 species of mammal. Water often streams along the canyon floor, causing the echo of splashing footsteps to bounce back and forth off the cave walls. It's a reminder of the enormity that surrounds you and provides a healthy dose of perspective. It might even make you tremble in your wet socks.

- Zion Canyon was created in large part by the Virgin River, which eroded rock layers and carried away debris. River channels in the canyon are still being carved out.

- Kolob Arch in Zion Canyon is the sixth-largest freestanding arch in the world.

- Zion was originally made a national monument by President William Howard Taft in 1909. It was originally called Mukuntuweap National Monument.

- An area along the north fork of the Virgin River is dubbed the Subway because the rounded arc of the canyon walls resembles a subway tunnel.

- Desert bighorn sheep and California condors were once rare in the area but have since been reintroduced to the park's habitat.

STATE: UTAH
ARTIST: DAN MCCARTHY

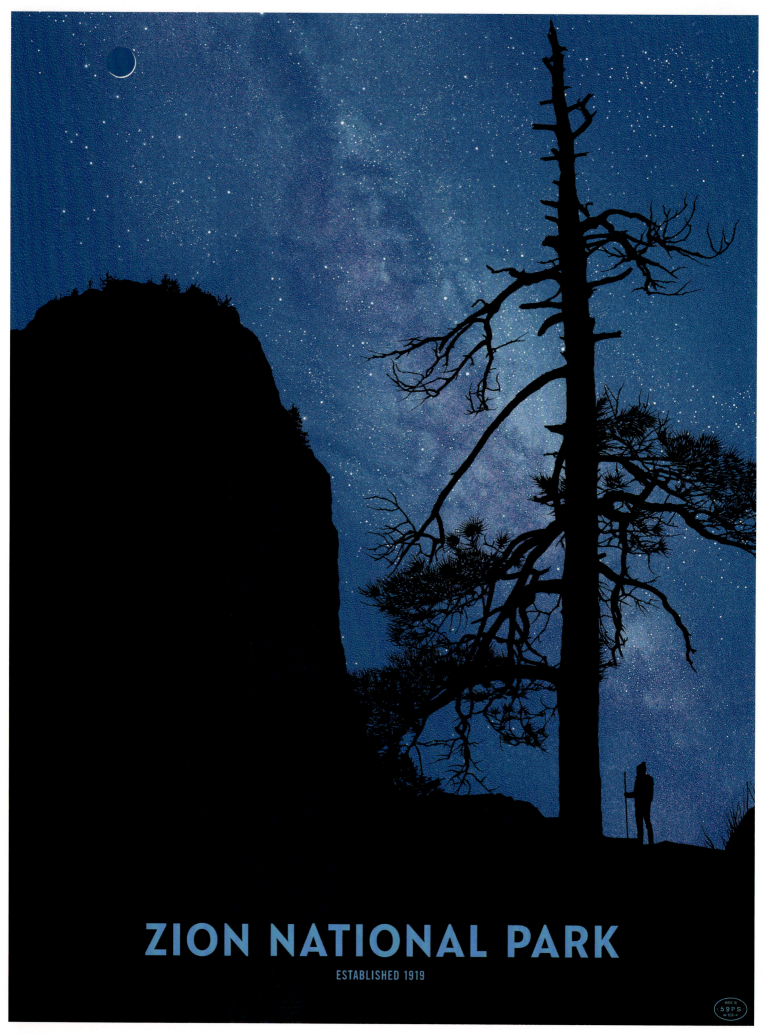

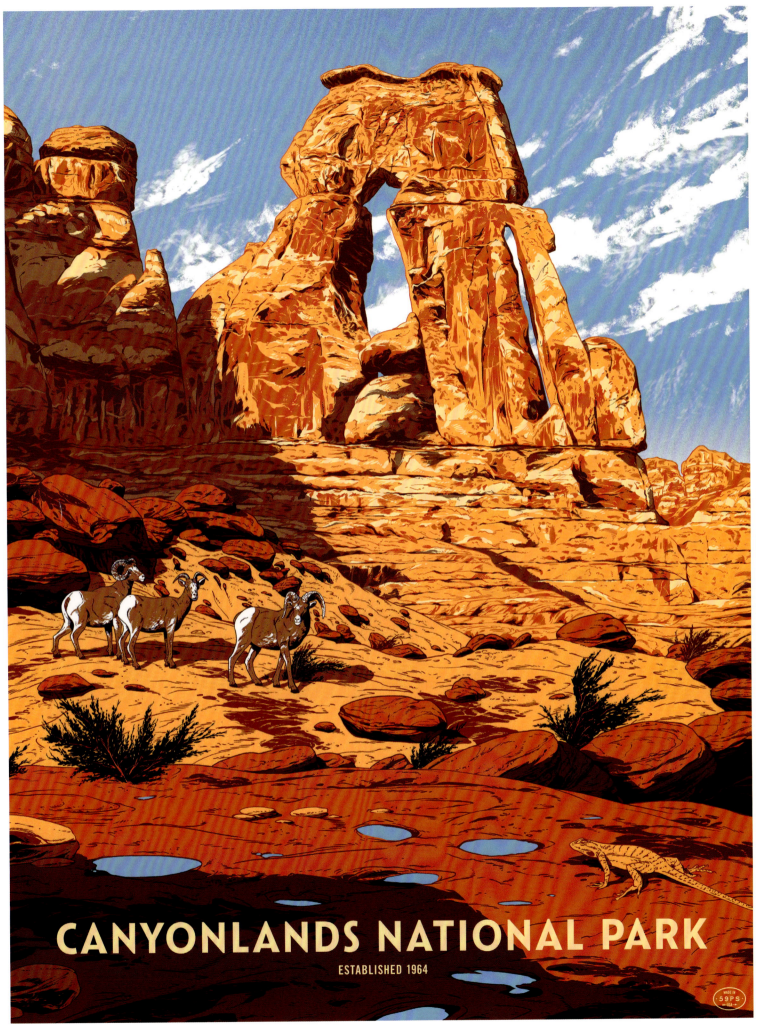

CANYONLANDS NATIONAL PARK

Desert dawn Rise up early, lift your song On the breath of life that rises from the Glowing stone Feel the rock of ages, smooth against your skin Smell the breath of flowers dancing on the wind Dancing on the Wind

—Aron Ralston

Southern Utah is rich with natural canyons preserved within national parks, but the sheer variety of geological formations at Canyonlands National Park makes it especially crucial to see for any aficionado. The Colorado River, the Green River, and their respective tributaries eroded the canyons, mesas, and buttes that make up this gigantic 337,598-acre park.

The largest national park in Utah, Canyonlands is separated into four distinct districts. The first, known as the Island in the Sky, sits on top of a 1,500-foot mesa and gives visitors a panoramic view of the canyons. Overcast days can make the mesa appear as if it's floating just above the cloud layer. Here you can find the famous Mesa Arch, which looks like a fossilized rainbow perched along the cliffside. The second Canyonlands district, the Needles, offers more of a backcountry experience, including day-long hikes replete with the technicolor spires that gave the district its name. Pothole Point features a short hike over slickrock to a large community of natural potholes filled with water. Or you could head to Cave Spring, a preserved cowboy camp complete with prehistoric rock paintings. The third district, the Maze, is harder to access but rewards visitors with the historic Horseshoe Canyon, home to pictographs and petroglyphs dating from as far back as 9000 BC. The park's final district offers access to the Green and Colorado Rivers. Canyonlands is a choose-your-own adventure that offers something to astound every type of explorer.

- Canyonlands National Park is gigantic. At 337,598 acres, it's the size of 225,756 football fields.

- The infamous scene at the end of the 1991 film Thelma and Louise was filmed in the Colorado River section of the Canyonlands.

- The film 127 Hours was also filmed in Canyonlands National Park. The film was based on the real-life experiences of Aron Ralston, who was hiking in the Maze when he found himself pinned to the canyon wall by a loose boulder. He was trapped for five days and ultimately broke free by amputating his own arm.

- Upheaval Dome, a deformed crater in the Island in the Sky, has fascinated geologists for ages. While some believe the crater was formed by the evaporation of landlocked seas, others believe it was made by the impact of a meteorite.

- The mysterious monolith of 2020 that went viral on social media was discovered just outside the confines of Canyonlands National Park.

STATE: UTAH
ARTIST: DAN MCCARTHY

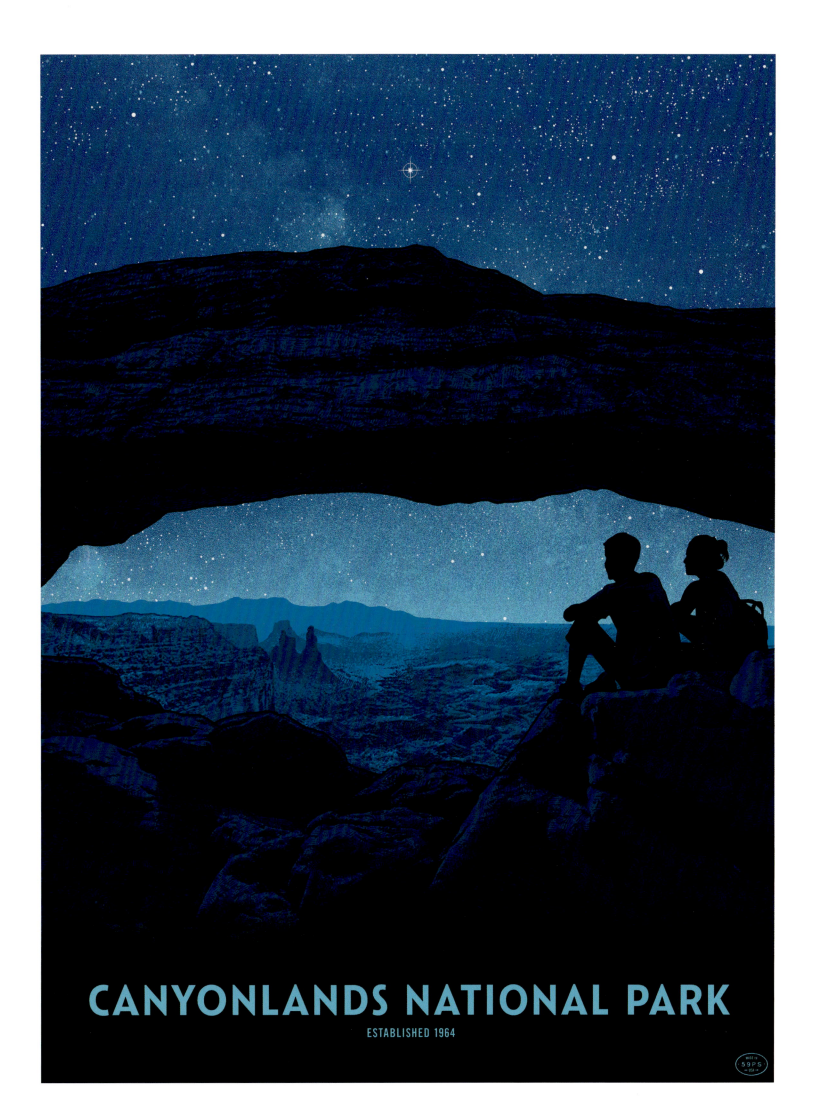

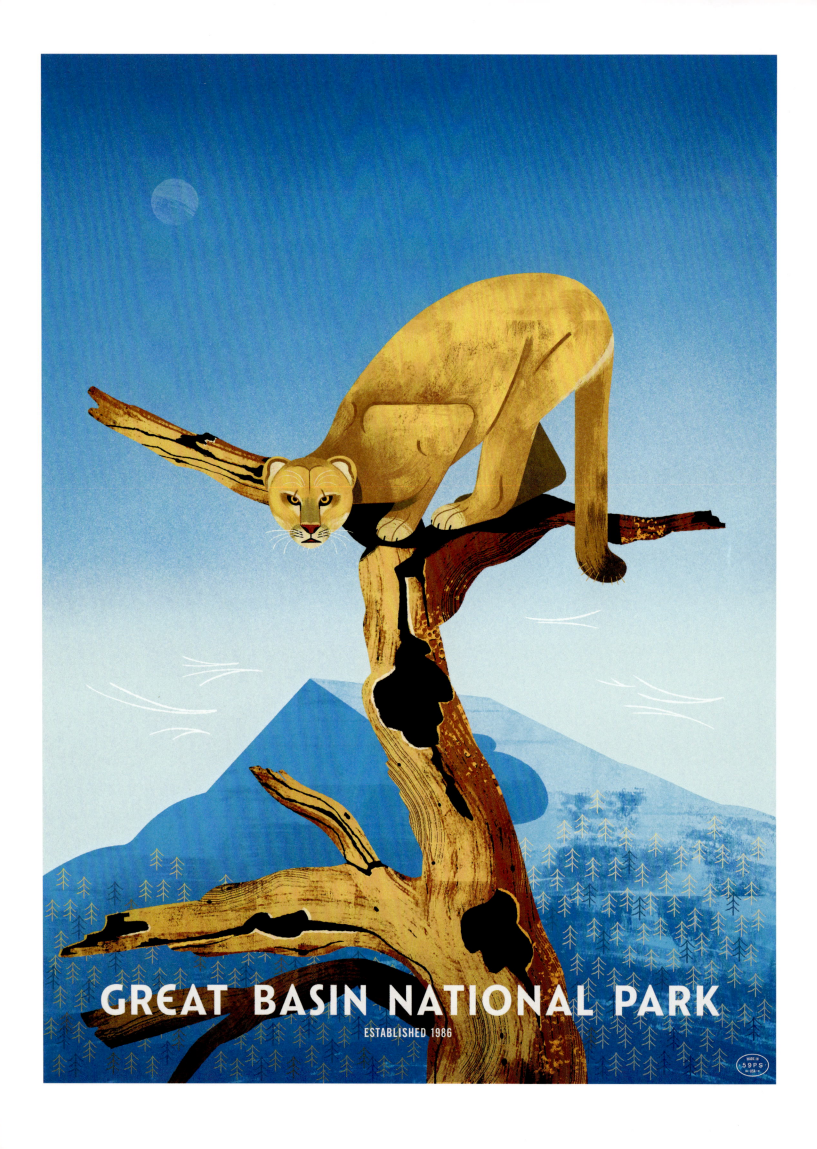

GREAT BASIN NATIONAL PARK

...here distances disturb desire to deliver a collision of breaths the desert echoes in this dark night sky stars reveal the ways heart can light a world.

—Nathalie Handal

The Basin and Range Province is a colossal series of faulted mountains, valleys, and basins that stretches over most of the western United States and into Mexico. Located in eastern Nevada along the Utah border, Great Basin National Park protects 77,000 acres of multifarious desert landscape bordered by soaring mountain ranges. The surrounding mountains can cause the temperature to fall well below freezing, resulting in a thin sheet of ice over a core of desert tundra.

The park offers an array of terrain ranging from dry desert sagebrush, saltbush, and juniper to towering aspen and pine trees. The arid desert brush is dotted with islands of deep green. At 13,063 feet high, Wheeler Peak is the second-highest mountain peak in Nevada, making it a great vantage point from which to view the patchwork landscape, even if sly North American cougars and bobcats patrol these rugged slopes.

At the base of Wheeler Peak is one of the world's southernmost glaciers. The 120,000-square-foot glacier is encased in rock and debris and contains a wealth of minerals such as marble, sandstone, and shale. Lehman Caves, a series of underground passageways formed hundreds of millions of years ago, also rests at the base of Wheeler Peak. These long and winding caves are studded with stalactites, helicities, and draperies in rooms as large as ninety feet wide. Great Basin National Park creates high contrasts: plateaus among clouds and arenas in the depths, both waiting to be marveled at and explored.

- Some of the oldest trees in the world live in this desert. The Great Basin bristlecone pine can survive up to 4,000 years.

- The oldest Great Basin bristlecone pine in the park was dubbed "Prometheus" and cut down for research. It was believed to be 4,862 years old.

- The Great Basin night skies are some of the darkest in the United States.

- The annual Great Basin Astronomy Festival takes place over three days in September.

- Only about 115,000 people visit the park each year, in part because it's so remote.

STATE: NEVADA
ARTIST: MARIE THORHAUGE

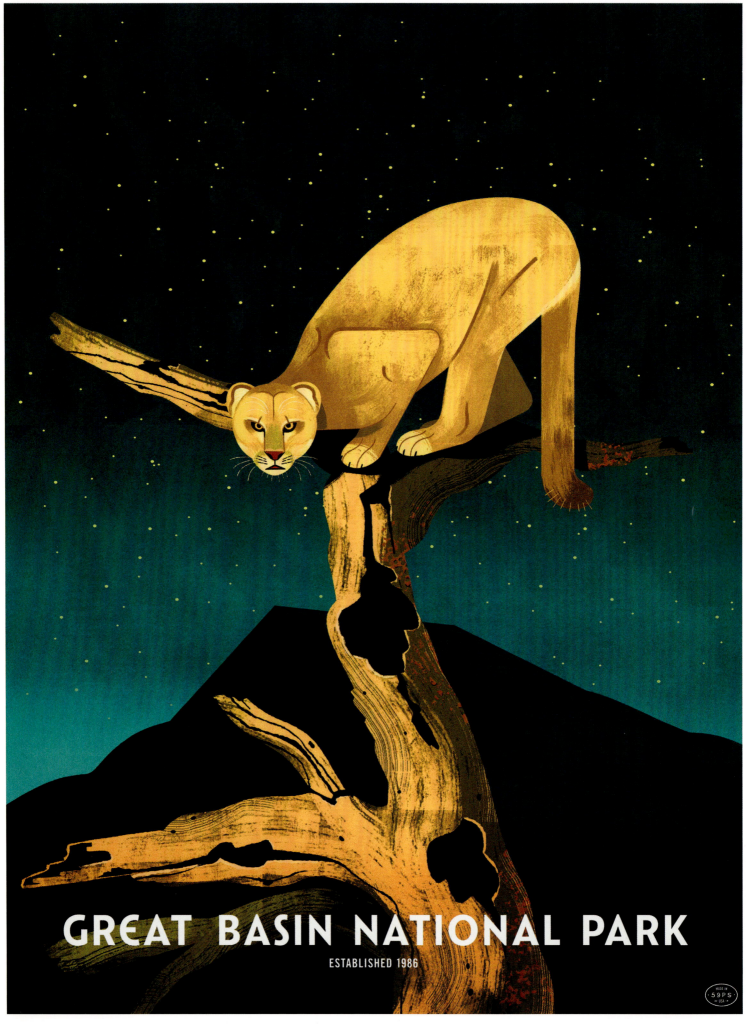

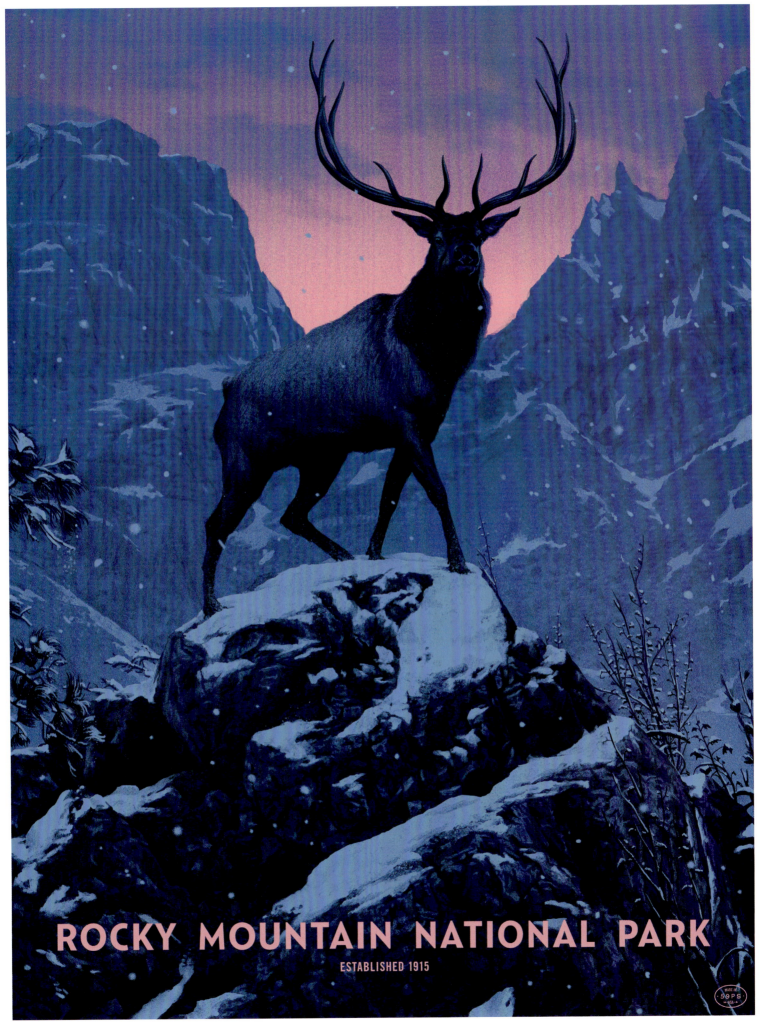

THE
NORTHWEST

MOUNT RAINIER NATIONAL PARK

This is what we see when we look up at Rainier, the beauty, the horror, the awe the unbelievability of size that confirms our own consequence on this earth.

—Bruce Barcott

Mount Rainier is a colossal, snow-drizzled behemoth of a mountain in western Washington State. Much of the area that surrounds it is lush and enchanted, with babbling brooks around every turn. Layered waterfalls trickle down the sides of mountains, coming to rest in subalpine meadows. In the section of the park known as Paradise, a collection of billowing hills hosts a profusion of efflorescent violet and red wildflowers. Ohanapecosh, in the southeast corner of the park, comprises acres of old-growth hemlock and cedar forests. The Ohanapecosh River runs alongside a section of forest known as the Grove of the Patriarchs, where towering trees can be seen from a suspension bridge that dangles above the water.

In the northwest, the Carbon area features a temperate rainforest. Nearby Mowich Lake sits inside the basin of Carbon Glacier, which is one of many glaciers stacked upon the giant mountain at the park's center. Reflection lakes like the one at Sunrise Point provide a perfect mirror of Mount Rainier in all its majesty. The park's idyllic beauty is almost enough to make visitors forget that Mount Rainier is actually an active stratovolcano. Its close proximity to Tacoma and other populated areas makes Mount Rainier one of the most dangerous volcanoes in the world. In fact, scientists believe that the volcano is due for an eruption soon. Nevertheless, as many as two million people come to enjoy the park annually, reveling in its gorgeous mountain setting for as long as nature allows.

- Mount Rainier's last eruption was in November to December of 1894; this eruption caused it to lose 1,500 feet in height.

- Mount Rainier has more glaciers than any other mountain in the contiguous United States.

- There are twenty-five named glaciers on Mount Rainier.

- Emmons Glacier, on the northeast flank of Mount Rainier, is the largest glacier in the contiguous United States.

- At 14,411 feet tall, Mount Rainier is the highest peak in the Cascade Range.

STATE: WASHINGTON
ARTIST: GLENN THOMAS

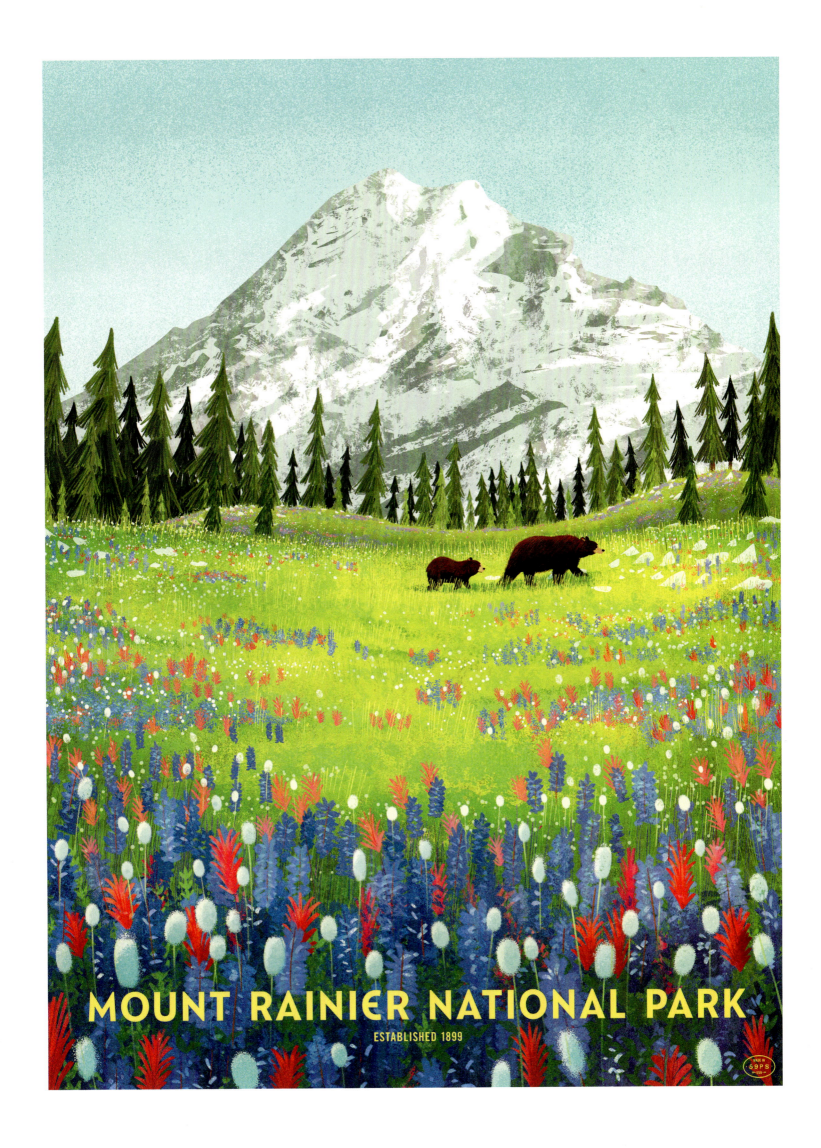

NORTH CASCADES NATIONAL PARK

The Pacific Northwest pines were shrouded in clouds; and further beyond were peak tops with clouds going right through them and then fitfully the sun would shine through. It was the work of the quiet mountains, this torrent of purity at my feet.

—*Jack Kerouac*

North Cascades National Park is just a three-hour drive from Seattle. Nowhere else can you find such vast, desolate wilderness so close to civilization. Here, mountains and glaciers surround the over 500,000 acres of preserved wilderness. There are few man-made structures or roads. Peaks tower to over 9,000 feet. More than half the glaciers in the contiguous United States can be found right here at the intersection of Skagit, Chelan, and Whatcom Counties in Washington. It's no wonder that famed Beat author Jack Kerouac escaped to this wilderness on his quest for a Zen state of mind.

At one end of the park, you'll find yourself in the snowiest place in the United States, where mountain tops wear a shawl of powder year round. Elsewhere, visitors can marvel at a menagerie of waterfalls, from roaring waves of whitewater to trickling ribbons of turquoise. The sound of chirping birds and babbling rivers and streams creates a feeling of deep tranquility, even if the surrounding mountains have names like Mount Terror, Poltergeist Pinnacle, and Ghost Peak. You come here to hike, bike, and climb. You come here for peace, and peace of mind.

- Mount Goode boasts the highest peak in North Cascades National Park at 9,206 feet.

- The peaks in North Cascades National Park are known for their quirky names, including Mount Despair, Desolation Peak, and Mount Terror.

- Mountain goats are regular sights on the peaks of the North Cascade Mountains. Wolves, wolverines, pikas, moose, grizzly bears, and coyotes are also common.

- Because their tops are routinely covered in snow, the North Cascade Mountains are often referred to as the American Alps.

- There are over 300 glaciers in North Cascades National Park.

STATE: WASHINGTON
ARTIST: BENJAMIN FLOUW

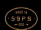

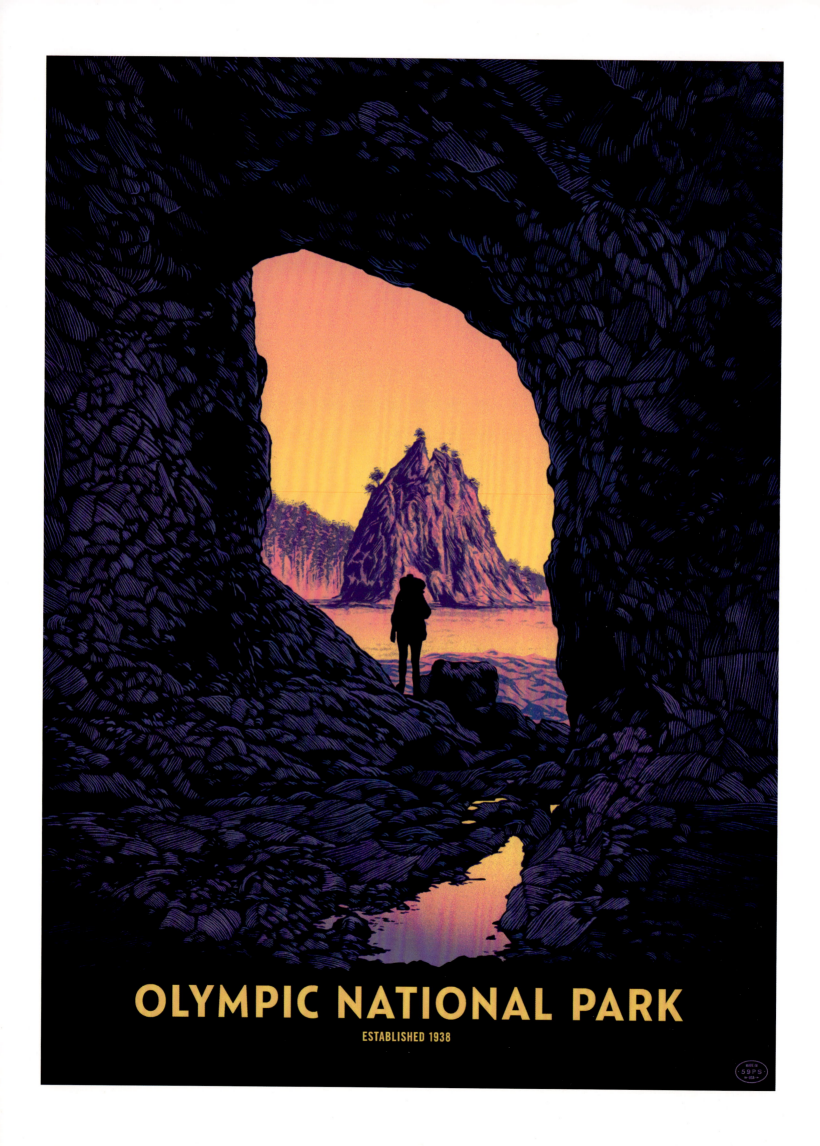

OLYMPIC NATIONAL PARK

If that be not the home where dwell the Gods, it is beautiful enough to be, and I therefore call it Mount Olympus.

—John Meares

Located in the northwest corner of Washington State, Olympic National Park encompasses nearly a million acres, including the transcendent Olympic Mountains. It's a park so big that it is often experienced as three separate distinct locales.

The coastal area of the park is Ruby Beach, a stretch of wild shoreline flanked by sea stacks that break up the waves. The glaciated mountains at the park's center include the Olympic Mountains. Because of frequent snow, the Olympic Mountains are the most glaciated nonvolcanic mountains in the contiguous United States. Mount Deception is the highest peak in the Olympic Mountain range, rising to 7,788 feet. These may not be the tallest mountains in the country, but they are still vast and imposing.

The western side of the park houses a temperate rainforest. Receiving up to twelve feet of rain per year, the area is the wettest in the contiguous United States. The combined wetness from the rainfall and the cold temperatures of the Pacific Northwest make Olympic's rainforest uniquely coniferous, filled with spruce, hemlock, and cedar trees that rise up to 300 feet tall and are often coated in coils of dripping moss. The forest floor breaks out in wildflowers wherever the sun penetrates the canopy. Everyone from snowboarders to mountaineers visits Olympic National Park to experience the challenge of the elements.

- In 2019, Olympic National Park had 3.2 million visitors. It is regularly one of the most visited national parks in the country.

- Ruby Beach is known for its tide pools, where waves wash up myriad creatures on the shore, including anemones and brightly colored starfish.

- Whales are often spotted feeding at the mouths of the Hoh and Quillayute Rivers or migrating along the park's shores.

- The forest floor of the park is known for a profusion of so-called banana slugs. These bright-yellow, slimy slugs are an important component of the park's ecosystem.

- Hurricane Ridge, one of the most popular destinations in the park, is the perfect place to gaze at the Milky Way.

STATE: WASHINGTON
ARTIST: DANIEL DANGER

CRATER LAKE NATIONAL PARK

The sight of it fills one with more conflicting emotions than any other scene with which I am familiar. It is at once weird, fascinating, enchanting, repellent, of exquisite beauty, and at times terrifying in its austere-dignity and oppressing stillness.

—*Jack London*

Located in southwest Oregon, Crater Lake National Park is a caldera formed by the eruption of the now-defunct volcano Mount Mazama. Visitors can take in stunning views of the lake by driving around the park's rim, but for a closer look, make the steep 1.1-mile hike down Cleetwood Cove Trail. At 1,949 feet deep, this is the deepest lake in the United States. Swimming is permitted, and if you're feeling brave, you can even choose to enter the water by jumping from the thirty-five-foot cliff at the end of Cleetwood Cove Trail. Crater Lake is a striking shade of cobalt blue. This unusual color is due to the fact that the lake's water comes entirely from rain and snow, with no inlets from any other water source. As a result, Crater Lake is one of the clearest and cleanest lakes in the world.

In addition to the lake, the park offers visitors forty caves and ten waterfalls to explore, including the popular Plaikni Falls, which rushes down from the high slopes of Mount Mazama. The park also features a host of volcanic phenomena, most notably the "pumice desert," 3,055 acres of arid land that has seen almost no growth for thousands of years due to the thick layer of ash left by Mazama's eruption. Hikes through the 50,000 acres of old-growth forest offer remarkable views of the lake and mountains, revealing the natural, stark beauty of Crater Lake National Park, where the once violent, now cold earth hides its ancient secrets.

- Established in 1902, Crater Lake is the fifth-oldest national park in the United States.

- Crater Lake is the deepest lake in the Unites States and the ninth-deepest lake in the world.

- Crater Lake is one of the snowiest places in the country, receiving an average of forty-three feet of snow per year.

- Winter in the park lasts through April, and the park remains covered in snow through June.

- The park is home to a wide variety of mammals, including bobcats, foxes, coyotes, badgers, and Canadian lynx.

STATE: OREGON
ARTIST: DAN MCCARTHY

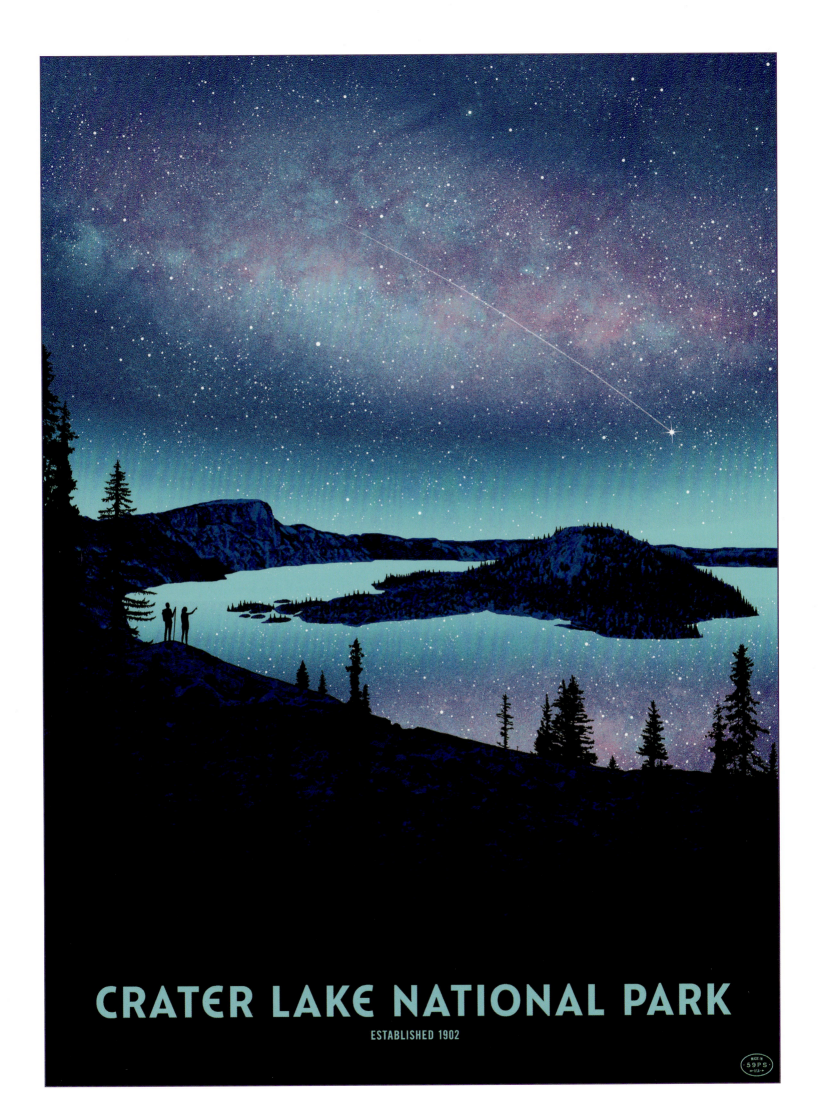

DENALI NATIONAL PARK

Alaska has long been a magnet for dreamers and misfits, people who think the unsullied enormity of the Last Frontier will patch all the holes in their lives. The bush is an unforgiving place, however, that cares nothing for hope or longing.

—Jon Krakauer

If you feel like you are on top of the world in Denali National Park, it's likely because you're visiting one of the highest points in the United States. Nothing here is easy. Trails are few and far between. The rivers and lakes aren't bridged over. The mountains are treacherous; the glaciers are slippery; and even the bushes will fight your progress. Everything in Alaska is gigantic: The park alone is larger than the entire state of New Hampshire.

There's only one way into this ice kingdom: a ninety-one-mile-long road, most of which is braved exclusively by Park Service shuttles. Once inside the park, mossy boreal forests are the first ecosystem to greet you. These forests include black spruce, white spruce, birch, and aspen trees, all looming in the shadow of the Arctic range. Bursting orange lichens thrive on the tree bark provided by lakeside forests. In the lush tundra, you may spot Dall sheep perching on the overlooks and crags of the surrounding mountains. You might also catch a glimpse of one of the 350 grizzly bears who call the park home. During autumn, the thousands of caribou that make up the Denali herd graze in the open tundra.

At the sled dog kennels, you'll meet the brave mushers who help the park rangers police the premises. In the depths of the park, Wonder Lake is a serene glacial lake that reflects the Arctic range in its rippled surface. Long winter nights in Denali offer stunning views of the aurora borealis, just one of the many rewards for striking out into the great unknown. Despite the attendant hardships, the effort you put into your adventure here in Denali will repay you with untold dividends.

- Denali's highest peak stands 20,320 feet above sea level.

- Denali was originally named Mount McKinley after William McKinley, the twenty-fifth president (then a presidential nominee). The name was coined by a frontiersman who arrived in Alaska in 1896 as part of the gold rush.

- In 2015, the name of the mountain was changed to Denali by President Barack Obama.

- The word denali means "the high one" in the language of the Athabaskan people, who are native to the region. They have always called the mountain Denali.

- Christopher McCandless, whose fateful journey was portrayed in the film Into the Wild, settled in the park near an abandoned bus along Stampede Trail.

STATE: ALASKA
ARTIST: DAN MCCARTHY

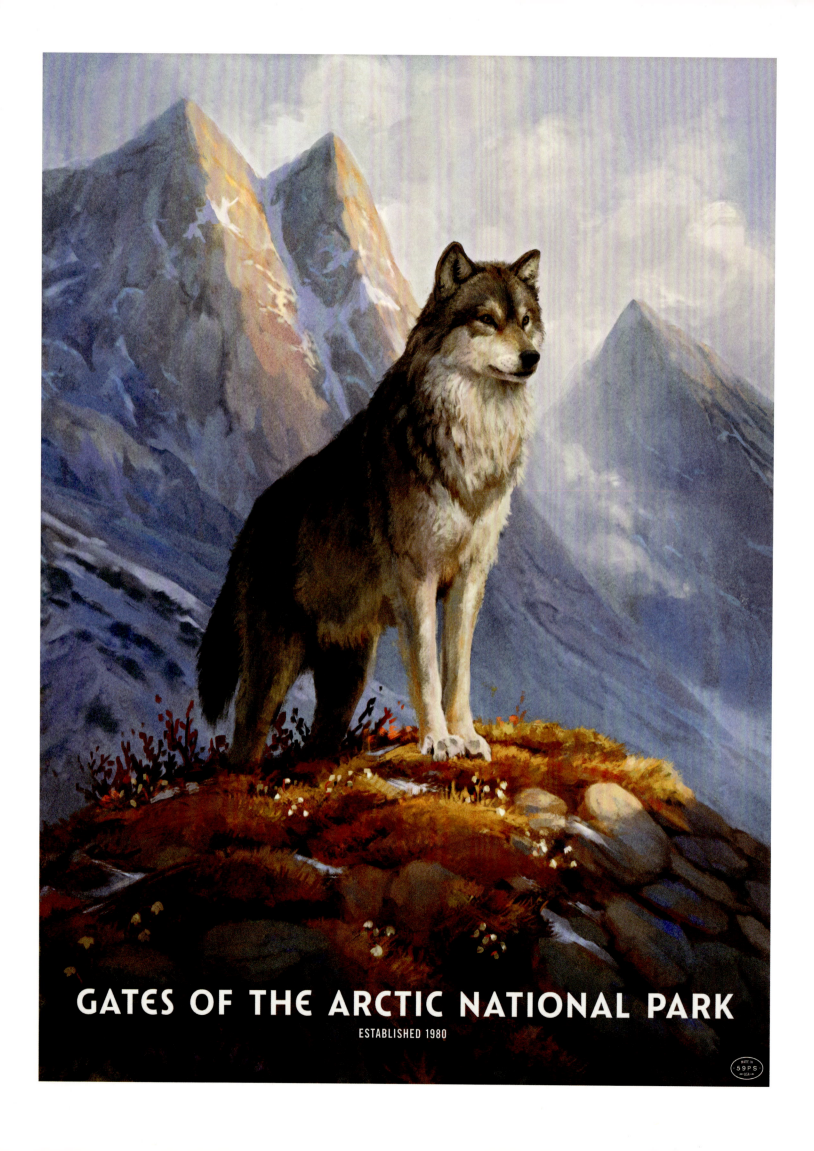

GATES OF THE ARCTIC NATIONAL PARK

From the hilltop, we saw rank after rank of shelved and peaked hills, little lakes and streams, all gold and green, a quiet empty land seeming to speak mutely of the lonely but seeking lives lived there in other times.

—Margaret Murie

Gates of the Arctic National Park is not a place you might discover by accident or visit on a whim. This is the most remote park in the country, stationed far above the Arctic Circle. Gates of the Arctic National Park is located in the Brooks Range of northern Alaska and includes 8.4 million acres of snow-blasted mountains, undulating sand dunes, and forests teeming with life. Here, grizzly bears storing up for the winter pluck dog salmon right from the dashing streams. During the unforgiving bleakness of winter, Dall sheep patrol the mountain ridges, looking to graze. Gray wolves trek through the snow, hunting and howling in packs. Pristine white polar bears wrestle each other to pass the time between feasts.

During the winter months, the Gates of the Arctic is one of the coldest places in the country. Despite this, the once nearly extinct musk ox now thrives in the park; sporting the longest fur of any living mammal, the musk ox's ultra-warm mane provides the perfect padding for the bitter cold. During the spring, meltwaters flood the plains, and caribou migrate here by the thousands. Like the caribou, human visitors don't arrive in the park by accident, but the journey is worth it if you are up to the challenge.

- Gates of the Arctic National Park is larger than the state of Maryland.

- Gates of the Arctic has no roads or trails.

- The park also has very few visitors. In 2014, only 12,660 people entered the park. More people visit the Grand Canyon in a single day than visit Gates of the Arctic in a full year.

- The lowest elevation in Gates of the Arctic is 280 feet, at the Kobuk River.

- Gates of the Arctic National Park is home to six rivers: the John River, Kobuk River, Tinayguk River, Noatak River, Alatna River, and the North Fork of the Koyukuk River.

STATE: ALASKA
ARTIST: LEESHA HANNIGAN

GLACIER BAY NATIONAL PARK

Glacier Bay offered a clarity more profound than any book; an original text, a reminder that our language evolved as we moved away from places like this, not into them.

—*Kim Heacox*

Glacier Bay National Park and Preserve is a massive display of raw and unfettered wilderness still engulfed by the ice that once covered the globe. Located in the islands of the Alexander Archipelago in southeast Alaska, Glacier Bay showcases the beauty of Alaska's mountains, fjords, and glaciers while simultaneously offering profound insight into our distant past.

The slow retreat of a 4,000-foot-thick glacier left behind a nearly seventy-mile-long cerulean bay with palatial glaciers still looming. Over time, new forests were born, and a profusion of spruce and hemlock trees painted the land in myriad hues of dark green. Sea lions lounge on the stony shores exposed by the glacier's retreat. Bears, lynx, and wolverines now call the park's inlets and islands home, but it is the many species of whales that frolic in the bay that draw nature lovers. Humpback and killer whales ascend from the depths, twisting above the surface for air before diving back into the Arctic sea.

- Glacier Bay National Park and Preserve currently has 1,045 remaining glaciers.

- The large glacier that once covered the entirety of the park has retreated sixty-five miles over the last 200 years.

- Humans are believed to have lived in the area as far back as 10,000 years ago.

- The first non-native person to explore the area was Captain George Vancouver in 1794. At the time, the area was locked together by a large glacier.

- John Muir was the next explorer to arrive in Glacier Bay—eighty-five years later. By that time, the glacier had melted significantly.

STATE: ALASKA
ARTIST: OLIVER BARRETT

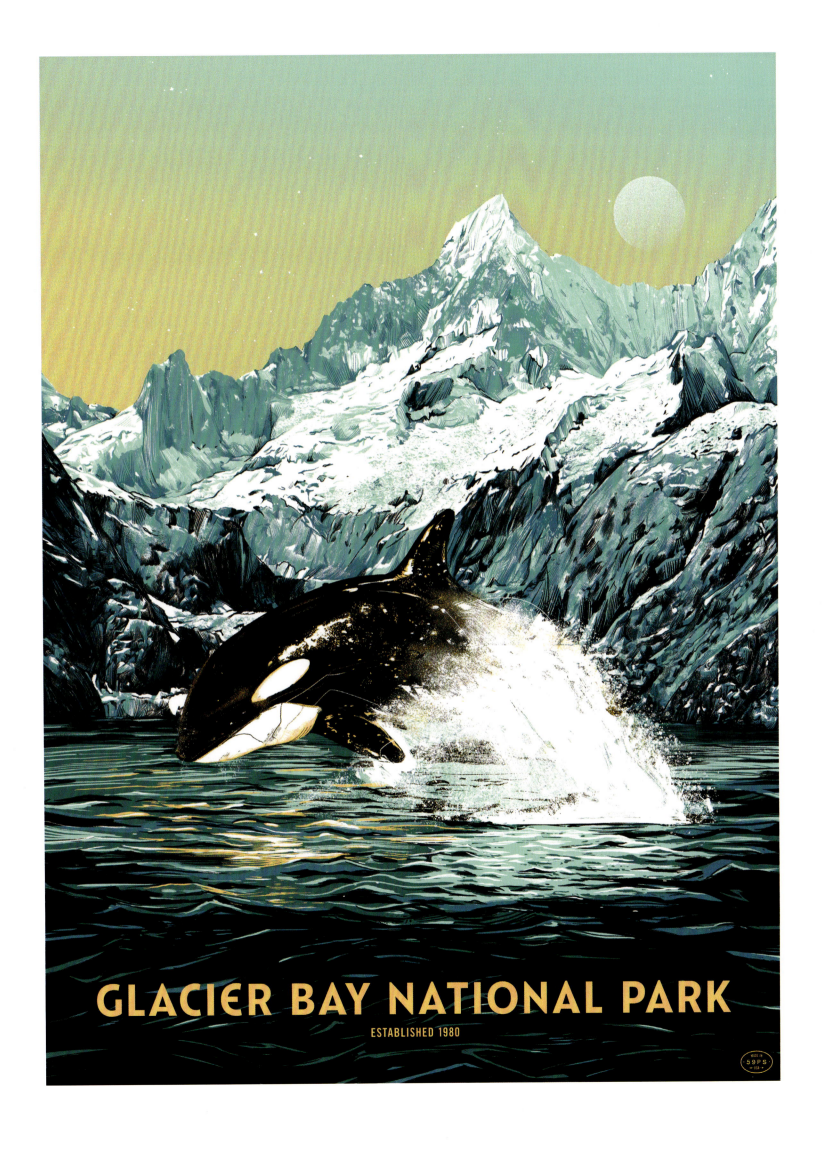

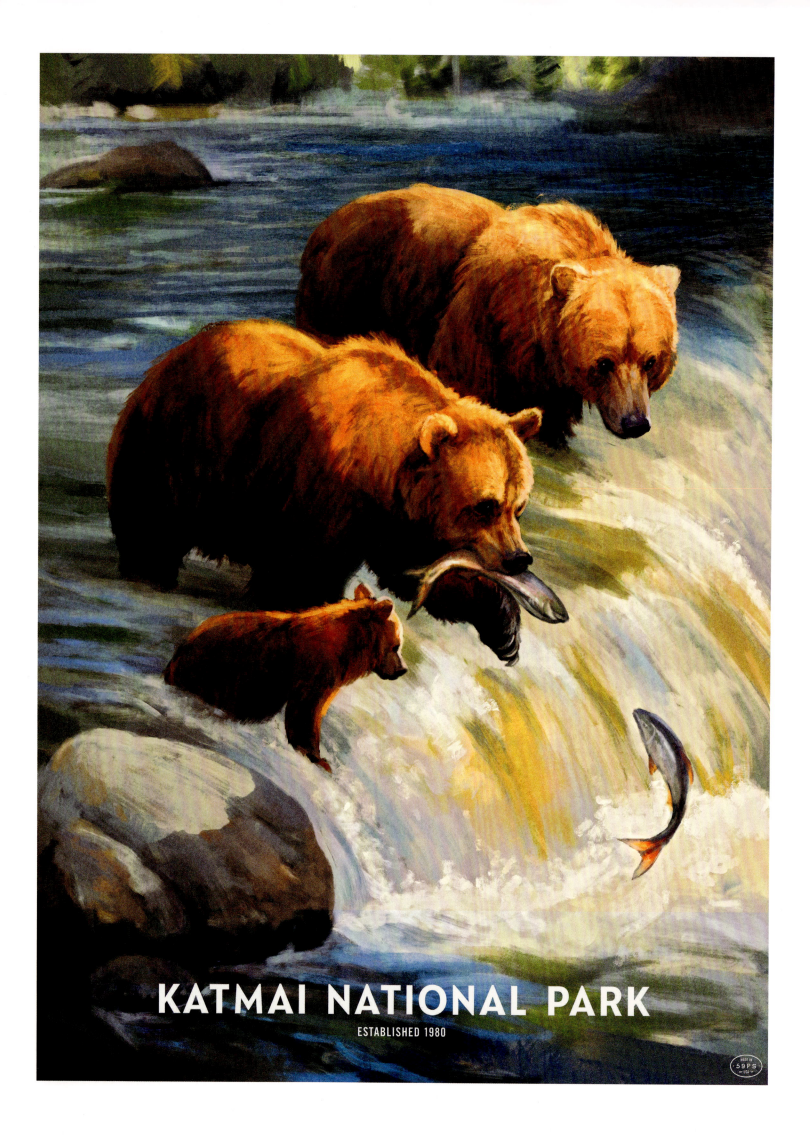

KATMAI NATIONAL PARK

Katmai National Monument is first of all a wilderness landscape, a place where the imprint of wildlife is greater than that of people, where clear lakes and rivers abound, where nearly two hundred miles of coastline bear little sign of man, and where steaming volcanoes rise above the entire scene.

—Gilbert Blinn

At the base of Alaska's southern peninsula, 200 miles from Anchorage, is a wilderness preserve larger than Connecticut. The soil here was once fertile with verdant foliage and bustling wildlife. Then, in 1912, a volcano erupted. This wasn't just any volcanic eruption: The eruption of Novarupta was the largest of the twentieth century, releasing thirty times the magma of Mount St. Helens. Ash, pumice, and rock blanketed the surrounding valley and was flung as far away as Texas. The surrounding valley was completely pummeled with volcanic ash and became known as the Valley of Ten Thousand Smokes. The name comes from the fumaroles that formed when steam captured underground erupted from small openings along dried-up riverbeds. The valley was so gaseous in the aftermath of Novarupta's explosion that scientists *and their dogs* had to wear gas masks to survey the area.

Today, life continues to reclaim the land, and the park is safe for tourists to explore. Fjords and bays now surround the valleys, and cerulean lakes glimmer in the shadow of the surrounding mountains. Cabins offer shelter to visitors who make the journey out to Katmai to kayak and fish. The biggest attraction comes in mid-July, when people gather at the multilevel Brooks Falls to watch brown bears snatch sockeyes right out of the river with their teeth. With over 2,000 brown bears in the park, Katmai has become the nation's premier bear-watching locale. Fortunately, the bears, accustomed to the presence of humans, are too focused on filling their bellies to worry about spectators.

- Sockeye salmon clear the inclines at Brooks Falls by leaping out of the water. This provides the perfect opportunity for brown bears to try and catch them.

- There are more brown bears in Katmai National Park than there are people living on the Alaska Peninsula.

- Katmai's glaciers, known as the Knife Creek Glaciers, are covered with more than six feet of ash.

- The explosion of Novarupta on Mount Katmai left a caldera 2,000 feet deep.

- Katmai hosts a cornucopia of wildlife, including Dall sheep, otters, coyotes, wolverines, lynx, and caribou.

STATE: ALASKA
ARTIST: LEESHA HANNIGAN

KENAI FJORDS NATIONAL PARK

Here skies are clearer and deeper and, for the greater wonders they reveal, a thousand times more eloquent of the eternal mystery than those of softer lands.

—*Rockwell Kent*

Located at the base of Alaska's southern peninsula, northeast of Katmai, Kenai is a blinding white expanse of ice and ocean. Forty glaciers carve out the park's serrated coastline. Melting snow on the cliffs creates a constant sheen of crystal-clear water and a haze of smoke that floats like a halo around the park. The wilderness of Kenai Peninsula is lush and green, with conifers adorning the slopes. Southern Alaska was once blanketed with icefields, and the remains of this bygone era are on display at the Harding Icefield, where 700 miles of thick ice still form a crust of jagged spikes along the surface.

Hiking trails in Kenai Fjords National Park provide up close encounters with ice rivers and glaciers. In the nearby town of Seward in Resurrection Bay, boat trips to the nearest fjord showcase downpours of cracking boulders of ice as they fall from the shrinking tidewater glaciers into the sea. The ice floes also make the fjords a haven for seals. Sea lions gather and lounge on the small islands of the area. A visit to Kenai Fjords National Park is an integral experience for anyone wanting to comprehend the delicate interplay between our mountains, glaciers, and the ocean.

- Alaska is home to the world's largest population of puffins, many of whom reside in Kenai Fjords National Park.

- Tidewater glaciers flow from land to sea, cutting off beneath the water's surface. Kenai Fjords National Park has five tidewater glaciers.

- The sea around Kenai Fjords National Park is home to many species of whales, including orcas, fin whales, minke whales, and humpback whales.

- The park is organized into three sections: wilderness (the icefield), backcountry (the fjords), and the front country (the exit glacier).

- At more than fourteen miles long, Bear Glacier, an outlet of the Harding Icefield, is the largest glacier in Kenai.

STATE: ALASKA
ARTIST: MATTHEW WOODSON

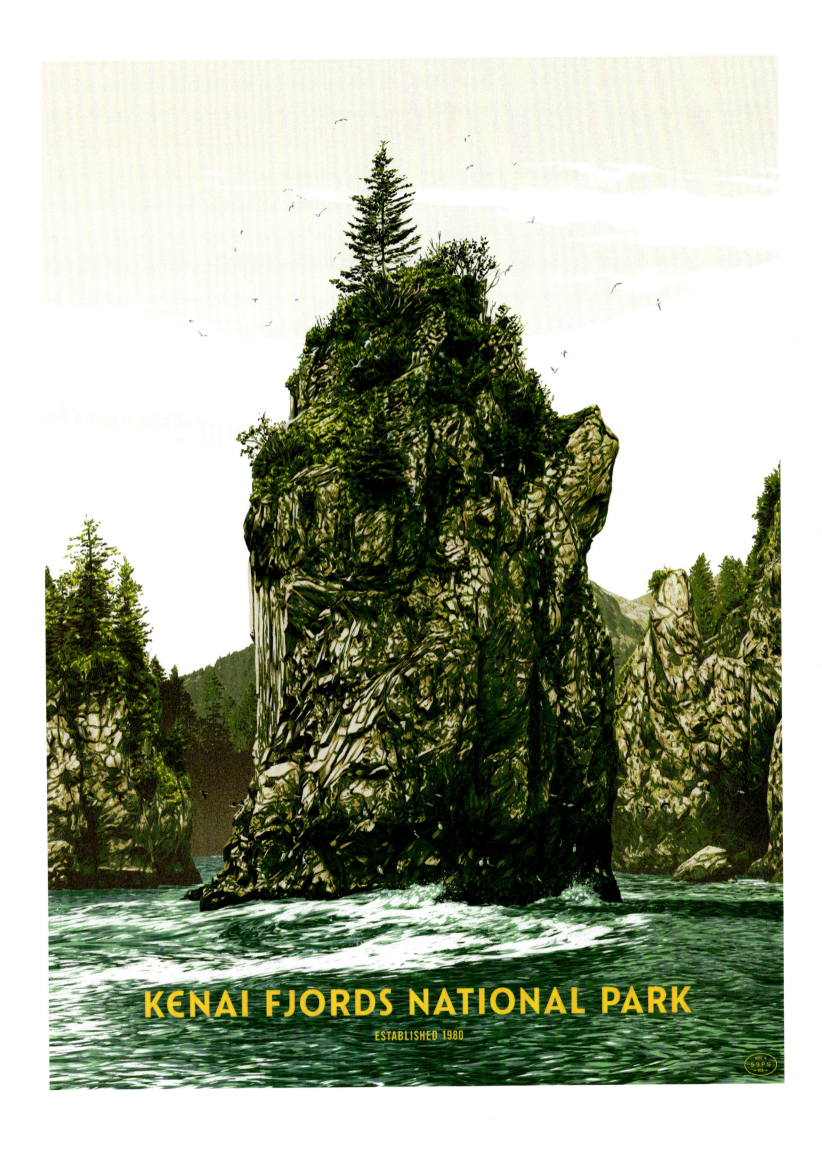

KOBUK VALLEY NATIONAL PARK

No one knows the way of the wind and the caribou.

—Inuit saying

Spread over more than two million acres of undisturbed wilderness in the upper reaches of Alaska, Kobuk Valley National Park is one of the most remote wilderness preserves in the country. Although it lies entirely north of the Arctic Circle, parts of the park are as sandy as the shores of California. Kobuk Valley is like a reverse oasis—a landscape of hazy sand dunes smack in the middle of the Arctic tundra. The dunes are the result of 30,000-year-old glaciers grinding the rocks beneath them into sand that then blew up onto the southern bank of the Kobuk River.

The temperature in the park soars to as high as thirty-seven degrees Fahrenheit—scorching by Arctic standards; however, the temperature can just as easily sink to negative forty-three degrees. Caribou migration routes run through this sandy domain. The caribou make their way from the surrounding mountains to their summer camping grounds. These herds vary in number from a few thousand to as many as hundreds of thousands. Every year, they can be seen crossing the Kobuk River, their horns poking out from the water's surface. The native Inuit population is always ready and waiting when the thousands of horn tips move in unison across the river. This is their one opportunity to hunt their yearly allotment of caribou, as the river water slows the caribou down enough to make them viable prey. The Inuit are careful not to kill any more than they need to feed their families as the caribou's annual return is integral to their survival and has been for centuries.

- Plant life has reclaimed much of the area around the dunes, including wildflowers and Kobuk locoweed, which is only found here in the Kobuk Valley.

- The Kobuk Sand Dunes, along with the Little Kobuk Sand Dunes and the Hunt River Sand Dunes, comprise more than thirty square miles of sand.

- Kobuk Valley National Park is larger than the state of Delaware.

- Caribou, black bears, grizzly bears, porcupines, wolves, foxes, and moose all call the forests of the park home. Their tracks can often be spotted in the sand near the dunes.

- The name Kobuk comes from the Inupiat word meaning "big river."

STATE: ALASKA
ARTIST: DAVID DORAN

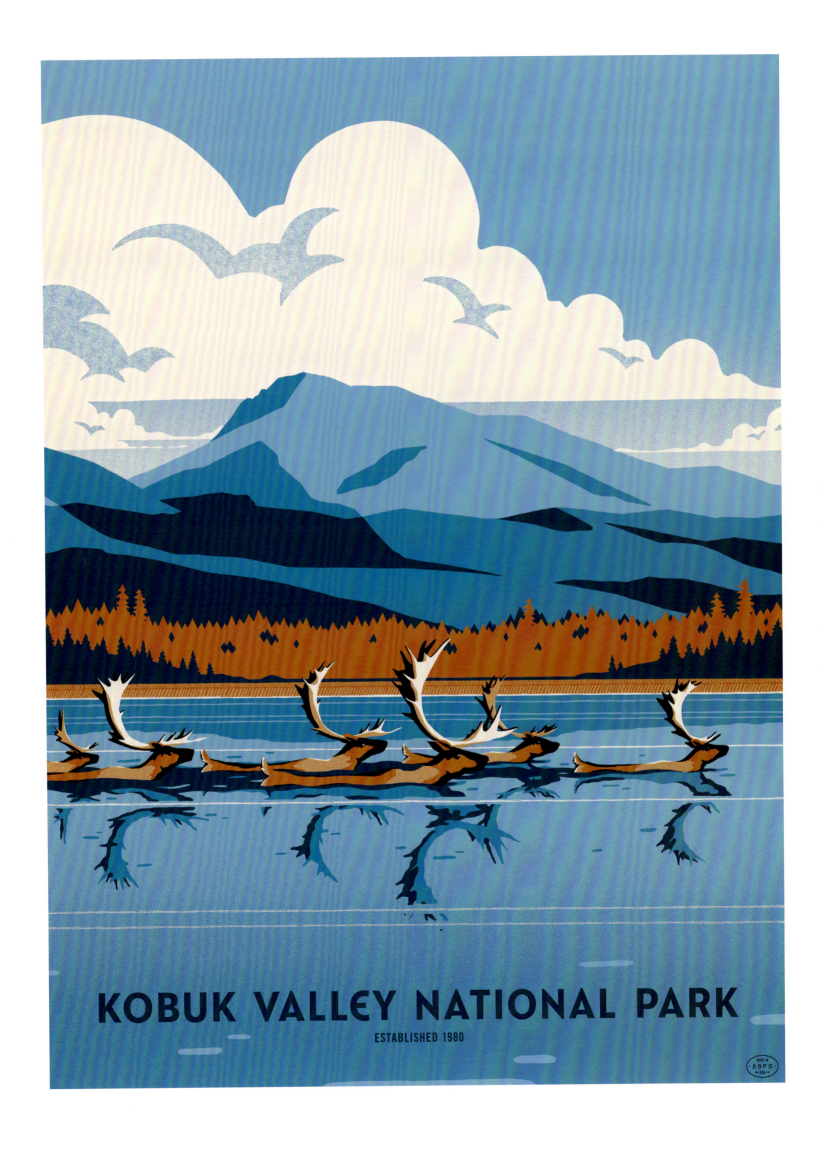

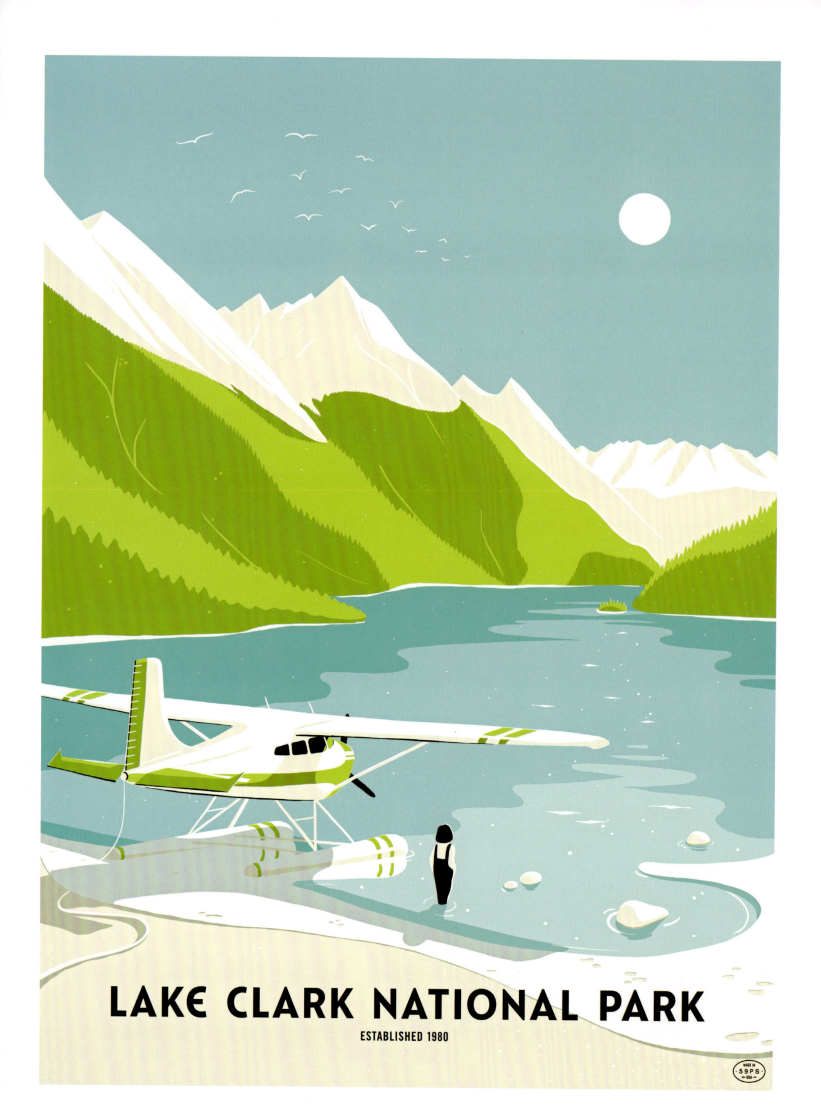

LAKE CLARK NATIONAL PARK

Think of all the splendors that bespeak Alaska. Glaciers, volcanoes, alpine spires, wild rivers, lakes with grayling on the rise. Picture coasts feathered with countless seabirds. Imagine dense forests and far-sweeping tundra, herds of caribou, great roving bears. Now concentrate all these and more into less than one percent of the state—and behold the Lake Clark region, Alaska's epitome.

—John Kaufman

Each of Alaska's numerous national parks highlights a completely distinct element of the great north. Lake Clark National Park, however, is unique in that its boundaries include most of the ecosystems and wildlife native to the larger state. Only accessible by boat or by floatplane, this chunk of southeastern Alaska is teeming with verdant flora and hearty fauna. The lake from which the park got its name is a forty-mile-long and five-mile-wide pool of fresh teal water. Mountains, volcanoes, glaciers, prairies, bogs, and shoreline surround the pool on all sides. Lake-adjacent cabins offer lodging for park visitors. Photography, hiking, mountain climbing, kayaking, and fishing are all available recreation here. Whatever your preferred activity, Lake Clark and its abundant wildlife offer the perfect backdrop for your outdoor adventure.

Alaskan brown bears gather in the park's meadows and fish for salmon in the bright blue lake, as the park is located at the headwaters of the Bristol Bay sockeye salmon run. Dall sheep climb the impossibly steep mountains. Caribou migrate through the tundra. Otters frolic in the lakes and rivers. Foxes, sly and curious, peer out from the cliffs around the lake. The Chigmit Mountains split the park in two. Because the coastal west side of the park is warmer than the cooler, inland east side, the plethora of wildlife native to Alaska all converge here, making Lake Clark the definitive Alaska experience.

- At nearly four million acres, Lake Clark National Park is larger than Rhode Island and Connecticut combined.

- The highest point in the park is at the top of Mount Redoubt, which stands 9,150 feet above the surrounding terrain.

- Mount Redoubt, an active volcano, erupted as recently as 2009.

- People are believed to have lived here as many as 10,000 years ago.

- The Dena'ina people are native to the area. The Indigenous name for Lake Clark is Qizhjeh Vena.

STATE: ALASKA
ARTIST: KRISTEN BOYDSTUN

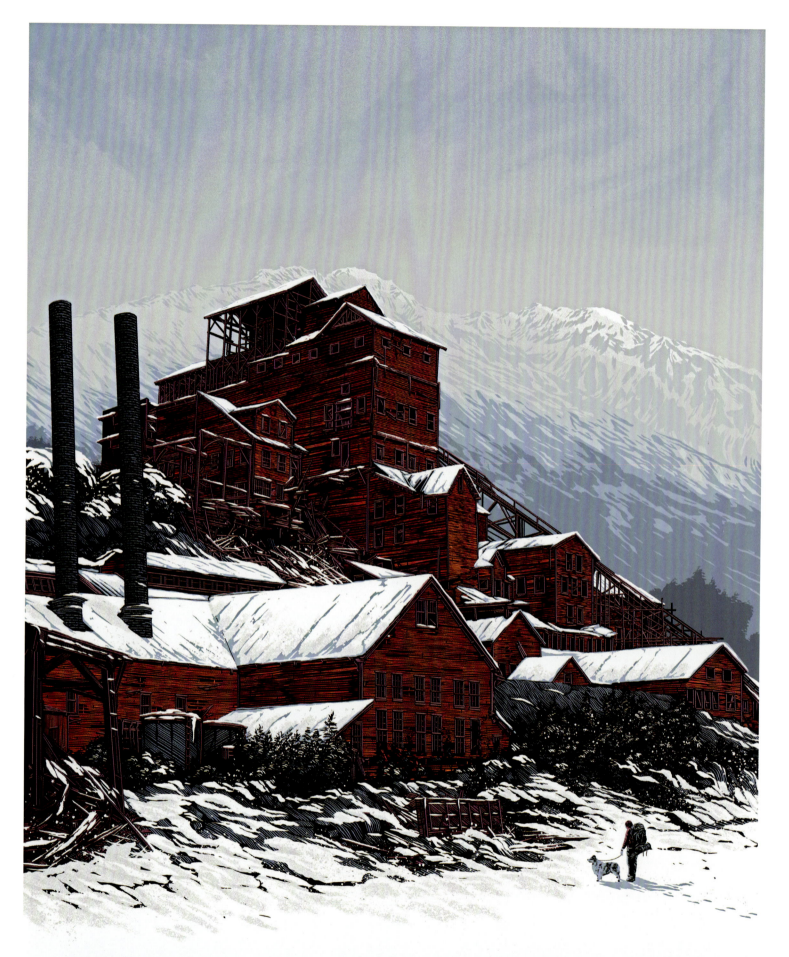

WRANGELL—ST. ELIAS NATIONAL PARK

It takes a lot of territory to keep this alive, a living wilderness, for scientific observation and for esthetic inspiration. The Far North is a fragile place.

—*Olaus Murie*

Each American national park provides a new piece of the puzzle in our efforts to more completely understand this world. Wrangell—St. Elias National Park, by far the largest national park in the United States, speaks to both the history of the land and the nation. Superlative in every way, it offers the most glaciers, the most Dall sheep, the largest grizzly bears, and the highest peaks of any park or preserve in the country. In keeping with its general grandeur, it is surrounded by imposing mountain ranges. The Wrangells in the north wear a crown of glaciers. The smaller Chugach Mountains loom in the south. St. Elias stretches across the east, and includes the second-highest peak in the United States.

Only two roads run through the park, meaning that much of its land is accessible only by plane. The local timber wolves, black bears, caribou, wolverines, porcupines, and lynx carry on with business as usual as they tend not to get a lot of visitors. Wrangell—St. Elias also offers a unique perspective on American history. In 1898, American settlers discovered huge deposits of copper in the Kennecott Mountains. An entire town was formed in a whirlwind, and a railroad was built to mine and export the copper. Kennecott became a mining boom town; but then, just as quickly as it materialized, the mining company dissolved, leaving a ghost town in its wake. Today, Kennecott and the adjacent town of McCarthy (where miners once went to drink alcohol and blow off steam) are mainly tourist attractions. People visit the abandoned Kennecott homes and restored mine that was once among the most successful in the country. The town and mine stand as reminders that natural beauty is a gift worth infinitely more than mineral rights.

- Wrangell—St. Elias National Park is by far the largest national park in the United States. At 13,175,799 acres, it's more than six times the size of Yellowstone.

- Though it hasn't erupted since 1900, Mount Wrangell is considered an active volcano.

- Wrangell—St. Elias National Park is home to the largest glacier system in the United States.

- Glaciers cover 35 percent of the park. These glaciers make up one-fourth of all the glaciers in North America.

- Hubbard Glacier is the largest tidewater glacier in North America. Unlike most glaciers (which are melting), Hubbard is actually growing due to increased snowfall.

STATE: ALASKA
ARTIST: DANIEL DANGER

THE
PACIFIC

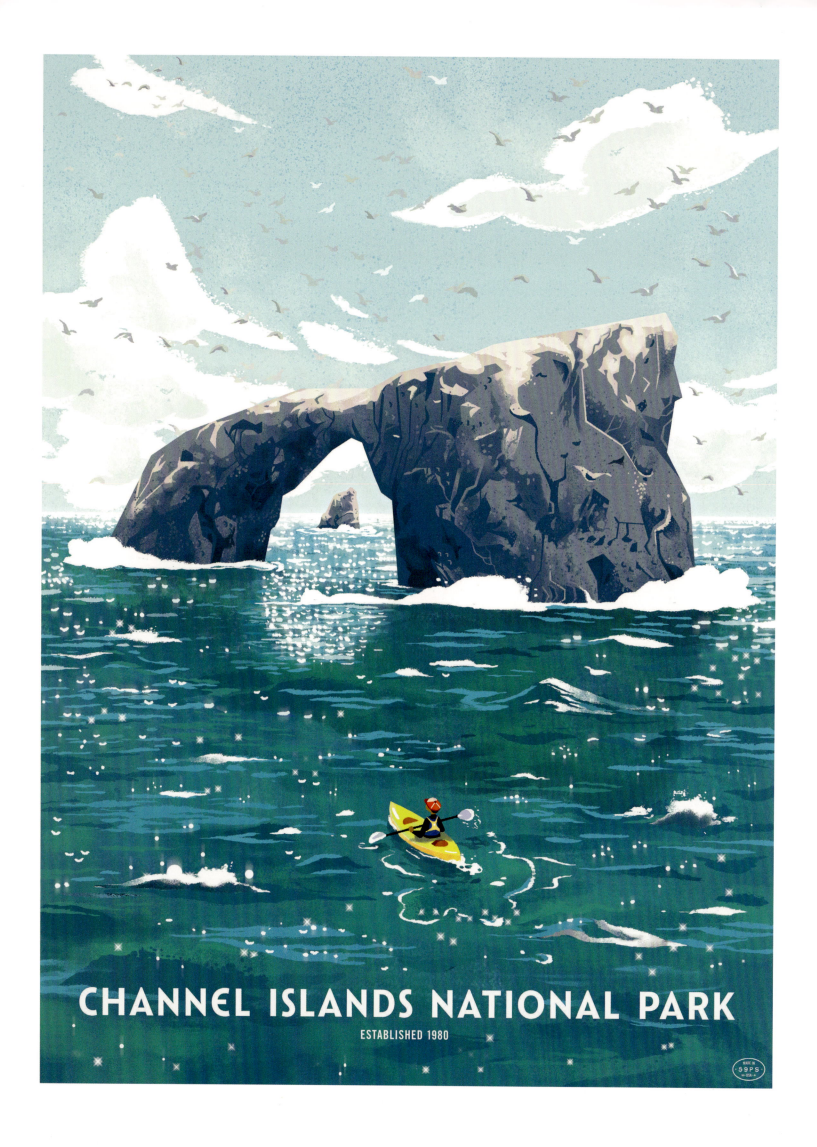

CHANNEL ISLANDS NATIONAL PARK

A national park is not a playground. It's a sanctuary for nature and for humans who will accept nature on nature's own terms.

—*Michael Frome*

Just offshore from Santa Barbara and Ventura, California, is an archipelago of the five islands that make up Channel Islands National Park. The islands range vastly in size. The largest, Santa Cruz Island, is nearly the size of a small American city, and the smallest, Santa Barbara Island, is barely a single square mile. The islands give us a sense of what the Pacific coast might have looked like hundreds of years ago, before the coffee shops and skyscrapers. The federally protected islands can only be accessed by boat or by air. Most visitors arrive by boat to Scorpion Ranch on the north shore of Santa Cruz Island, only bringing what they can carry in their hands. Once on the islands, the comforts of the real world must be left behind. Inhabitants must make use of the bare minimum while camping and hiking. The reward is the stunning sights, sounds, and sensations that the islands provide.

Half of the 249,354 acres that make up the park are underwater. Bottlenose dolphins play in the waves, sea otters float near the shore, and sea lions lounge on the beach in large packs. Gray whales are extremely common to the area during the spring, and humpback whales, blue whales, and orcas are no strangers to the islands. The still-standing Anacapa Island Lighthouse was once a beacon for ships braving the Pacific. All five islands are biosphere reserves, meaning that the wildlife here is fastidiously protected. You must make sure to take out what you bring in and leave no trace: This park is a testament to the value of preservation.

- The effort to protect these islands was due in part to their importance for nesting seabirds. In fact, the Channel Islands are often considered the American Galapagos.

- The entire population of Xantus's murrelets, a penguin-like seabird, resides on the Channel Islands.

- Only three species of mammal are native to the islands: the spotted skunk, the deer mouse, and the Channel Islands fox.

- In 2006, a bald eagle egg hatched in the park. This was the first time in fifty years that this had happened on the islands without assistance from humans.

- The oldest human bones ever found in North America were found on Santa Rosa Island. The bones date back to 13,000 BC.

STATE: CALIFORNIA
ARTIST: SOPHIE DIAO

HALEAKALĀ NATIONAL PARK

It is the sublimest spectacle I ever witnessed.

—*Mark Twain*

There is no place on the island of Maui that isn't beautiful, but five square miles of land surrounding a defunct volcano were deemed so enchanting that they were made into a national park. Puʻuʻulaʻula, the highest point on the island, stands 10,020 feet tall and looks down upon the Haleakalā Crater Valley. The valley's seven-mile expanse is dotted with craters, cinder cones, and other volcanic phenomena. The crater plunges down 2,600 feet deep.

The scenic Hāna Highway leads visitors to the Kīpahulu Valley. The upper part of this valley is an inaccessible but integral rainforest preserve that features plants and animals from all over the world, including some that exist nowhere else on the globe. Below this preserve is a collection of freshwater pools, cascading streams, and waterfalls. Waimoku Falls is a straight 400-foot drop down volcanic rock into a boulder-strewn pool. The Seven Sacred Pools of ʻOheʻo, considered by many to be the essence of island paradise, is a series of waterfalls carved out over centuries by rainforest streams. If Maui itself is heaven on earth, then this park is the eternal Eden at its center.

- More endangered plant and animal species live here than in any other park in the United States.

- One such plant species, the Haleakalā silversword, is a small, spiny white plant that was once so plentiful it made the mountain appear covered in snow.

- The nene is an endangered species of goose that once existed throughout the world but now only exists in Hawaii. As of 2010, only 2,000 of them were still alive.

- Hosmer's Grove is a forest in the park featuring trees from all over the world, including deodar from the Himalaya, sugi from Japan, and eucalyptus from Australia.

- Haleakalā means "house of the sun" in Hawaiian. According to legend, the demigod Maui lassoed the sun as it crossed the sky in order to make the day last longer.

STATE: HAWAII
ARTIST: DAN MUMFORD

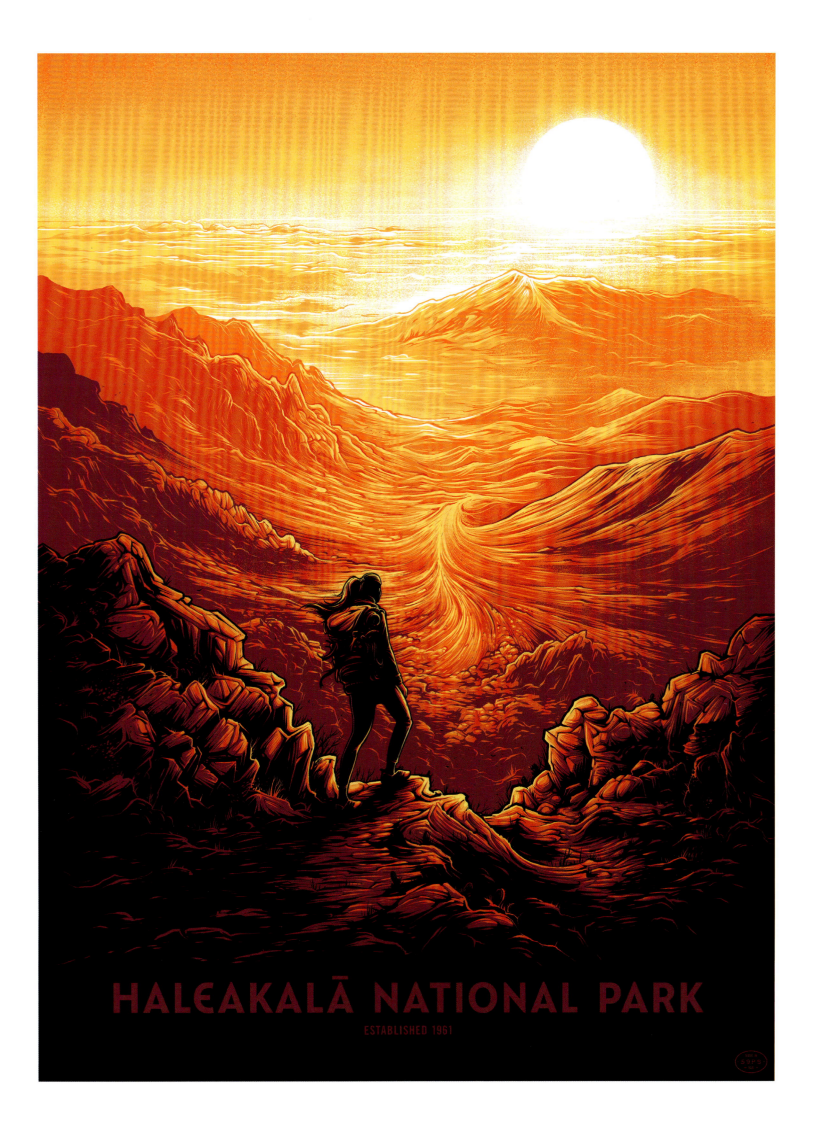

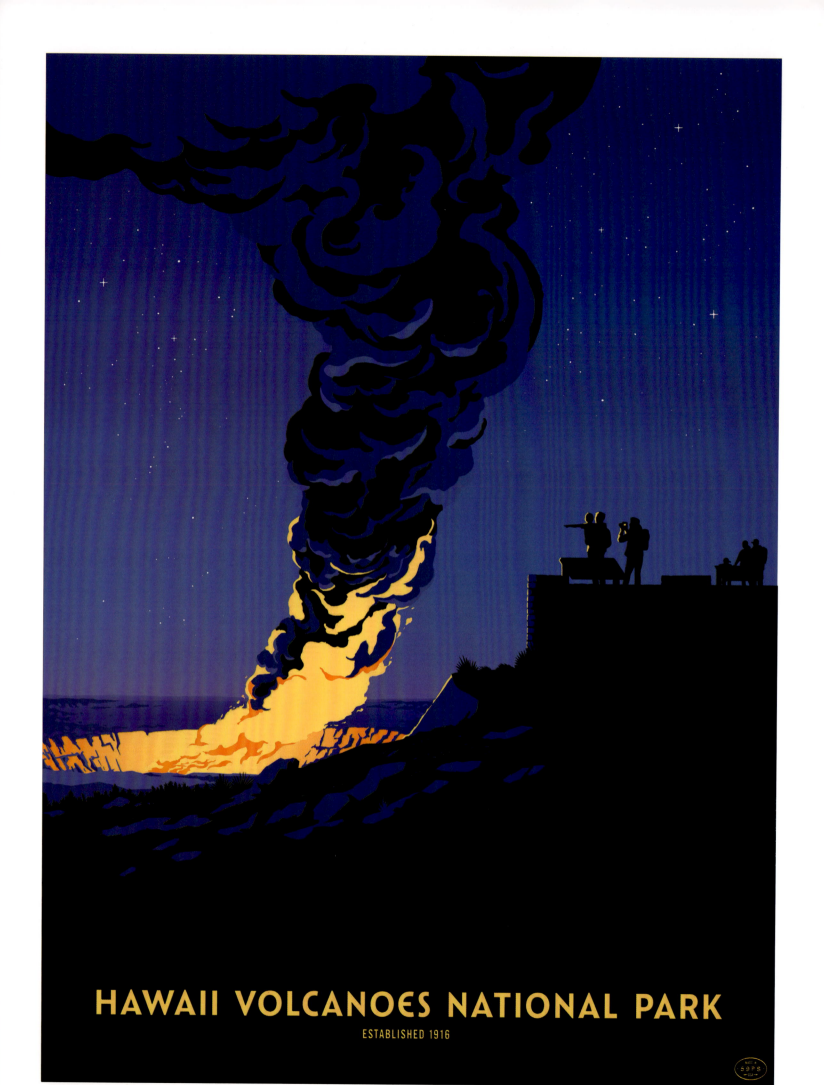

HAWAI'I VOLCANOES NATIONAL PARK

The beauty of Hawaii probably surpasses other places. I like the Big Island and the two mountains, Mauna Loa and Mauna Kea, where you can look out at the stars.

—Buzz Aldrin

Children sometimes pretend that the floor beneath their feet is made out of lava, but how many of us have actually stood close enough to lava to feel the heat radiating from its syrupy glow? Hawai'i Volcanoes National Park contains two volcanoes. Mauna Loa, standing 13,679 feet high, is the world's largest shield volcano; shield volcanoes are so called because active, viscous lava flow sculpts them into the shape of a wide hill with shallow slopes. Mount Kīlauea stands 4,091 feet tall and is considered the world's most active volcano. Between 1983 and 2018, Kīlauea erupted continuously. In May of 2018, there was a massive explosion of lava from Kīlauea that caused untold damage to nearby communities and ecosystems.

Today, visitors can still drive right up to the summit of this lake of fire. Lava from Kīlauea is carried to the Pacific Ocean through underground "lava tubes." When portions of the roof of these tubes fall off they create "skylights" that allow us to witness the fiery stream inside. Having risen above sea level only 100,000 years ago, Kīlauea is the second-youngest volcano on the island. Throughout Hawai'i Volcanoes National Park, unprecedented access to these remarkable engines of the earth's crust teaches visitors exactly how land forms anew. You can literally watch this park change and transform before your very eyes.

- The summit caldera of Kīlauea contains a lava lake called Halema'uma'u.

- Halema'uma'u is said to be the home of the Hawaiian volcano goddess, Pele.

- Mauna Loa means "long mountain" in Hawaiian. It lives up to its name, standing over 13,000 feet tall.

- Ninety percent of the native plants and animals found in Hawaii are found only in Hawaii.

- Most of the species that live on the island of Hawaii were either able to fly there or were small enough to be carried by birds; as a result, exotic bat and bird species are common on the island.

STATE: HAWAII
ARTIST: VINCENT ROCHE

NATIONAL PARK OF AMERICAN SAMOA

We don't farewell a moonlit night.

—Samoan proverb

National Park of American Samoa is the tropical equivalent of Denali or Glacier Bay in Alaska. Like Alaska's national parks, this untamed wilderness is lacking in amenities but bristling with natural beauty and cultural soul. Situated along three oceanic islands, American Samoa offers an array of tropical biodiversity ranging from mountains and volcanoes to coral reefs and rainforests. Tutuila, the largest island in the park, is home to the port of Pago Pago, American Samoa's capital city. This volcanic island embodies the celebratory and close-knit culture of the Samoan people. Many locals in the Pago Pago area host park visitors in their own homes.

Efforts to establish the park began in 1984 as an attempt to protect the island's endangered wildlife and distinctive rainforest. Because Samoans don't believe in land ownership, it took several years of deliberation between the National Park Service and island natives before the park could become a reality. In 1988, island councils agreed to lease the land to the National Park Service for fifty years provided the agency agreed to protect the sanctity of the region's natural gifts.

Today, visitors can traverse the teeming prehistoric rainforests of American Samoa through the park's many hiking trails. Mount Alava Trail brings hikers face to face with the island's exotic vegetation and wildlife, and offers panoramic views of Pago Pago. Beneath the rippling waves, some of the Earth's most vibrant and illustrious coral reefs thrive. Pristine tide pools and sparkling waterfalls accent the exceptional beauty of this tropical paradise.

- Interest in establishing a park on the islands began as an effort to protect Samoa's population of flying foxes (also known as fruit bats).

- The image of a Samoan fruit bat was featured on an American quarter commemorating the park.

- Tutuila is the only island in the park that is reachable by car. Ta'ū is only accessible by airplane, and Ofu is only accessible by small boat.

- The ocean surrounding the park is home to more than 250 species of coral.

- The word Samoa means "sacred earth."

LOCATION: AMERICAN SAMOA
ARTIST: TOM HAUGOMAT

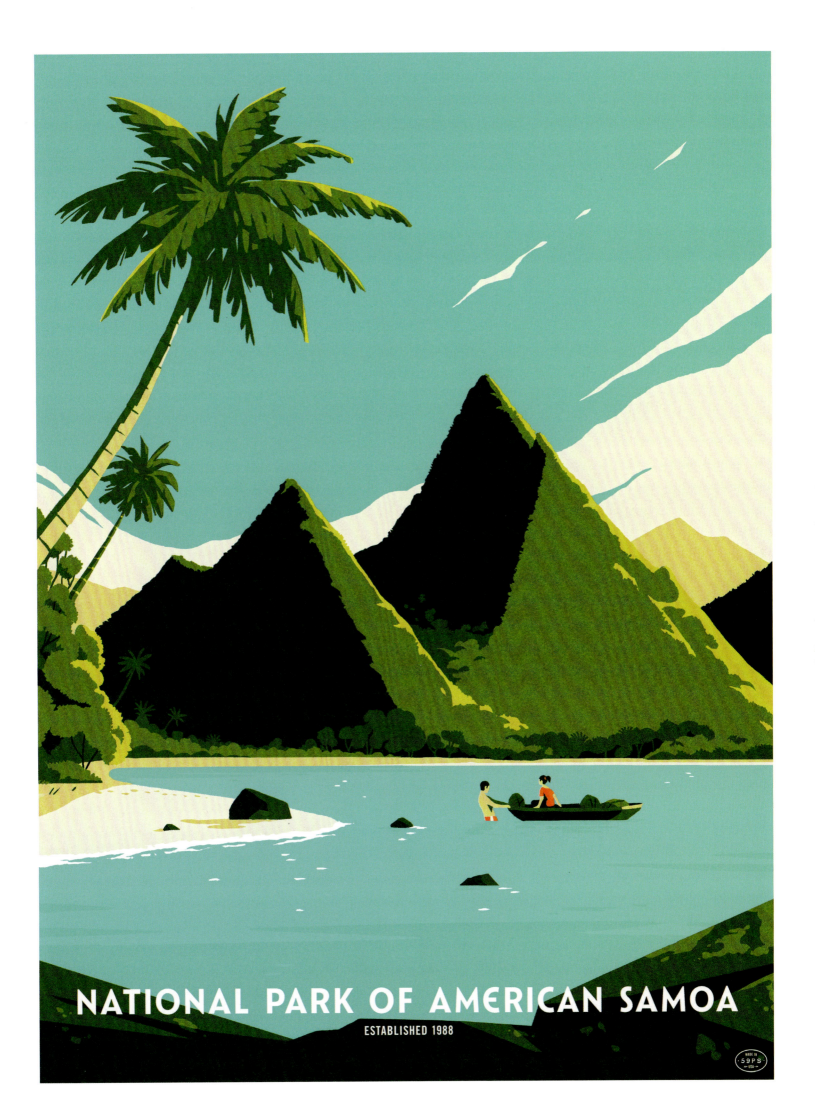

BEHIND
THE SERIES

OUR MEDIUM OF CHOICE

We trek across the United States every year to share the collection with thousands of people at gallery shows and conventions. The question we're asked the most is "how do you print these?" The answer is always "oh, we screen print them!" The second most asked question is "Got it! Um...what is screen printing?"

SO, WHAT IS SCREEN PRINTING?

In simplest terms it's the process of pushing ink through a mesh stencil. Each color of a poster is printed one at a time. Screen printing dates back to the Song dynasty (960–1279) in China. The printing technique eventually spread to Japan and later to Europe. Back then screens were created using human hair or silk—hence the term "silk-screen printing." The medium was refined over the centuries and used to make prints, wallpaper, and clothing. The medium was masterfully used in the 1930s to create the iconic WPA posters that we all love.

HOW DOES SCREEN PRINTING WORK?

First we draw our poster and separate each color onto its own layer. We then use a large format printer to create films of each color. Next we use light sensitive emulsion to coat a screen. We rest one film on a prepared screen and expose them both to a strong light source. The exposure time for a screen is dependent on the strength of the light. Any area that features our art blocks the emulsion from light. The parts of the screen that are hit by light slowly harden. The part of the screen that is blocked by our design then washes out with water. The areas that wash out create the opening which lets ink pass through the screen. We then repeat this process anywhere from six to twelve times—depending on the color count of a poster. Once our screens are made, we then print each color one at a time.

Back in the day we would use a set of hinge clamps and a sturdy table as a makeshift printing rig. These days we work with world-class printers who print on more sophisticated presses. This allows for finer print detail, tighter color registration, and larger print runs.

WHY NOT USE ONE OF THEM LASER PRINTERS?

If you couldn't tell, we love screen printing! There's some kind of magic that enchants screen printed posters. The tactile qualities of prints are so refreshing in the digital age. Colors are mixed by hand and matched by eye. Paper is hand-fed into the press. Every step of the design and printing process requires some TLC that machines just can't provide on their own. This also means each print is slightly unique and has a sense of the human touch. We admire the medium because it's so approachable for DIYers and professionals alike!

PRINTING OUR POSTERS: STEP BY STEP

- ILLUSTRATE A FUN POSTER
- SEPARATE COLORS ON INDIVIDUAL LAYERS
- PRINT OUT FILM FOR EACH LAYER
- COAT A SCREEN WITH PHOTO EMULSION
- PLACE THE FILM ON THE DRIED SCREEN
- EXPOSE THE SCREEN (AND FILM) TO LIGHT
- WASH OUT THE SCREEN WITH WATER
- REPEAT STEPS ABOVE FOR EACH COLOR
- PRINT EACH COLOR—ONE AT A TIME

SCREEN PRINTING TERMS

SCREEN
Typically an aluminum—or wood—frame that has a fine mesh stretched over it.

MESH
A material—typically made from polyester—that is stretched over screens. The denser the mesh, the more art detail a screen will hold.

SEPARATIONS
Each color is isolated onto its own layer and then printed onto film.

FILM
Clear plastic that has art printed in black.

PHOTO EMULSION
A light sensitive solution that coats screens. The emulsion hardens when exposed to UV light.

SQUEEGEE
A flat rubber blade that is used to pull the ink across the screen.

BURNING A SCREEN
Film is placed on a screen coated with photo emulsion and exposed to light. Areas not featuring artwork are hardened. Areas that feature artwork wash out—thus creating the stencil.

REGISTRATION
The alignment of one color with another.

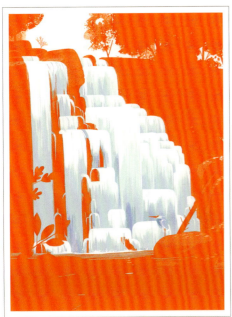
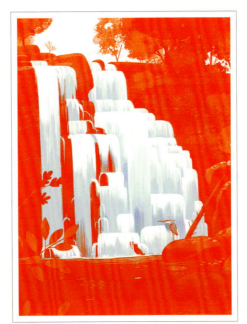
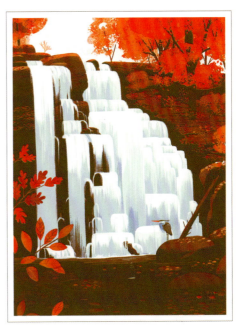
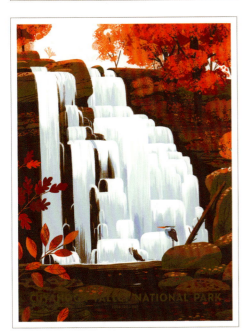
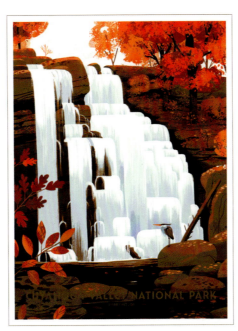
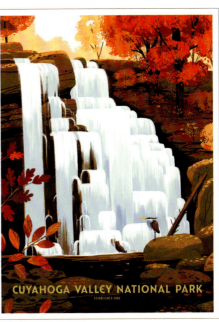

A LOOK AT COLOR SEPARATIONS
Cuyahoga Valley National Park Poster by Kim Smith

COMMON THREADS

One of the things we hear the most is that the series is so diverse yet so cohesive. That's one of the highest compliments we can receive. People often struggle to put their finger on just what makes this eclectic group of posters feel at home together. Is it the colors, the theme, the medium?

THE BRANDING

One of the common threads throughout everything we make is the branding. Though we use it sparingly, it really does have an impact. That's largely because of the incredible work by our friend Curtis Jinkins. Having consistent yet flexible branding is a cornerstone of the series.

ABCDEFGHIJKLMN OPQRSTUVWXYZ

TYPOGRAPHY

The custom typeface used on every poster is a big unifier of the series. Type designer Riley Cran did fantastic work on Catlin Sans. Catlin was designed to be a tip-of-the-cap to classic American letterforms from the early twentieth century. Riley did some amazing work capturing that classic vibe while still creating something fresh!

ART DIRECTION

The series largely features a different artist for each park. That means many hands have made important contributions to the collective whole. Having three consistent sets of hands at Fifty-Nine Parks has been immensely helpful. This means we can work with color in a similar way across every print. It also means we can be intentional with each composition to make sure there's not too much overlap.

THE POSTER TEMPLATE

Creating a system to apply across every single image is another way to unify the series. Consistent typography, branding, borders, poster dimensions, and poster orientation are simple—but effective—ways to help provide a common thread between each poster.

CURATION

There's a lot of intentionality that goes into pairing artists with each specific park. We strive to be as inclusive as possible with the series. This means we work with poster artists and non-poster artists alike—from all around the world. The ultimate goal is to play to each artist's strengths and interests. This is the best way we've found to honor each park while celebrating the medium we love!

INDEX

Acadia National Park 18

Arches National Park 114

B

Badlands National Park 56

Big Bend National Park 64

Biscayne National Park 33

Black Canyon of the Gunnison
National Park 80

Bryce Canyon National Park 83

C

Canyonlands National Park 124

Capitol Reef National Park 119

Carlsbad Caverns National Park 74

Channel Islands National Park 159

Congaree National Park 31

Crater Lake National Park 138

Cuyahoga Valley National Park 43

D

Death Valley National Park 96

Denali National Park 141

Dry Tortugas National Park 34

E

Everglades National Park 37

G

Gates of the Arctic
National Park 143

Gateway Arch National Park 48

Glacier Bay National Park 144

Glacier National Park 94

Grand Canyon National Park 69

Grand Teton National Park 90

Great Basin National Park 127

Great Sand Dunes National Park 85

Great Smoky Mountains
National Park 28

Guadalupe Mountains National Park 63

H

Haleakalā National Park 160

Hawai'i Volcanoes National Park 163

Hot Springs National Park 51

I

Indiana Dunes National Park 47

Isle Royale National Park 44

J

Joshua Tree National Park 99

K

Katmai National Park 147

Kenai Fjords National Park 148

Kings Canyon National Park 101

Kobuk Valley National Park 150

L

Lake Clark National Park 153

Lassen Volcanic National Park 103

M

Mammoth Cave National Park 22

Mesa Verde National Park 87

Mount Rainier National Park 132

N

National Park of American Samoa 164

New River Gorge National Park 27

North Cascades National Park 134

O

Olympic National Park 137

P

Petrified Forest National Park 70

Pinnacles National Park 104

R

Redwood National and State Parks 107

Rocky Mountain National Park 88

S

Saguaro National Park 73

Sequoia National Park 112

Shenandoah National Park 25

T

Theodore Roosevelt
National Park 55

V

Virgin Islands National Park 38

Voyageurs National Park 52

W

White Sands National Park 77

Wind Cave National Park 58

Wrangell—St. Elias
National Park 155

Y

Yellowstone National Park 93

Yosemite National Park 110

Z

Zion National Park 121

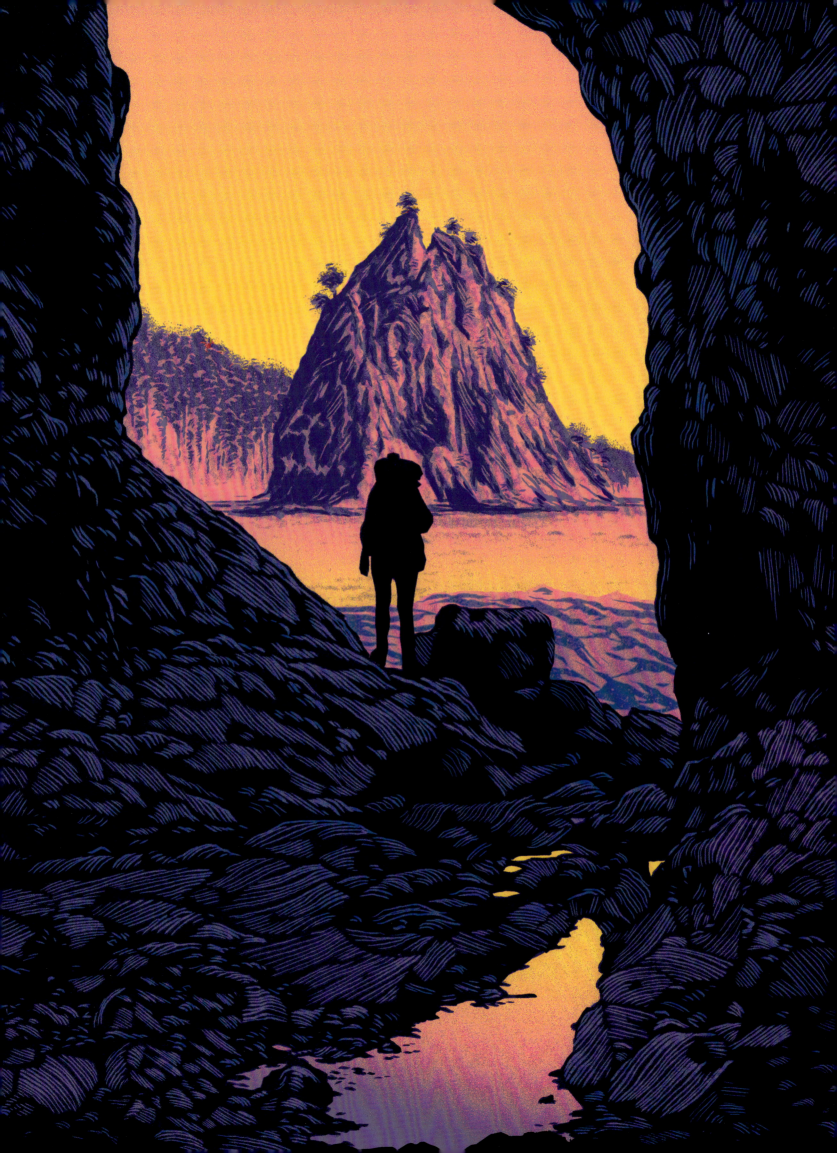

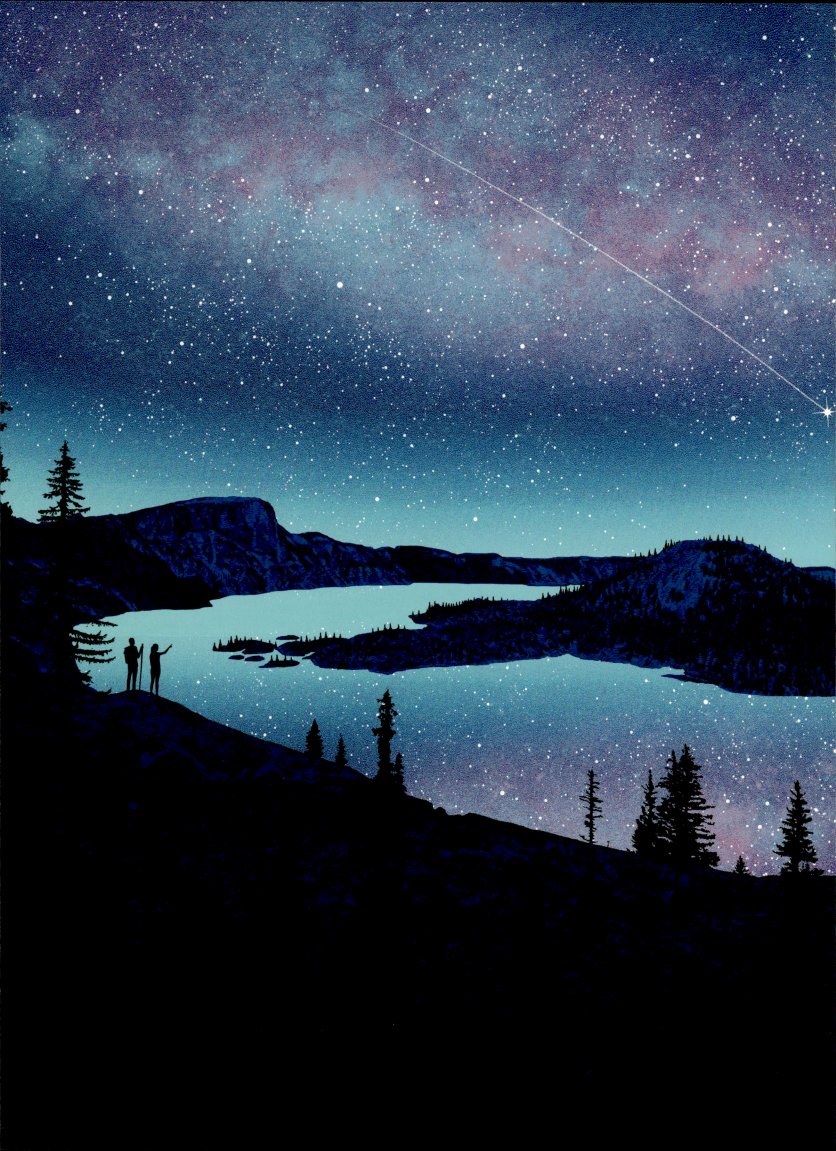

WITH GRATITUDE

We would love to give the biggest shout-out to every artist in the series! None of this would be possible without you! We admire everything you've done for the world of design and print-making. We're forever grateful for your hard work and partnership. You're an inspiration!

Marc Aspinall	Johnny Dombrowski	Curtis Jinkins	Nick Slater
Oliver Barrett	David Doran	Adisa Kareem	Kim Smith
Jonathan Bartlett	Laurent Durieux	Rory Kurtz	Jeremy Spears
Kristen Boydstun	Jack Durieux	Little Friends	Studio Muti
Brave the Woods	Josh Emrich	Simon Marchner	Eric Tan
Camp Nevernice	Kilian Eng	Mike McCain	Matt Taylor
Riley Cran	Cristian Eres	Dan McCarthy	Telegramme Paper Co.
Daniel Danger	Benjamin Flouw	Elle Michalka	Glenn Thomas
Thomas Danthony	Jeff Langevin	Dan Mumford	Marie Thorhauge
Owen Davey	Ft. Lonesome	Eric Nyffeler	Marianna Tomaselli
Jacquelin de Leon	Jay Gordon	Plaid Mtn.	Chris Turnham
Nicolas Delort	Leesha Hannigan	Aaron Powers	Two Arms Inc.
Sophie Diao	Tom Haugomat	Vincent Roché	John Vogl
Dingbat Co.	Kevin Hong	Justin Santora	Tom Whalen
DKNG Studios	Claire Hummel	Steve Scott	Matthew Woodson

This series also wouldn't be possible without the hard work and support of the following people. Your encouragement, life chats, and guidance mean the world to us. You all have a permanent home on our version of Mount Rushmore. Thank you for being who you are!

Mom Boneyard	Erin Davis	Lisa Rosowsky	Katherine Blood
Brian Buccaroni	Matt Wilding	Fish McGill	Alex Bibby
Angela Kyrish	Eli Epstein	MassArt	The Topo Team
Mom Buccaroni	Danny Askar	Elissa Dunn Scott	KelleyAnn Schilke
Grandma Boilard	Nate Walsh	Shayla Barber	Tony Diaz
Grandpa Boilard	Justin Brookhart	Shayla Forsey	Industry Print Shop
Daniel Niejadlik	Mitch Putnam	The Adobe team	Crispin Giles
Michael Swiatlowski	Rob Jones	The Half and Half	The NXNE Team
Chris Herland	The Mondo team	Sean & Ellen Saathoff	Angelin Borsics
John-Paul Jimenez	The D&L team	Bethany Heck	Seizure Palace
Brian Butler	Burlesque	Alex & Ellie Buck	Paula Pierce
Brad Woodard	Chris Everhart	Paul Roth	Andy Kokoszka
Krystal Woodard	Claire Hummel	Jeff Noble	Christopher Swist
Susan Loughran	Gabriel Chicoine	Jim Coudal	Kevin Bouvier
Anne Kelley	Mattox Shuler	Aaron Draplin	Eric Hnatow
David Boilard	Jennifer Graham-Macht	The Field Notes Team	Jeremy Smith
Shelly Dumont	Kyle Key	Brian French	Bill Russell
Will Dumont	Matt Aiken	French Paper	John Wooden
Jen Gelineau	Keymaster Games	Nick Sambrato	Happy Buccaroni
Dan McCarthy	Henry Audubon	Mama's Sauce	Shepard Fairey
Jacob Cummings	Julie Manzi	Brittani Mathis	Phil Elverum
Nathaniel B.	Mike Swartz	The SXSW Team	Kirk Goldsberry
Roger Shaw	Tito Bottitta	Kathy Morgan	Theresa Pierno
Warren Buchanan	Jared Novack	Doug Penick	Flywheel
Matt Wise	Upstatement	Clare Maney	The Old Store & the Shed
Chrissy Kwasnik	Vahalla Studios	Heather Sakai	Diamond Junction
Brooke McCullum	James Weinberg	Bart Kibbe	The Nat'l Park Service
Insight Editions	Joe Quackenbush	Nick Wilson	and YOU!

BEHIND THE SERIES | 175

Fifty-Nine Parks

www.59parks.net

Find us on Instagram: @fiftynineparks
Follow us on Twitter: @fiftynineparks

P.O. Box 3088
San Rafael, CA 94912
www.MandalaEarth.com

Find us on Facebook: www.facebook.com/MandalaEarth

Publisher: Raoul Goff
Associate Publisher: Roger Shaw
VP of Creative: Chrissy Kwasnik
VP of Manufacturing: Alix Nicholaeff
Designer: Brooke McCullum
Sponsoring Editor: Matt Wise
Editorial Assistant: Sophia Wright
Senior Production Manager: Greg Steffen
Production Associate: Deena Hashem

Published by Earth Aware Editions, San Rafael, California, in 2021.

The Art of the National Parks © 2021 Fifty Nine Parks, LLC

No part of this book may be reproduced in any form without written permission from the publisher.

ISBN: 978-1-64722-370-0

Insight Editions, in association with Roots of Peace, will plant two trees for each tree used in the manufacturing of this book. Roots of Peace is an internationally renowned humanitarian organization dedicated to eradicating land mines worldwide and converting war-torn lands into productive farms and wildlife habitats. Roots of Peace will plant two million fruit and nut trees in Afghanistan and provide farmers there with the skills and support necessary for sustainable land use.

Manufactured in China

10 9 8 7 6

CELEBRATING 50 YEARS

At NatureBridge, we believe creating environmental leaders and stewards begins with a powerful educational experience, one in which our students discover their own interest and passion for the environment. We know that when young people discover the wonder and science of the natural world, they're prepared for a lifetime of exploration and stewardship of the environment. As the largest nonprofit educational partner of the National Park Service, NatureBridge serves over 30,000 students and 600 schools each year in Yosemite National Park and the Golden Gate National Recreation Area in California; Olympic National Park in Washington; and Prince William Forest Park in Virginia. NatureBridge increases access to the outdoors by providing scholarship support to 45% of students who may not otherwise have the economic opportunity to experience our parks.

Founded in 1971, and led by the likes of Robert Redford, Ansel Adams and Apollo 8 Astronaut, Bill Anders, NatureBridge has assumed a fundamental role in introducing and connecting youth to the beauty, uniqueness and fragility of our planet, particularly youth that require a champion to forge this connection. Collectively, our programs have reached more than one and a half million young people to date.

Our innovative programs take youth out of the classroom and into national parks where they spend multiple days immersed in nature, living and learning alongside their peers.

WE ARE COMMITTED TO

EXPERIENTIAL EDUCATION: We lead the field in overnight, multi-day environmental science education, guided by the latest research and a team of expert scientists and researchers.

INCREASING ACCESS: We believe every young person should have access to the outdoors and our programs, regardless of financial ability. We provide 45 percent of participating schools with financial support.

BUILDING CHARACTER: We help young people develop knowledge, skills and character to grow into caring, inquisitive and informed adults.

INSPIRING STEWARDSHIP: We are committed to creating new leaders and stewards who represent the diversity of our nation and who have the skills to advance their passion for championing the natural world.

A portion of the proceeds from the sale of each copy of this book will be donated to NatureBridge, www.naturebridge.org